Typeset in Caslon by
Andrew Adamides, andrewadamides.org

Front Cover Image: *Psyche Revived by Cupid's Kiss* (1793)
by Antonio Canova. Photograph by Dennis Jarvis and
distributed under a Creative Commons License.

The short stories in this collection are works of fiction. The
characters and organizations portrayed in these stories
are from the author's imagination or used fictitiously.

To The Muses,

Tania, A Faithful Reader,

Jess, A Trusted Reviewer,

Deb, A Dedicated Wordsmith,

&

Alice, A Steward of Art History

TALES OF ART, SEDUCTION AND OBSESSION

Gods and Girls

JOHN R. TSCHIRCH

TALES

For by the ruling powers of heaven
All virtues are to mortals given
Wisdom is theirs–from them are sprung
The active hand, the fluid tongue.

EXCERPT FROM *THE FIRST PYTHIAN ODE*
PINDAR

The Face of Venus

"Fleur, Fleur, look this way."

Indifference marked the finely proportioned face. As the paparazzi struggled to get their prized shots, Fleur floated into the posh classicism of the Hotel Crillon. Her pale blue eyes stared past the crowd. Other people and places preoccupied this goddess, who thought only of Greek islands and a much-anticipated text message.

"Fleur, more beautiful than ever," said Pierre, fawning and nearly fainting in her presence. With an entourage of stylists, Pierre fluttered nervously about the lobby in an effort to satisfy every one of Fleur's spoken and unspoken desires. Her blond locks tied into into a soft bun, no makeup, a gray t-shirt, an ivory-colored wool sweater softly draping over her torso, hip-hugging jeans and distressed leather shoes were all that she required at present.

Detached from the whirl of fans and flunkies all about her, Fleur sauntered across to the elevator waiting open in readiness. Doors closed. The living Venus departed. The moment over, all assistants, photographers and sycophants now lost their reason for being. Dispersed and despondent without their Muse, they disappeared into the night.

With the first faint rays of morning light, the beauty appeared once again in the lobby.

"Miss Belmont, your car is ready."

"Fine," she said before taking her last disinterested sip of pear juice and handing it back to the panting waiter, who quickly snapped a photograph of her once she turned away.

Fleur never said, "thank you." Only the word "fine" passed her lips. Never did she express appreciation for the efforts of any human on her behalf. Upon reaching the threshold of the hotel's entrance, a monumental rendition of some ancient temple's gateway in cream colored stone, Fleur stopped, aware of the camera-ready moment, intuitively sensing when in an ideal frame. Cameras snapped away, then she stepped out on to the sidewalk, taking no notice of the sun rising over Paris.

"Good morning, Miss Belmont."

Fleur nodded her head slightly but said nothing to the chauffeur holding the car door open with all due formality. She ignored the bouquet of roses placed on her seat by hotel management. Only the screen of her phone drew her attention while the vehicle made its way through the grandeur of the Place de la Concorde, the square's fountains in full spray and its granite obelisk, once the glory of an Egyptian god-king, reigning over the scene. She did not care that King Louis XVI and his queen, Marie Antoinette, lost their heads to the guillotine on this very spot. History had never called to Fleur. To her right, she could have enjoyed a view down the Champs Elysees to the Arc de Triomphe. Just ahead, the bridges over the River Seine emerged from dawn's mist and the Eiffel Tower loomed in the distance. She paid no homage to these architectural splendors. Only a single concern occupied her mind as she searched her phone in vain for only one message.

Stately rows of trees acted as nature's honor guard on the avenue approaching the Louvre, but Fleur took no account of these

elegantly clipped sentinels. As the car arrived at the museum, two nattily uniformed officers saluted while Fleur's personal assistant, Cheri, paced back and forth on the steps chattering on her cell phone. Upon seeing the goddess emerge from the vehicle, Cheri abruptly ended her call and buzzed about her boss like a bee at its honey.

"We are all set to go. Reporters have been at me for days about the Face of Venus campaign, but I'm leaving them in the dark. The world knows you are here yet nobody knows why. EROS Cosmetics said they haven't paid a fortune for you to launch their new line and then let the tabloids break the story. That scoop is for the fashion editors tonight."

Fleur did not acknowledge Cheri or her fretting and fussing. She moved forward in a measured pace towards a relentless parade of colonnades and arcades asserting the old palace's once divinely ordained royal authority. The sculptural show of defiant deities soaring from the roof and the cascades of flowers on every cornice made no impression on her, but Fleur did notice scores of people hanging about an assortment of doors and leaning out of various windows.

"Everyone seems to be on duty," scoffed Cheri. "I'll say one thing for the staff of the Louvre. When you are going to appear, they become very efficient. The public relations person can't wait to meet you. Several of the curators want to be you. I said you might be free at lunch if the director wants to show you a few things. You know, like the Mona Lisa."

While Fleur floated on air among her admirers, Cheri stormed ahead as if the Louvre were a barricade to be breached. She passed by a cadre of security guards until arriving at an oak and wrought iron door of imperial proportions. Originally made for the crowned heads and conquerors of times past, and always sealed shut to common visitors of the present day, the mighty portal now opened solely for the reception of Fleur.

Cheri whispered in a none too subtle tone, "some of these security dudes are hot, in that beat- up sort of way that I like."

"Yes, some of them," said the brawniest of the guards. "We have hundreds to choose from. Take your time and pick well, Madamoiselle. The Louvre is a treasure trove."

"So, guards are wits here in Paris," Cheri retorted. "And see themselves as works of art."

Winking at Cheri, the guard made no further remarks while escorting the honored guests to a monumental flight of stairs. Every secretary, intern, research fellow and art conservator made a point of being in the corridors to bear witness to the woman proclaimed the world's most beautiful. Fleur remained aloof; Cheri beamed in the reflected glory.

While human onlookers expressed a mix of curiosity and admiration, a bevy of faces in oil, pastel and graphite rested contentedly on the walls, unconcerned at being duly ignored by Fleur and Cheri as they journeyed into the heart of the museum. Writhing torsos and noble profiles in marble, clay and bronze high atop their pedestals had better things to do than wonder about two young women of mere flesh and blood passing by in a heartbeat. Beauty, barbarity, benevolence and countless other emotions and deeds on display in centuries of accumulated art offered themselves for anyone's pleasure. Fleur's thoughts, however, focused on a world far removed from the museum's august halls while Cheri's seemed channeled only onto her own anxieties. Personal woes had to bow to professional obligations once they arrived at the Antiquities Department, where a fragile, ancient figure stood in front of a modest door unencumbered by the Greco-Roman fripperies of the Louvre's grand galleries.

"Hello, Father Time," said the guard as he slapped the old man on the shoulder. "How goes it this morning? All the statues still here? Or did they walk out on you?"

The man made a courtly bow and mumbled, "permitte divis cetera." Pointing to the frieze above the door, he continued, "old Latin saying, meaning leave all else to the gods."

"Who is that troll?" whispered Cheri.

"Victor!" proclaimed the guard in a deep voice resounding through the stone hall. "The oldest and most honored employee at the Louvre. He has been here so long no one knows when he actually started, so we call him Father Time. He skulks up and down the galleries all day and night talking to the portraits. He is odd, but harmless. Now, you are his charge."

Cheri scowled at the guard as he made a mocking salute before departing. Fleur nodded to the ancient man, who returned the gesture and opened the door onto a grim little office serving as a makeshift dressing room. A lady with a mass of jet-black hair, a prominently crooked nose and a sullen expression, more suitable to the guardian of a tomb rather than the makeup artist to a beauty, sat in front of a cosmetic-laden table. With uncompromising precision, she arranged potions, eyebrow pencils and powders under a lamp casting a most intrusive level of light.

"Francesco wants you to be in tones of silvery gold. I don't know how I am going to make that happen."

"And good morning to you, Andrea," said Cheri. "I see you're in the usual maudlin mood."

Andrea remained motionless, in no way providing any sign to confirm the assistant's remark. Fleur tapped Andrea's cheek with her own. She kissed no one. Cheek to cheek embraces sufficed to indicate any kind of affection, real or perceived. Andrea gestured for Fleur to be seated and then sneered at Cheri.

"Stay out of my light."

"Whatever you command, Signora Sunshine!" chirped Cheri, who leaned against the wall and began to check her text messages.

Andrea angled the mirror on her subject, adjusted the makeup lamp and readied for her performance. As Fleur faced the looking glass, Andrea came from behind and cupped the model's face in her hands, examining every feature in search of areas near the eyes, along the cheekbones and around the lips to enhance or tone down for the camera. Her own dark deep-set eyes, deadened and unmoving, seemed as if they had witnessed a thousand years of human folly. They scanned the beauty's face with the probity of a microscope.

"I told Francesco his lighting has to create the final touches for that silver and gold mix he wants so badly. I can only do so much. He spent all night studying that statue, lighting and relighting it. The curator looks exhausted even though all he did was stand and watch. And I'm expected to create magic in this rabbit hole of a room. Oh well, for what it's worth, let's begin."

Andrea sighed the longest sigh as she gently dabbed a pale ivory-colored foundation onto Fleur's cheeks. She wiped it off, started over, made an exasperated growl and removed it again.

"This is wrong. You cannot be imprisoned in makeup. They just do not understand beauty and certainly do not appreciate you. Creams and lipsticks are all they care about."

Andrea cupped her hands on Fleur's cheeks once again. The two women gazed into the mirror in quiet contemplation.

"The face. They do not know that it all starts with the face. They want their makeup to be the center of attention, but it needs to be a servant to the face, not the other way around."

With a soft brush, she applied a scant amount of rouge to Fleur's cheeks then threw the brush across the room.

"EROS Cosmetics launches The Face of Venus campaign. How absurd. I will only use moisturizer, oil and a little powder. Nothing else will do."

A barely discernable grin appeared on Andrea's face as she picked up a glass vial filled with an amber-toned liquid.

"You will be the face of a cosmetics campaign while not wearing any of their makeup. They would have you painted up like a clown. Imagine that. All the beauties in the Louvre's collection laughing at you from their picture frames. No need to worry, though. I am here. I will keep you safe."

Pouring a few drops of almond oil and ground gold from the vial onto her index finger, Andrea applied it to Fleur's cheeks and under her eyebrows. Flesh began to lightly sparkle. Lips became ever softer with the application of a plant and honey extract. The dour makeup artist had once more created magic. Seeking out the mirror again, Andrea's eyes came alive as she beheld her angel. She raised both hands to her mouth and threw a symbolic kiss into the air.

"Yes, the Face of Venus campaign. The executives want a certain look. Clean and classical. They have it but not in the way they think. The gods demand perfection for you and I ensure it, even if I complain. After all, I am only human. Or that is what most people think."

Cheri applauded. Andrea attempted, without success, not to grin. This rarest of pleasant moments between the two evaporated instantly upon the ringing of Cheri's phone.

"Yes, the editors will be at the reception."

Fire filled Cheri's eyes as she ground her teeth.

"Yes, all the big fashion magazines are confirmed. Yes, Fleur will wear the Grecian goddess dress. Dior has outdone itself. Yes, she will only wear Marie Antoinette's sapphire in her hair. The museum and the government have agreed to lend it. Yes, there will only be white roses on the tables. How many times do I have to say 'yes?' Everything is done. Fleur is here. Andrea and Francesco are on it and I'm about to have a meltdown if I don't get a cigarette, but they

don't allow smoking in the Louvre because of all of this artsy stuff on the walls. Enough said! Okay. See you later."

Fleur stared directly ahead as Andrea applied ground gold to her eyelids. Flipping through her iPad, Cheri exclaimed, "this campaign will be the death of me."

Barely touching Fleur's eyebrows with a fine silver-toned pencil, Andrea said, "what do you expect when one Venus meets another?"

Smirking, Cheri retorted, "then I'll get the world's most famous statue to give an interview. She's probably more cooperative than the world's most famous model."

No word passed Fleur's lips. She moved not a muscle as Andrea performed her cosmetic ritual. Silence, in partnership with beauty, formed Fleur's arsenal. It created a mystique around her while every other celebrity revealed all. Sphinx-like, she appeared untouchable and otherworldly. No one ever seemed to know what she thought or felt. Reporters ate it up.

"Our girl only speaks when she has something to say," said Andrea. "Fleur doesn't play for the press. They play for her and record her every whim because they know they are in the presence of the goddess."

As she patted the last daub of powder, Andrea circled around Fleur to examine the line of the jaw, the bridge of the nose, the forehead and the back of the neck.

"If I want Nefertiti, I call Christy. Linda for Helen of Troy, Kate for Eve and Adriana for Cleopatra. They are exquisite, but only mere mortals. No one has the face of the goddess. Only you, Fleur. You are the one and only Venus, the divine one."

Andrea gently framed Fleur's face with both of her hands for one final, intensive review of bone structure, skin tone and hair color.

"I can't even apply makeup on you as I do with any of them. No. Your face is a mystery. I wonder if the camera ever really captures it.

Mario, Mark, they came close, yet never quite got it. But Francesco is determined. He's so sure he'll achieve it this time in front of the Venus de Milo. I doubt it, though. The gods won't allow it. You belong to them."

Glancing at Cheri, Andrea said, "you, on the other hand, belong to any brute who pays attention to you. How is that useless music rep you have been throwing yourself at these days?"

Pursing her lips, Cheri snapped, "I don't know. We aren't speaking."

Andrea's stern face surrendered to a grin.

"There will be another by any minute. But my other girl here is waiting much too long."

Adding one more bit of oil to Fleur's lips, Andrea said, "you waste your time with Adonis. He will never be true to you."

Fleur remained motionless, impossible to decipher, except for Andrea, who effortlessly read her mind and body. Cheri, in marked contrast, never stopped talking and kept no secrets whatsoever. She pulled up an image of Adonis on her phone and held it up to the mirror.

"How could being with Adonis ever be a waste of time? Those thighs. That tight waist. The rock-hard abs. Mmmmm. And the boy has one fine package. No doubt about that. All the world's fun in one place. And, baby, those shorts swing with a load-full at every game. Keeps everyone watching. I could waste my time forever on that Greek god."

Andrea's glance distilled pure disdain.

"So, he is the up and coming soccer star. Adonis Viachos, the new Greek version of Beckham. Fine, fine, fine. The world's number one model with the greatest athlete. We have seen it before. He served his purpose. Now he is bored and I can tell that my beauty is just as tired of him."

Andrea wrapped Fleur's hair around her index finger, letting it fall in curling tresses.

"But my girl will not let go. She thinks only about sailing the Greek islands with him. That trip will not change things. And wait not for the text message. It will never come."

Finished with her work, Andrea leaned against the counter and began to polish her nails.

"A woman's beauty is always a curse. It drives men mad. They can only take from beautiful women, never give. Helpless fools. They worship the divine ones who made them insane with desire, but they marry the girls who are real."

Smirking yet again, Cheri said, "Carlo swears he fell insanely in love with you at first sight and has never stopped, even after twenty years. So, are you divine? Or is he blind?"

Andrea tapped Cheri on the nose with her nail file.

"There are some secrets I will never reveal."

A knock on the door ended the banter as three young ladies, all with the name 'Grace' hanging from each of their thin gold necklaces, ceremoniously entered with a garment of diaphanous fabric falling in the luxurious folds of a Greek gown. Gold and silver flecks in the textile matched the color shading Andrea had brushed over Fleur's eyes. Within minutes, all three Graces had precisely fitted the dress to Fleur's torso and hips.

"Perfect," they declared. "You were made to wear this."

As light as air, the dress softly caressed every inch of Fleur's body. Everyone stood in rapt attention. For all of the campaigns they had worked on together, these professionals, so skilled at the art of illusion, had never beheld such an effortless vision of beauty. There they stood in meditative embrace around their creation until interrupted by the flash of a camera.

"Enough, you harpies. Time to let the goddess go. No more

painting and primping."

Francesco raised his hands as if to heaven in praise.

"Fleur. My divine one. It's time."

Everyone left the room, excitedly scrambling down the gallery with the ancient guard plodding behind at a glacial but determined pace. In the distance rose the statue of the Venus de Milo amidst cold stone vestibules and cavernous arches.

"Fleur and Venus finally together. The resemblance is astounding," pronounced Francesco as he led his model before the statue. "This campaign is going to make history. I will be the master of the universe. All photographers will bow down before me. And you, Fleur, are about to become an icon."

Seated in Francesco's chair, massaging her cuticles, Andrea remarked, "you are tempting the Fates. Be careful not to soar too high. You will surely fall."

Arranging the lights, measuring their angles within a fraction of a centimeter, Francesco said, "so, now you are the messenger of the gods? Mind your tongue, Andrea, and put away your claws. If it weren't for me, you would still be doing nails in that shabby salon in Milan."

"And you forget that without me, your models would never glow. You would still be in that dirty loft in Genoa doing nude photos by the hour."

Francesco threw Andrea a kiss.

"Any nude in any setting is worthy of my attention, but I confess, there is no figure that is as pure as our Venus. I feel I am finally at the holy of holies before this beauty."

As Francesco circled about the objects of his fascination, Fleur posed in the same manner as the statue. Everyone present looked on in wonder, except Andrea, who easily asserted, "that piece of stone is merely a copy of our Fleur. Who is the real beauty here?

Maybe the all-seeing photographer can tell us."

Focusing his camera lens, Francesco said, "our Fleur and Venus might be one in the same. I have been studying the topic."

Placing the lights to create a soft hue on his subjects, Francesco knelt, contemplating the figures before him. He spoke in a hushed reverent tone as one addressing the sacred.

"Venus is the ancient Roman goddess of beauty and love. No one could resist her. She possessed a power beyond mere physical strength. Women worshipped her as an ideal. Men withered in her presence. Born of the sea foam that landed in a scallop shell on the island of Cythera, she came ashore and astonished one and all as the perfect form of womanhood. Married to Mercury, she gave birth to Cupid, the impish child who shot golden arrows through those he wished to make fall in love."

Francesco laid on the floor and shot upwards at the model and the sculpture to record the stark play of light and shadow on every drape of fabric and bodily feature. He moved quickly, making preliminary studies and assessing what his camera might reveal in this initial flirtation.

"Venus also has her dark side. She is the one who promised Paris the most desirable woman in the world if he would name her as the fairest of goddesses over her competitors, Athena and Diana. He chose Venus and won the woman named Helen, whom he carried off to his home city of Troy to present her to his father, King Priam. Thus began the first act in the Trojan War."

Rising from the floor, Francesco eyed the harmonious line of Fleur's profile from forehead to nose, over lips and down to chin. Once finished, a wry smile flashed across his face.

"Beauty brings bloodshed. Desire decrees destruction. Beware of beauty, my friends. It begins with delight. It blooms into seduction, flowers into obsession and ends in annihilation."

Gently, he angled Fleur's head to create a profile of her face, running his index finger along her cheekbone, assessing the distance between neck and ear lobe, comparing these features to those of the sculpture. He then lined up his subjects, superimposing one upon the other, playing flesh against stone. With every click of the camera, he continued his tale of Venus.

"The statue graced the temple at Melos in the Aegean Sea. When all fell to ruin, she slept for nearly two thousand years until a farmer found her buried in Mother Earth in the spring of 1820. The goddess then caused a chain reaction of enchantment. She bewitched the farmer then bemused a French naval officer, who appealed to his ambassador to purchase the beauty. Although the Greeks referred to her as Aphrodite, the French called her by the Roman name, Venus. A name that strikes right to the heart. As Venus, she would be introduced to the world again. Venus of Melos."

Francesco directed Fleur to recline at the base of the statue. With unflinching grace, she posed for photo after photo, each one more exquisite than the last while Francesco's mood became far more intense in both movement and words as he darted about speaking in a heated tone.

"Of course, the French ambassador instantly fell in love with her, paying the Turkish authorities who ruled the island a king's ransom for Venus. She was brought to Paris and presented to the King of France. Dear old decadent Louis XVIII. His Majesty could have made Venus his very own, but he chose to share her. From the day this stone goddess arrived at the Louvre, she has been worshipped as she should be, as the standard of beauty. That indefinable thing that women hope to be, that men long for, sing of, write about and live and die for."

Andrea, keeping an ever-protective eye on Fleur, watched for every change of light that might affect the appearance of her creation.

"Our girl is more beautiful than that statue. And when did you, Francesco, become such an expert on art?"

"I research all of my subjects in order to bring out their true spirit," said Francesco as he focused his attentions on the statue. "Did you know that Venus also enchanted the Duke of Sagan? He secretly rushed her out of Paris and hid her deep in the countryside at the Chateau de Valencay during World War II to keep the Germans from seizing the beauty for themselves."

"That is much like our Fleur," said Andrea. "who has every rock star, billionaire and delivery boy swooning. But I doubt they would protect her as Sagan did his statue. They only want to use Fleur. Mortals cannot be trusted with a goddess in human form."

Francesco climbed on to a staging specially built for this occasion so he could work from above. He hung off the metal contraption, floating high above the floor, in order to record the soft curves of the shoulders and backs of the two female figures. Upon finishing his shots, he remained suspended in the air while gazing downward.

"Venus possessed me from the moment I laid eyes on her. And Fleur is the ideal pairing. Look at the soft flesh on our girl and the smooth marble of the sculpture. Warmth and coolness. Divine and mortal beauty side by side. It is right here and I am the only man to capture it. Only me."

Francesco jumped down on the floor and began a non-stop binge of picture taking. Silence now reigned as he went into hyper-focus on his task. He walked forwards and backwards, side to side, pacing and pondering. Accustomed as they were to long photo shoots, the assembled group could not believe how many hours ticked by as Francesco took long shots and wide shots, close-ups and odd angle shots.

Regardless of the time passing, Fleur remained as still and calm as the statue itself. Francesco's face, however, began to flush with excitement. His clenched jaw betrayed anticipation. His twinkling

eyes displayed naked ambition, distilling the hope that he might be on the verge of revealing the essence of beauty, that intangible triumph that had eluded him with every other model. The moment of glory, however, did not burst forth. He froze. Breathing deeply, his body was stricken as if a greater presence forbade him from continuing.

Standing still, as if in a trance, Francesco gazed upon the Venus de Milo until chattering emerged in the background. The museum had opened for the day and hordes of visitors began to appear at the entrance to the gallery, chirping excitedly and gawking at the presence of fame. Andrea went over to stare directly back at the onlookers as if they, too, were on exhibit.

"I wonder who they have come to see," she said. "The statue of Venus or the living goddess? Based on the number of Fleur's admirers flocking about us, the Louvre should have given EROS Cosmetics a discounted fee for using this place. I am sure there has been a boost in ticket sales to the museum today. You had better stop shooting for now, Francesco, since the crowd will swamp us at any second. Let me have my girl back. She is cold from laying against all of this stone."

Andrea picked up a shawl and put it over Fleur's shoulders. Noticing reporters on the march, Cheri scurried over to deal with them. Francesco, barely able to lift his fingers, put his camera down. Once the lens left his grasp, he exhaled, his posture improved and his limbs moved more freely.

"I need to speak with our beauty to go over what I want from this evening's shoot."

Perturbed, Andrea said, "not too long. Fleur needs rest. I have never seen you take so long on a shoot. You are lucky our girl is so patient."

With a wave of his hand, Francesco dismissed Andrea. She grimaced and made her way back to the dressing room.

Placing his hands on Fleur's cheeks, Francesco said, "we made gold this morning as if you were kissed by the sun. Yet, there is still that pure essence waiting to be caught. I almost had it but it eluded me. At the midnight shoot, we will focus on silver tones as if the moon is caressing Venus. I know it will happen then. You must have fresh, clear eyes. So, no alcohol at the reception. And get some beauty sleep. I will stay here with Venus."

Limping like a wounded warrior, Francesco returned to his camera and lights, pacing before the statue. With the photo shoot over, Fleur looked for Cheri but she was nowhere to be found. Desperate to avoid the gaze of the public, Fleur left the gallery in search of solitude. She let silence be her guide through hall after empty hall until she came upon a door with a 'No ADMITTANCE' sign hung from its lion-headed bronze handle. Turning the metal ring in the mouth of the fearsome beast, she pried the door open and dashed forward as it closed behind her with such heavy finality that there was no turning back.

Fleur found herself in a gallery filled with staging, piles of boxes and stacks of picture frames. On one of the walls hung three portraits she could not ignore. Moving closer, she looked into the most grotesque of the images labeled as *The Ugly Duchess, Quentin Matsys, circa 1513. The National Gallery, London.* Next was an almost identical version in red chalk on paper identified by an engraved brass plaque as *Leonardo da Vinci. On loan by gracious permission of Her Majesty, The Queen, from the Royal Collection at Windsor Castle.* With a nose like a pig, sallow skin and sagging breasts, this visage both repulsed and commanded attention. As Fleur beheld a face so very opposite to her own, she felt the sadness in the woman's forlorn eyes and the pain in every bone.

"May I help you, Mademoiselle?"

Startled by the intrusion of a voice on her encounter with the homeliest of ladies, Fleur turned quickly and saw a young man before her.

"Oh, I didn't know anyone was here," said Fleur.

"Are you lost, Mademoiselle?"

The young man adjusted his thick black glasses while curls of brown hair fell in his face, shielding most of his features, except for pouting lips and a dimpled chin.

Fleur rarely explained herself, but she felt compelled to do so.

"I was looking for my assistant, but, obviously, she is not here."

"No, Mademoiselle, this wing is closed while we prepare for an exhibition, so no one is here."

"Except you," she said.

As he made eye contact with her, he jerked his head in a nervous twitch and quickly averted his attentions to the floor.

Amused at his shyness, Fleur moved a little closer to tease him a bit.

"Avoiding the public certainly leads to interesting places. I am a model for a shoot that is being held in the Antiquities Wing."

With a slight grin revealing more of his dimple, the young man said, "yes, Mademoiselle, I know who you are."

"I see," said Fleur. "And who are these bizarre creatures on the wall?"

"They are portraits for the upcoming *Ugliness* exhibition. The curator has assembled works of those poor souls deemed unusual or distorted. They come from collections all across Europe and Britain. I am in charge of installation so I suppose you could call me the caretaker of the ugly."

The young man pushed the curls from his face and, with the slightest flourish of his arm, invited Fleur to have a closer view of the other works of art.

"This is the *Insane Woman* by Theodore Gericault, painted in

1820. The face reveals a long life of suffering. Maybe she began as a beauty, but we will never know. Her leathery skin is worn from work under the sun and the eyes burn with a crazed intensity. She looks off to one side. It could be someone she is about to murder or maybe it is a sound that intrigues her. We are left to wonder. She just sits there in the prison of her own lunacy. Or, possibly, it has freed her from life's cares. Who knows? We are left to draw our own conclusions."

Bringing Fleur up to the last portrait in the series, the young man pointed out a much-reworked digital photograph of the Venus de Milo taken from several angles and superimposed on an island set in a deep blue sea.

"The photographer took the eternal symbol of beauty and made her ugly by rearranging features, elongating her face and making her torso bulge. But it is still her, the divinely beautiful one. The artist is challenging us. How can she still be the symbol of beauty while being portrayed as ugly? So, the exhibition asks, what is beautiful and what is ugly? Is it all in our perception?"

Stepping right up to the photograph, Fleur's eyes revealed a clarity of sight and an abiding sympathy. She seemed at home with the image, comfortable in its presence. No questions came forth, only confident expression.

"She is being called home. Behind her is the island of Melos. Venus is abandoning the others on these walls. Maybe, when she leaves, one of them will then become the most beautiful in the room."

Rubbing his forehead, the young man remarked, "I don't believe that beauty is a relative thing. Venus is always the measure, even when she is not present. She is a universal truth."

"Maybe," said Fleur. "Beauty in flesh, stone or paint are the same. Flesh withers. Stone crumbles. Color fades. Truth is eternal, but beauty in any form is fleeting."

"Well said, Mademoiselle. You seem to have come to a truth of your own."

"Maybe," said Fleur as she dwelt upon the photograph.

"I met Venus today and now I realize how they all see me. It is not me, of course. They view me like the statue. An ideal. Not something real. It is not the truth. There is no truth, only an obsession with a figure in marble."

The young man brought over a small sketch of the Venus de Milo. He pointed out the light gray lines, a mere suggestion of the sculpture's curving contours and noble pose.

"Venus takes many forms. It is in stone in the museum, in pencil on this piece of paper, in the photograph on this wall. In each case, the beauty is true. If we seek it, we will find it. Seduction, obsession, admiration. They are all on the spectrum of our emotions when we encounter beauty. Through these, we find the truth whether we want to or not. Beauty always challenges me. Sometimes it makes me happy and hopeful. Sometimes I'm distorted by it. Other times tortured. Often, it makes me despair, like the people in these portraits. It may lead me to many places, but, eventually, it always brings me to the truth, especially about myself and what I want, what I need and who I become when I encounter it."

Dimpled cheeks complemented the young man's dimpled chin as he confessed to Fleur. He did not retreat after confessing vulnerable truths. He simply returned to his works of art, tenderly leveling frames and adjusting labels. Fleur watched him, seeing how carefully he measured the wall space so exact proportions reigned in his placement of portraits.

"You have created a beautiful exhibit out of so-called ugliness," she declared. "I admire the detail with which you do everything."

The young man put aside his measuring tape and brought her back to the photograph of Venus. He took out a wooden stencil cut into a grid pattern and laid it across the image, fastening it to one

side of the frame with hinges.

"This is the final part of the artwork. The stencil may be opened and closed so the viewer can see how the artist arranged the image. When we look at the photograph as a whole, the body of Venus appears distorted. Cover the image with the stencil and each cut-out square isolates a body part. Alone, the arm or the leg or the neck look perfect. The details are beautiful. What appears distorted at first is, on more careful observation, exquisite. That's the truth of the image."

Fleur took the stencil off of its hinges and held it in front of her face.

"What do you see now?"

"True beauty, whether whole or in parts."

"I believe you speak the truth," she remarked as she wistfully observed the photograph's dismembered head and assorted body parts. "Maybe I will encounter the truth about beauty in its own home ground. I am supposed to go to Melos with my boyfriend, who promised to bring me sailing in the Aegean."

"Melos!" exclaimed the young man. "It is in the Cycladic Islands. They are as old as time. Maybe even older than recorded time. Our curator of antiquities told me the Athenians massacred all of the male population. It is not a friendly island for men. They either suffer in war as the victims of Venus or suffer in peacetime as the slaves of Venus."

Leaving the photograph, Fleur fixed her gaze upon the young man, whose deep brown eyes melted as they took in the fullness of her face and body.

"Thank you for showing me the pictures. I must be on my way now."

She took a moment to pay her respects to each portrait of ugliness. At the end of this courtly exercise, she approached an enormous pair of iron gates carved with grotesque masks. At once,

the ancient guard appeared.

"Father Time joins us," said the young man. "Maybe he knows if you'll get to Melos."

"Maybe," said Fleur. "I will get there if my Adonis ever calls. Or, maybe not."

The ancient guard bowed his head. Fleur returned the gesture.

"Time will tell," she said, waving goodbye.

The guard opened the gates with all due ceremony and Fleur disappeared into the labyrinth of the Louvre's galleries.

"I'll be working late," said the young man.

"Yes, sir," said the ancient guard. "I will check in on you this evening."

The young man returned to his frames and measuring tape. Hours passed as he worked silently and alone in the empty cavernous hall while, in the rest of the museum, hordes of tourists crowded the galleries seeking out the objects of their desires. The art treasures of the Louvre rose above all the commotion, patiently witnessing the interested, disinterested, informed and ignorant swirling about. Day eventually surrendered to dusk and the portraits and statues welcomed silence and darkness with equal measure.

Watching the last visitors leave the museum, the ancient guard waited patiently at the exit as if he had all the time in the world. This once royal entrance wore the scars of revolutionaries and invading armies, but now simply bore a sign listing the times of the gallery openings and directions to the cafes, gift shops and restrooms. The guard's task for the night included playing host to invaders of a different sort as Andrea, the three Graces and scores of workmen and assistants arrived at eleven o'clock to prepare for the midnight shoot. As the crew set up, an agitated Cheri stormed up to the door.

"Where is she? Have you seen her?"

"Who, Mademoiselle?" asked the ancient guard.

"Fleur Belmont. Has she checked in with you for the evening shoot?"

"No, Mademoiselle. But the photographer has been here all day sitting in front of the statue."

Cheri ran at breakneck speed down the long corridors until encountering Francesco before the Venus de Milo.

"Is she here? She wasn't at the reception. What a disaster. The editors are fuming and the EROS Cosmetics people are beyond furious."

Francesco did not appear overly concerned as he attended to his tasks.

"I don't know where she is. Leave me alone now while I set the lighting. The silver and white tones are going to be magical, mystical, mythical. Ohhhhh yes."

"That lump of stone isn't going anywhere," barked Cheri. "It's our model you should be worrying about!"

No answer followed as Francesco remained transfixed by Venus. In a frenzy, Cheri aimlessly ran off through the galleries. Turning the corner, she stumbled into the young installer of the *Ugliness* exhibition with a force that knocked him to the ground. As he laid on the floor in shock, Cheri threw herself down beside him.

"Have you seen her?"

"Who?" asked the young man.

"Fleur Belmont, for Christ' sake! Only the most famous model in the world. Only the most beautiful woman you'll ever see. I'm her assistant, so help me find her!"

"Beg pardon. I did meet her this morning when she wandered in here searching for you. But she left and I've not seen her since."

Without thanking him, Cheri ran back to the Antiquities Department where she saw Francesco crumpled on the floor, his

eyes glazed over.

"What's the matter, Francesco? What's wrong? Is it Fleur? What's happened? Oh, God. Don't say it's bad."

Francesco caressed his camera in a daze, his skin jaundiced, his eyes reddened.

"While taking shots of Venus, I saw Fleur's face superimposed on the statue. Then I thought I heard her say she found the truth, that she was following the truth. It seemed so real. When I looked back through the lens, she was gone."

Francesco returned to observing the statue through his camera, muttering, "I must find it again. I must find the true face of beauty."

He began to shoot the statue over and over, sweat beading down the side of his face, his lips quivering.

"Francesco, forget about that hunk of stone! Your greatest model is missing and every minute is costing millions of dollars."

Cheri scanned her cell phone in a futile attempt to get help.

"Your little machines won't help you now," said Andrea, who appeared out of a shadowy corner.

"Maybe Fleur has run off to sail the Greek islands with Adonis. She has been waiting for his message since she first arrived. But I doubt it."

Cheri furiously dialed Adonis's number. By some gift of fate, he answered his cell phone.

"Is Fleur with you?" she asked. "No? Has she called you? Why haven't you called her? Ugh. You're useless!"

Her face becoming pale, Cheri held her phone to her heart.

"This is insane. It's destroying her career and mine along with it! Andrea, can't you do something?"

"Destroying her career?" said Andrea. "Nonsense. What career?

Such a ridiculous word. Fleur has no career. She never needed one. She is beauty personified. Always was and always will be. I have been doing her face for years and she is unlike any girl I have ever seen. She always says to me, 'Andrea, you are the only one who understands me.' I know my girl. She is going to be fine. You are the ones in trouble. You cannot live without the goddess."

With a howl, Cheri smashed her phone on the floor.

"Lose the attitude, Andrea. Fleur belongs to the Venus campaign and to EROS Cosmetics. Her photo with this armless old statue was going to appear worldwide in every store from Milan to Manila. And all you can do is spout your typical 'she is a goddess' crap."

Falling to the floor, Cheri moaned, "It's over. No, correction. We are all so over."

In a hypnotic state, Francesco uttered, "EROS Cosmetics must make do with the statue if the model has disappeared. At least we have the real thing in front of us."

"That statue is not the real thing," said Andrea. "It is only a faint likeness. The real thing was among us. But maybe the gods have called her home. Maybe time has other plans for her. And my work here is done."

As Andrea wandered away, Cheri remained weeping on the floor while Francesco stared at the statue.

Passing by the ancient guard, Andrea asked, "do you have the time?"

"No, Madame, I do not."

"How do you tell the time, then?"

"Time can't be measured, Madame."

Andrea laughed gently as she watched him amble away.

"There he goes. Father Time, the guardian of this tomb of ancient beauties, who never knows what time it is. Or does he?"

Shrugging her shoulders, Andrea made one last smirk as she looked about the gallery, then left with her box of creams and potions. As the ancient guard made his rounds, he stuck his head into the hall where the curly haired young man still worked tirelessly to meet the deadline for the exhibition.

"Is everything all right, sir?"

"Yes, very well, thank you," said the young man with a dimpled smile. "Venus is home. She is ours again."

HOLY WISDOM

"MYSTICAL. HAVE YOU EVER BEHELD ANYTHING LIKE IT?"

"Mystical? Hardly that, my dear. You are too easily bewitched. Corrupt and decadent, I say. Justinian and Theodora had very earthly ambitions in creating this pile."

"My dearest, no! The golden dome hovers above, sacred and sublime, inspiring higher ideals in we mortals gathering below, so often prisoners of our profane and pedestrian desires."

Rosemary laughed to herself as she overheard the banter of the well-heeled couple, armed with their definitive guide books on Byzantine art. She left them to their debate about the virtues and vices of Hagia Sophia while she, dwelling on her own profanities, circumnavigated the mighty church. Men and money, manipulation and malevolence, these were the passions and debaucheries playing in her mind.

Occupation with her sins, however, did not last long. Every wall sheathed in marble and porphyry captivated with glisten and sheen. Much like her, no surface remained unadorned. Much like her, no surface gave fully of itself, either, as soft light filtered by rows of windows from high above infused the entire space with a filigree of pattern and shadow adept at both revealing and concealing material

splendor. Atop this display of earthly richness rose a cavalcade of half-domes and vaults culminating in the crown of the basilica, the great dome itself, a triumph of architectural virtuosity reigning over a space inviting both eye and spirit to a heavenly ascent.

Rosemary's finely crafted high-heels tapped on the stone floor as she moved at a measured pace inspecting the visual feast found in every direction. Jacket by Chanel, blouse by Valentino, skirt by Herrera, shoes by Jimmy Choo, purse by Gucci, her outfit and the structure about her possessed much in common. Masterful design, fine craftsmanship and luxurious materials cloaked both church and lady. She felt a camaraderie with the building as she pressed her hand against a marble wall, feeling its coolness, appreciating its finely grained texture and polished veneer. A beam of light then lured her attention away from stone to a misty world above. The golden ray led Rosemary to the center of the building, which enveloped her in the bosom of pure form. The great circular dome floated overhead, the triangular vaults of the supporting arches soared about her and the massive square pillars anchoring this structural wonder all hailed the supreme power of a divine geometry.

"Pardon me, Madame. I didn't mean to invade your space."

Drawing her eyes away from shapes and surfaces, Rosemary beheld a young man standing directly in front of her.

"Oh, not to worry," she quipped. "I didn't even notice you. I was so engrossed in my sightseeing."

"I confess, I was doing the same thing," he said. "The light lured me here and I didn't see anything else until I almost walked directly into you. Please forgive me."

"No confessions or forgiveness required," said Rosemary.

Handsome in its severity, the man's face struck Rosemary with the watery sadness of his brown eyes, as if a soul cried out to escape. They seemed to possess a kind of ageless wisdom for so young a person. She did not enjoy the sight for long since those

same eyes filled with hesitation as he shyly glanced back and forth. Accustomed to being looked at by men, she had not experienced this particular kind of countenance, so detached yet so searching.

"It's a mystical space, is it not?" he said abruptly.

Rosemary laughed, noting his quizzical expression.

"I'm so sorry," she said, "I heard a man state that very same thing a while ago. His wife found the church quite the opposite of mystical."

"I suppose that depends on one's point of view, Madame."

"Our perspective does color everything," she said as the young man, with downcast eyes, began to outline one of the paving stones on the floor with the tip of his foot.

"My apologies again for disturbing you. Enjoy the rest of your visit," he mumbled as he walked away.

Rosemary could not take her eyes off of the softly crumpled white cotton shirt clinging to his lean frame as the young man headed towards one of the darkened side galleries. His pair of worn tan pants clothed a body moving in humble measure, taking up as little space as possible.

"What is your point of view, if I may ask?" Rosemary called out, her words echoing through the space.

Making a hard stop, turning around, the young man's posture immediately became upright as he very firmly arched his shoulders backward and put his chest forward while returning to Rosemary.

"I see the church as a manifestation of the sacred and the profane united. It is the story of humankind. The journey each one of us makes."

"Well said," remarked Rosemary with surprise in her eyes. "It is clear from your words and demeanor that you don't hesitate with such opinions. My guess is that you are a theology student?"

"You might say that. I was a monk."

"So, you sought the sacred."

"Well, I suppose so," he said. "I tried to. It is all one can do. I pursued it. But I never attained it."

"That's alright," said Rosemary. "I pursued the profane. Unlike you, I obtained my goal."

"Did you? What was that goal?"

Reaching into her purse, Rosemary took out lip gloss, carefully applying it while inspecting the profile of her mouth in a little mirror, noting how the young man's eyes followed the contours of her lips.

"To enjoy the things of this earth. And I did so until my keeper died last year."

"What did he keep?"

"Are you that innocent?"

"None of us are truly innocent, Madame."

"Good point," said Rosemary. "But, to get to the point, he kept me as his mistress. The international banker owned me. Some say he was a crook. Who was I to judge? I made a fortune out of seduction and extortion. Married men always wanted to keep me quiet. The banker kept me hidden away in high style in Geneva. He kept his wife openly in a more respectable style in Zurich."

"Were you happy?"

"I don't think I've ever been happy," said Rosemary as she raised her head up towards the dome. "You ask very simple and direct questions which are rather hard to answer. Did they teach you that in the monastery?"

The young man fixed upon the row of windows at the base of the dome.

"We were taught to direct our life to God's simple message of faith."

He then looked directly at Rosemary.

"We aspired to simplicity but it never answered the questions that haunted me. I found that life is both simple and complex, like this church."

"Have you found the simplest way to be the best way in a complex world?"

The young man bowed his head.

"Yes and no. I'm not sure. I left the monastery last year, as a failure."

The inward folding of his chest and his downward glance all bespoke of disappointment. Placing her hand on his arm, Rosemary said, "there is no place for shame here. Life is too short. Trust me."

Raising his head up, a gleam appeared in his eyes and the visible sense of a heavy weight disappeared from his shoulders.

"These days, I am a wanderer, a sightseer of life from afar," said Rosemary. "I am unashamedly drawn to the profane in this church. The marbles, the gold, the shimmer of it all."

"Hagia Sophia certainly has its share of the profane," said the young man. "Though I don't make any distinction between its worldly and sacred beauty. Both are joined here."

"Both with the seeds of the other's destruction," said Rosemary. "Salvation suggests itself in all the sunbeams above but temptation lurks in the dim corners around us."

"And so do love and forgiveness, which redeem us," said the young man.

"Hopeful thought indeed. And what is the name of someone so wise?"

"I am Demetros."

"And what brings you here?"

"I am an art history student these days at the University of Athens. My project this year is on Byzantine architecture and this church in particular."

"I am Rosemary."

"Remembrance," said the young man. "Rosemary is the symbol of memory."

"But I came here to forget," she said.

Twilight enveloped both of them. Shadow lines fell on gray granite pillars and green marble veneers. The dome wafted ever more lightly on the haze of a sunset flowing through the windows. Colors tempered and architectural features softened as dusk came upon the church.

"I feel this moment between the end of day and the beginning of evening is the time to pivot," said Demetros. "To recall the tasks we love, resent or regret from sunrise to sunset. Then to forget those dutiful daytime hours when the darkness calls the head and the heart to delve into other places."

Demetros circled around, scanning the entire building, as Rosemary watched his reactions, which she interpreted as hovering between mild disapproval and wholesale condemnation. When he fixed on fine plaques of porphyry, he tightened his jaw. Setting his sights onto golden mosaics high on the vaults, he furrowed his brow. When he spoke, his tone seemed to veer from ecstatic to depressive.

"Some justified these splendors as serving the glory of god. Justinian and Theodora certainly did, and glorified themselves by association. Others had a different view. The iconoclasts of the 8th century destroyed all graven images, seeing any material opulence as a detriment to true spirituality. I agree with them but I disapprove of their violent approach. The maker of an icon of the Virgin and Child could certainly have experienced genuine

spiritual inspiration in the act of creation. So, it's always a tug of war between the sacred and profane. And I've talked myself into total confusion on the subject."

"Maybe you should think less and just follow your instincts," said Rosemary. "Feel what you feel without apology."

"I don't know," he said. "I can only follow the light."

"Then take your cue from it and lighten up."

Demetros froze in place while a fire flared up with a fury in his eyes.

"How dare you abuse light," he said with the longest breath in the lowest voice. "You haven't even begun to comprehend its depth. But you do not go deep, do you? No deeper than that blouse you wear. Is there anything underneath it? I doubt it. You drift on the surface with things of the surface. And you greet my confession with contempt. I suppose that is easier than truthfully feeling something."

Demetros charged towards the high altar. Before leaving, he yelled across the vast expanse of the church, "you remain with the profane. I'll stay with the sacred."

"Why take any well-meant advice from a harlot," Rosemary yelled back, her last word resonating through every nook and cranny of the building as she stormed off in a rage equal to that of the young man.

"Your word, not mine," he bellowed.

Rosemary took refuge near the time-worn fragment of a baptismal font. Demetros leaned against the sculpted image of an Old Testament prophet on the front of the altarpiece.

"Lecturing me on this and that in your holier than thou tone," said Rosemary.

"God forbid you should let go of any of your cynical barbs," retorted Demetros.

The two souls sat in their respective places, brooding and sulking. Neither left the church. They merely held their ground in silence until a group of pilgrims' emerged from the galleries. Kneeling on hard stone, this faithful flock filled the church with words of prayer, each verse repeated in happy harmony. Said over and over again, these recitations washed against the walls and reverberated in every direction. The clank of coin in a collection box announced the end of the pilgrims visit. Finished with their devotions, they departed in laughter and banter.

"Forgive me," came the same words from two distinct locations.

"We speak in unison," said Rosemary.

"And in the same spirit," said Demetros.

They both abandoned their chosen citadels of defiance and returned to the nave of the church.

"You spoke the truth, which opened a wound from long ago," said Demetros. "I am too serious because I cannot forgive myself for failing in my vocation."

"You spoke the truth, too," said Rosemary. "I hide behind surface things. Anything deeper is too ugly to bear."

"Maybe we can agree to both be sinners," said Demetros.

"And to be forgiven," added Rosemary.

"I will lighten up," said Demetros with a faint smile.

"I will open up," countered Rosemary.

As he looked upwards, Demetros said, "the answer was here all the time. This church is beautiful in body and spirit, both on the surface and in its substance."

"And plenty of sinners have passed under its dome, so here's to two more." said Rosemary. "It's survived for thousands of years, so something here must be good, must be worthy of redemption."

"Now that is an indisputable truth," said Demetros. "This has

been a holy place for ages. First, a Christian church for a thousand years, then a mosque for five hundred years until it became a national museum in the twentieth century. The faithful and the flawed have all sought it out, for good and bad reasons. It may no longer officially be an active place of worship, but the spiritual still dwells here."

With a lightness in his step, Demetros paced in a circle, mimicking the outline of the dome above. Rosemary followed. He weaved in and around the multi-colored paving stones. Rosemary did the same, observing him more closely than the building, noting how he changed in mood as he moved. From dour monk to delighted student of art, she found him as complex as the church itself. She knew his eyes possessed equal amounts of pleasure and pain as he pointed out details.

"The four great pillars, one in each corner, are the people," said Demetros with outstretched arms. "The semi-domes above are the priests supporting the Emperor Justinian, who is the dome itself, and the light, flowing in over all, is God. This is the meeting of heaven and earth. It is the marriage of architecture and ornament. Holy space infused with heavenly rays."

"Do you think Justinian played at being God?" asked Rosemary. "Emperors have that tendency."

"Can we ever be sure what lives in the hearts of men and women?" said Demetros. "Yet, I am sure of one thing. When Justinian commanded this church be built in 547, never had a dome of such magnitude been attempted. It took the genius of two mathematicians to make a dream into a reality. Isidore of Miletus and Anthemius of Trailes devised the calculations to bring squares, circles and rectangles to life in the hands of artisans and builders. From the farthest reaches of the Empire came the finest marbles and semi-precious stones. White onyx and yellow alabaster here, deep maroon-colored porphyry there. Great architecture dressed in the most precious materials."

They stopped in front of a mighty row of columns topped with capitals that seemed to pulsate with life as interwoven vines of the utmost delicacy and complexity invited their eyes to wander in a sinuous trail of greenery carved in stone.

"Seductive," said Rosemary.

"Decorative detail has its merits but also its dangers," remarked Demetros. "It should serve to celebrate and elevate, bringing you upwards along the columns to the dome, where the vision of God awaits. But, too often, one can be diverted by ornament and go no further, wallowing in its beauty, preoccupied with its pleasures."

Rosemary's chest beat faster and her eyes burned. Years of guilt weighed heavily as she felt her own shallowness exposed by the young man's words. Worldly things had always possessed her. Matters of the spirit seemed a foreign and most unwelcoming land. Unable to move, she sunk into the hard stone under her high heels and her vision became blurred. She blinked to regain her sight and found Demetros had already directed his attentions to a monumental entrance.

"This is Justinian's door, the portal for God's representative on earth. As he came into the church with great ceremony, his wife, Theodora, watched from above while seated on a jewel-encrusted throne in the Empress's gallery. She reigned over a divine realm, but the great lady actually began life as an actress, living among circus performers and dancers. Some say she was a prostitute. Whatever she was, she captured the Emperor's heart and mind. And she eventually achieved sainthood."

"I have a confession for you, Demetros."

"We are in a church, Rosemary. It's a good place for it."

"I rose like Theodora. I was not always a mistress. I started out as a hooker on the streets of Chicago when I was sixteen. Then I graduated to an escort in New York when this lady took me as her disciple, or sorts, and taught me to walk, speak and dress so I could

move in a richer crowd of men. I wanted to be an ornament. Clothes from Paris, shoes from Italy, watches from Switzerland. I became a connoisseur of luxury. The finest leather work, the stitching in a jacket, no detail escapes me. I sat on my own version of a jewel-encrusted throne with a yacht in Forte di Marmi and a villa in Eze."

"You are not your actions," said Demetros. "You are a person who has lived a life. You have no reason to be ashamed."

"If you say so," said Rosemary with the coy look of a woman of the world yet with a nervous flutter in her stomach.

"Theodora was brilliant and formidable," said Demetros. "She stared down rioting mobs and advised Justinian in his darkest hours, securing his crown in good and bad times. The prostitute began with the profane and the Empress ascended to the sacred. But listen to me, sounding like I am making a sermon."

"Well, we are in a church," said Rosemary.

For the first time, a truly broad smile without reservation crossed Demetros' face.

"Ornament is not all bad," he said. "Have you noticed that it only appears on the interior of this holy place? The outside of the church is severe, just stark walls with no decoration. No earthly delights tempt the viewer. Only once within does opulence present itself, but it is all directed towards heaven, not towards us."

They paced in and around the niches created by the semi-domes, winding in and around posts and pillars, exploring hidden-away vestibules. Along the way, a golden mosaic, a painted archangel or one of the four evangelists commanded a ceiling.

"We can never be too sure of ourselves," said Demetros. "Justinian created the mightiest building in Christendom. It combined the engineering skill of ancient Rome with the imagery of a new religion. But God's dome partly collapsed twice in earthquakes and Medieval warriors looted the church during the Crusades. Yet, it

survived. Rebuilt, repaired, it marched on for centuries. Since brick and stone failed and humans desecrated the building, I believe only faith, in the end, made Hagia Sophia endure."

Among aged walls, Rosemary and Demetros continued to find remnants of once venerated objects, a worn piece of marble here, a faded image of a saint there, mere fragments of ancient beliefs.

"I wanted to be like this church," said Demetros as he placed his hand on a reliquary that once contained the bones of a long-forgotten saint. "I believed I was strong and filled with divine light. What spiritual arrogance. Who was I to think I could be all-knowing, all-embracing? So, I left the monastery, empty and alone. I found Byzantine art and decided to channel my feeling of loss into learning. It has not cured me, but it diverts me."

"You seek holy wisdom," said Rosemary. "You immerse yourself in arches and ornament, get yourself tied into knots decoding its messages, obsessed by its entangled geometries."

"Yes," said Demetros. "You see that."

"I don't see it, Demetros, but I sense it. You seek answers. You study this landmark, searching for God in old stones. You analyze historical and cultural meaning in its details and hope to capture the divine light that floods in from the dome. Maybe you should let go of seeking and studying and let yourself be seduced by it. Surrender to the moment and accept the unknown. See where it leads you."

"See the church from your perspective," he said.

"As I have begun to appreciate it from yours," she said.

They paced in silence, Rosemary wondering if she had made Demetros feel worse. She did not inquire, hoping that all would be revealed in time. They said nothing while the hushed voices of visitors echoed among the arcades and up through the vaults.

"We are back where we started," said Rosemary. "The sacred

and profane meet in the epicenter."

They found themselves standing directly under the golden glow of the dome.

"Guided by the light," said Demetros.

"We certainly took different routes to get here," said Rosemary.

"But we arrived at the same spot at the same time," countered Demetros.

"Obsessed by architectural geometries and seduced by ornament," said Rosemary as she cupped his chin in her hands. "Two souls in search of something. I took the profane path, you took the sacred way."

"True indeed, Rosemary," said Demetros as he placed his hands on hers. "All points lead to holy wisdom, in the end."

"And to each other," said Rosemary.

THE PORTRAIT'S EYES

HIS BROODING BROWN EYES PENETRATED Ivy. Her eyes met his directly as if both knew each other. One initial glance and he possessed her. She drank in the pupils and savored the soft lashes that shaded the most soulful expression she had ever beheld.

"Before us is the greatest of all German Renaissance painters, Albrecht Durer, who created this self-portrait, in oil on wood, in 1500 as we can clearly see by the date in the upper left-hand corner of the work. It came here to Munich when the royal family of Bavaria purchased it in 1805 from the town fathers of Nuremburg."

The clinical sound of the tour guide's voice startled Ivy, distracting her from flirtation with the intense young artist, who ever so surely seduced her from his honored place on the museum wall.

"Durer perfected the art of portraiture and capitalized on the power of his own image. Note the letters A and D in the upper right of the painting. The artist invented this personal logo based on the use of his initials. It appeared on all of his work, from paintings to the prints which spread his fame far and wide. He embraced the new invention of printing and benefited from its revolutionary effect on the arts. While only the privileged few could afford a painting, a

larger audience happily spent on prints sold for modest sums. In our own day, we would describe Durer as a master of marketing and image-making."

Informative and fact based, but completely uninspired, the tour guide's lifeless monologue continued unabated, only relieved when he and his flock of visitors lumbered on to the next unquestioned masterpiece in the cold halls of the Altes Pinakotheka, the severely classical shrine to Munich's art treasures.

Remaining focused on Durer, Ivy did not see a self-aggrandizing impresario, but a pair of eyes intensely fixed on her as if the artist were trying to warn her about something. Both reassuring and at the same time unnerving, the eyes made her heart sink one minute then beat faster the next. Of one thing she was sure. She couldn't take her eyes off of the face of the genius.

"Move it, Ivy! We have to photograph this dude for the meeting tomorrow. And shouldn't you be helping me rather than hindering my work?"

Violently jolted out of her communion with Durer, she found herself in the harsh world of Rudy. Armed with a digital camera, he pushed her aside to begin his study of the *Self Portrait* from various angles.

"On the job for only one month and you're already slacking. Take notes while I talk."

Dutifully, if resentfully, Ivy took out her iPad and began to record every word.

"So, this is going to be the new face of New Semblance," quipped Rudy, appearing to adjust the focus of his lens but, in fact, simply posing and posturing. Here was no photographer. Here was a director of marketing, a slogan master, a huckster and a trickster. He had an instinct for only one thing: selling.

"He looks like every hipster. The kind who will only spend cash if it alleviates his conscience while indulging every other desire. Of

course, we won't say that in the ads. I have to think of one phrase that sums it up."

Without emotion, without any indication of censure or praise, Ivy wrote down every utterance.

"Buy New Semblance Software. Be New Semblance. Be the New Durer."

As slogans poured forth, Ivy ignored the meaning of Rudy's words as best she could until he began to fist pump the air.

"I've got it. I've got it. Yes, oh yes, I am so, so, so the man. We so, so know that I am the man."

Rudy reveled in his personal cheer until interrupted by a beeping noise. Mortified at being the source of such an offensive noise in a museum, Ivy fumbled for her cell phone.

"Hello," she whispered.

"Hey doll, it's me."

Running a lock of her hair over the phone in a sheepish attempt to muffle her voice, she responded out of obligation rather than pleasure.

"Oh, hey Jude. I can't talk. Rudy is doing his thing."

"Rude Rudy? Oh, dollface. You need a drink. Meet me at the Baader Bar around eight."

Shoulders slumping, eyes rolling, she said, "um, well, uh, okay, I guess. Bye."

Rudy paced back and forth reciting, "image, power, eternity. Seize them all. New Semblance."

Each time he repeated the slogan, his eyes honed in more deeply on the portrait.

"Yes, That's it! Albrecht Durer with the words scrolling across his chiseled face."

As Rudy stared down Durer, Ivy saw the artist unflinchingly stare back from the canvas. She then reminded herself that the portrait wasn't human so, of course, it wouldn't flinch. Yet, for her, there was something decidedly alive about the painting.

"Every dude will want to be him," exclaimed Rudy with an oily, gloating glimmer in his eyes that made Ivy cringe. "And girls from Berlin to Brooklyn will wanna do him. His face on every package of New Semblance will seduced them into buying it. I'm giving them their dream date."

Relentlessly peering at the artist, Rudy continued to assess the man before him.

"Dude certainly loves the camera and, I have to agree, it loves him. He's practically climbing inside the lens. Those eyes just don't stop."

Rudy moved closer and closer to the painting until his nose almost touched the artist's. The stare down with Durer ended when a museum guard intervened. Rudy backed off physically but not in his plan.

"Oh yeah, he'll appeal to every ego and libido. He is the artsy package that will totally sell the software program. I've got this. I own this. He's gonna serve me well."

Backing away, Rudy put his hands together to create a frame through which he viewed the portrait from a distance. Ivy had seen this routine before and the pose Rudy took when he acted as a human camera scanning a subject from the right, then from the left, considering every view of the person, place or object about to be violated for commercial ends. She knew he only valued Durer as a commodity like a model up for a multimillion dollar fragrance or underwear contract.

As Rudy continued to leer at his prey, Ivy's thoughts wandered to six months earlier, to her last semester of college, when she believed art only existed for the soul, to be a thing of meaning for its own

sake. She reminded herself that such meanderings of the mind were best left back in the hills of western Massachusetts, where the ivory tower of enlightenment now seemed a faded memory.

"He's about to make us a fortune," said Rudy.

Ivy snapped to attention at the grating sound of his voice.

"Chicks will screen print his face on every t-shirt while they pout about how their boyfriend will never be like him. Thank you, God, Buddah or Whoever for making me so brilliant."

Closing her iPad, Ivy banished bombast and boasting to the oblivion of the unrecorded word. It comprised her only form of silent protest.

"The deed is done," proclaimed Rudy. "Now we can blow this dump. Good bye dark, dank, cold Munich. Hello sunny L.A."

He threw himself three kisses, then marched out of the gallery. Ivy followed in his wake, passing by the assorted canvases of Tintoretto, Titian and Rubens, each masterpiece evoking her sense of longing for all things once dreamed of. The Old Masters had been her bridge to an imagined world both creative and fulfilling. Now, such musings had to wait since she had to keep pace with Rudy, the ugly truth of her present reality.

Upon reaching the museum's entrance, Ivy found Rudy already stamping his foot on the pavement and pointing to a taxi sign. She hailed a car, which drenched her from head to toe with icy slush as it pulled to the curb.

"You sad little thing," said Rudy as he jumped in first. "A lamb to the slaughter. Or, should I say a sacrificial lamb, if you don't pull yourself together. We have a date with destiny. So, get in and let's get going."

"Could we stop somewhere so I can dry off?"

"What?" barked Rudy, "you and your wet hair don't matter. Just deal with it."

Ivy wiped her face and slicked her hair back into a neat ponytail, the most she could do to pull her soggy self together.

"I will turn up the heat for you," said the taxi driver."

"Bless you," said Ivy. "The kindness of strangers means a lot."

Rudy appeared not to hear a word of the exchange as he sat back and repeated slogans to himself while the taxi rumbled through the combination of ice and rain coating the grey streets.

Arriving at the Hotel Olympic, Rudy darted into a lobby of the most clinical white minimalist décor. He headed towards the black doors of a private elevator for the penthouse suite where Stephen Maximilian Telenbacher, who preferred to be called "Max," held court. Ivy barely made it through the doors before they shut and the ascent began. Rudy's right eye twitched and he tapped his fingers on his thigh ever more quickly as a blinking red light signaled their advance towards the summit of the hotel.

"You know, he didn't create New Semblance. His friend did. Max only founded the company."

Ivy said nothing, accustomed to Rudy's habit of talking incessantly before a meeting with Max.

"He grows up in the posh suburbs of Connecticut, flees his bourgeois life for one of those weed smoking artsy colleges and then founds New Semblance on his trust fund money."

Feeling his anxiety consuming all of the air in the elevator, Ivy directed her energies to watching the lights go from floor six to seven and eight, looking forward to the tenth and freedom, at least from being in a confined space with Rudy.

"Max moves to Oregon and hits it big with New Semblance computer software. It wasn't brilliance, just luck. Without his parent's cash, he'd be working in a juice bar in Portland."

Ivy reeled inside while the blood vessels in Rudy's neck bulged as he poured forth every bitter word imaginable. She watched him

pull deeper and deeper into himself, his lip biting the precursor to an exploding well of resentment.

"Oh, little Max is the boy who would be king. Thinks he's all that. Walks down the street like he's the second coming of Christ. Believes every word he says is a gift from heaven. Every indie hopeful designing their coffee bar menu or festival poster now worships New Semblance as a divinely ordained product. Give me a freaking break."

The elevator finally stopped. Rudy shot out like lightening, tore down the hallway and stopped before the penthouse door. He ran his fingers through his hair, cleaned the spaces between his teeth with his smallest fingernail and checked his jacket for any sign of lint. Although he had never once engaged Ivy directly the entire day, he now fixed his eyes upon her.

"We have to come to Munich in March, when I could have been in Hawaii, because Max wants to rebrand himself. What a waste of time."

Repulsed by actually having to make contact with him, Ivy blinked her eyes twice and held her head slightly back as if avoiding a stench. Rudy looked sullenly at the floor and then furtively at the ceiling as if trying to ground himself one minute and then seek redemption the next.

"Well? Do I have to do everything?" he exclaimed as he eyed the doorbell.

Ivy pressed the buzzer. A young man wearing skinny jeans and a t-shirt emblazoned with the word "ZEN" opened the door.

"Good afternoon. I am Max's assistant."

Rudy pushed the young man aside without any apology.

"The wunderkind returns to his ancestral homeland! Nice to see you, Max. Great to be here. What a treat to see Munich at Easter."

Seated on the sofa in the middle of the room, a darkened

silhouette against the wall of windows, Max offered no words of welcome.

"Do I have news for you," exclaimed Rudy. "I have it. The essence of New Semblance's rebranded identity. It took hours at the museum, but I have it. Call me the deliverer. Call me the bearer of good news."

"You are soaked," said Max to Ivy as he gestured to the assistant, who removed her coat and offered her a woolen shawl.

Remaining seated, Max pointed to the table in front of him.

"Beer. It's a favorite of mine from the Kreuzburg Monastery. Local, of course. The pretzels are made in a village just a few miles from here by a ninety-year old lady who only uses Austrian salt and a four-hundred-year-old cutting board made of oak from the Black Forest. The cookies are Lebkuchen. Made throughout Germany but these are from Nuremburg. I prefer them since it was Durer's home town. I feel they have more soul."

The assistant brought in an iron teapot steaming with the scent of Sencha.

"Exquisite workmanship," said Max. "It is of 17th century Japanese design, the property of a samurai who killed himself for falling short of his honor code. He drank a single cup of tea from this pot as his last act before taking his life. I acquired it in Kyoto when I went to see the cherry trees bloom last spring. A warrior's sacrifice ends his time on earth. A tree blooms again. Life renewed. We are all part of a cycle of birth, death and renewal and must accept our place in it."

Max made a barely discernible nod, which prompted the skinny young man to disappear now that the food and drink were precisely placed.

"Something for either taste. Please, help yourselves."

Rudy went for the Kreuzburg. Ivy opted for tea.

"Let us begin," said Max as he folded his hands together and rested them on his lap.

Rudy presented his tablet with four photographs featuring fragments of Durer's *Self Portrait.*

"Image. Eternity. Embrace them. New Semblance."

Rudy sat back while Ivy watched Max, whose stillness struck her as inhuman. Not even the flutter of a lash enlivened his eyes.

"New Semblance is about image-making," continued Rudy, once he had let quiet endure for exactly fifteen seconds. "The best images are powerful and universal. Durer will be our symbol, the ultimate image-maker. The concept is a home run."

Rudy spoke in a rapturous tone, which Ivy recognized as his firm belief that he had just unlocked the secrets of the universe in a slogan.

"It is clean, sharp and direct. The artist is sexy in that dour depressive sort of way. It's what every hipster aspires to. No one can resist it. The temptation is too much. They will run to buy our newly launched graphic arts software so they can be the new Durer, the all- seeing, all-knowing genius."

"Lost on you, isn't it?" said Max as he glanced at Ivy, who averted her eyes to the ceiling.

"Well, um, sort of."

"I feel the same," said Max. "I have been musing on the notion of depth, particularly the depth of one's feelings. The need for meaning in a shallow commercial world. Durer is depth. I want. No, correction, I need that depth of feeling. So do our people. They live for it and they beseech me to deliver it to them."

Walking over to a cabinet, Max took out a small toy sailboat made of multi-colored blocks, which he rearranged to change the colors of the sails and the hull.

"I bought this at the outdoor market yesterday. German craftsmen have made these for centuries. It says much about them. Clarity of line and pure forms with eternal meaning. All the things I want New Semblance to be known for."

He placed the toy on the table and rocked it back and forth.

Ivy, you have degrees in graphic design and art history, correct?

"Yes, I had a double major."

"Then I decree it. You will go deep into the Durer portrait. Find its meaning. Seek out its soul and bring it to me. He represents everything we need today. But go deep. No surface trivia. There is something there in Durer. I believe only you can find it."

Ivy never ceased to be thrown by the messianic tone of Max's phrases. Every time he spoke, she felt as if he truly believed heaven blessed each word. His sullen gaze and black garb reminded her of the brooding saints of Byzantine icons. She sensed he would have liked that comparison but would never tell him. She had learned that only he spoke freely. Her job was to merely answer.

Max observed her for quite some time, making Ivy wonder if he could read her every thought. He then rose from his seat and stood by the window, gazing out over the Munich skyline, watching the street lights come on as dusk blanketed the city.

"Germany is a new frontier. It's an ancient country now mostly forgotten. No one thinks of it anymore. It's not current. It's not in the collective consciousness of cool like Tibet or Guatemala, yet there is something here and it is my calling to reveal such things to my people."

Folding his hands and raising them as if in solemn prayer, he remained quiet for a minute until he turned his attention to Ivy once again.

"My family came from here, living and working under the spires of Munich. Simple, hard-working craftsmen and artisans. I return to find them, to seek my identity, to claim my roots. They are the

source of something great. Durer is that greatness distilled. He has been waiting for us to release him. Once freed, he will lead the way."

Max returned to ponder his view in Zen-like mode. Ivy didn't believe he actually meditated, but knew he liked to pose as a deep thinker. She stood at attention when he affected his soulful stance. Everyone knew the rules. You just watched and waited for Max.

"What about my slogan," asked Rudy.

Without turning to face him, Max said, "California calls you."

Rudy's jaw dropped. He uttered not a word, the rarest of things for him. When Max stated that someone should return home from a creative venture, like this trip to Munich, it spelled the end. It meant exile, for Max never technically fired anyone. He merely relegated them to oblivion. On each "immersion experience," as Max called these business junkets, someone always received the axe.

Clasping his hands, Max sat down in a chair facing the window and turned his back to the room, the standard sign for the end of a meeting. Aware of the protocol, Rudy and Ivy said nothing as they left the penthouse. In seconds, they were in the elevator watching the lights signaling their descent.

"He is in his luxury suite in the clouds," said Rudy. "While I go down into a living hell."

Rudy began hitting the door with his knuckles, harder and harder each time.

"Damn. I had this totally covered but, oh no, no, no. We can't just do a marketing blitz that earns millions. The wunderkind wants a message with soul. We have to meditate on the meaning of life before convincing our customers to spend money."

Nostrils flaring, teeth clenching, his eyes took in every inch of Ivy.

"Now it's your turn, Ms. Art History. Let's see if little Ivy from the Ivy League can be Max's pint-sized prophet, the bearer of good news. Let's see if the hipster waif with the long brown curls,

the doe-like eyes and fancy education can churn out a marketing juggernaut. Now you can use that degree from what school? Smith? Swarthmore? Sarah Lawrence? One of those schools with an S name for so-called super smart sisters seeking the sublime."

Rudy's eyes twinkled as he opened his mouth to hurl the next volley of alliterative insults, but the elevator doors opened onto the lobby and redirected his fury.

"Good luck finding Durer's soul. It'll never happen. There is no edge to Munich. It's just a fancy mall with a Dior on every corner. It's been nice working with ya. Oh, wait a minute. NOT!"

He marched out of the elevator then stopped himself and turned back.

"When you can't give Max a new campaign, you can always serve him in other ways. That will keep you on the payroll for a little longer. He's a hipster. You're a hipster. You can gaze into each other's existentialist eyes while he gropes your yoga tight bod. All those hours in the lotus position will finally pay off, won't they, little girl?"

Without saying goodbye, he stormed off and ordered the doorman to hail a taxi.

"Whatever," she sighed with relief as she gave a slight wave, more a sign of dismissal than a farewell.

In full possession of herself now that she no longer needed a forcefield to repel Rudy, Ivy decided to walk and take in the streets. She made her way through a city alive with the sound of church bells tolling for Good Friday masses. As thoughts of daytime business faded, she enjoyed the show of bunnies, eggs and candies in store windows and the bustle of shoppers now that Easter Sunday was only two days away.

Central Munich exuded an uncomplicated happiness and

contentment in the form of spectacular chocolate box displays and silk-lined boutiques catering to label loving patrons. Eventually, she hopped on a bus to a less grand but equally colorful part of the city, the Glockenbachviertel, to meet Jude. Excitement and wariness filled her mind, for he was more than an old friend.

Alighting at a large square known as the Gartnerplatz, Ivy instantly took to the sights, scents and sounds of this buzzing part of town. Every type of bike, both brand name and home made, lined the sidewalks and the delicious smell of roasted coffee beans filled the air. These things all made her feel at home, even though she had never been here before. She also found herself among her people, all the folks Rudy would have referred to as hipsters. Skater dudes maneuvered over church steps, girls sported their latest unstructured dresses and every sort of tattooed type hung out in the bars.

With an ever increasing bounce in her step, Ivy proceeded through this pulsing neighborhood to the Baader Bar while dwelling on the type of reception she might encounter. Finding the self-consciously decrepit building, tentatively entering its doors, she braced herself.

"Ivy. Looking fine as ever."

A pretty boy with a mop of wavy blonde hair gave a warm embrace.

"How is the t-shirt business these days, Jude?"

"Good, good. Can't complain."

She gave a big smile, her flawless white teeth lending a glow to the darkly lit room.

"How is Sabina?"

A shrug of the shoulders confirmed that Sabina was no longer an issue, an item or an interest.

"I've missed you, Ivy."

"Oh?"

"Now, Ivy, don't 'oh' me. I really mean it."

"Jude, you always miss me between girlfriends."

"But you are the only one I asked to marry me."

"That was a long time ago, Jude."

"It was only four years ago."

"Long enough, Jude," she quipped while batting her eyelashes.

Laughing, he said, "no getting around you. Then I guess we'll change the subject. Come on. Meet my friend. Super cool dude."

They walked over to the bar. Ivy instantly froze upon seeing Jude's friend. Before her stood the spitting image of Albrecht Durer as if he had just stepped out of the *Self Portrait*.

"Hans, meet Ivy."

Remaining motionless, Ivy stared into his eyes until Jude tapped her on the elbow.

"Um, dollface, say hello to Hans."

"Oh, I'm so sorry. Forgive me. Has anyone ever said that you bear a striking resemblance to Albrecht Durer?"

With a gentle smile, he said, "a few."

Jude then slapped him on the shoulder.

"He looks like the most famous artist in German history. Not a bad gig, although he never capitalizes on it. I try to get him to wear my Durer t-shirt but he won't give in."

With introductions made, all were ready to drink. As they approached the bar, Ivy took a seat between the two men while carefully maneuvering so she touched neither one of them. Her efforts, however, failed as she brushed against Hans, feeling the

muscle of his forearm against her wrist. He glanced at her. She demurred, eyes downcast, then a tentative grin appeared. Hans raised an eyebrow and tilted his head, making the well-defined angle of his jawline even more pronounced to Ivy, who followed its sturdy line up towards his ear and back over his razor-sharp cheekbone until she met his eye.

"So, I met Hans when I came here to do my graduate degree at the University," said Jude. "But I dropped out and so did he."

The bartender placed three draft beers on the bar. Hans accepted and raised his glass.

"Hail to dropping out. Jude speaks the truth. I had a two-year fellowship teaching art history at the University while I finished my research on Albrecht Durer, of all people."

"Isn't that convenient," said Jude.

Ivy couldn't take her eyes off of Hans. She examined his every feature, taking in the lush curly brown hair and, most of all, the piercing eyes, which seemed to beam rays of a divine sort of light into the darkness of the bar. Jude intruded on her sacred moment as he began to recite a complete resume of his friend's life.

"This is no ordinary art historian, though. This man is the bomb. Hans got his Ph.D. in Molecular Biology before coming here. He also hiked the Gobi Desert, was a shepherd in Turkey and a fisherman in Trieste. There is also the repelling in Nepal, his fluency in Hebrew, Greek, Latin and Italian. Oh, and he plays the flute. Since he is super smart, uber-talented and thinks for himself, he got fired from the University because academics just don't get him. Obviously, they were intimidated. Now he makes bikes from used parts and gives them to the shelter. They are so cool he now has a massive following. So, you'll see people in rehab with his bikes. And a billionaire will be trying to special order one from him. Still, he won't take a dime. Tells the rich guy to donate to the homeless instead."

Hans offered no reaction. He just sipped his beer.

"This dude is his own man. Tell Ivy how you lived in a cardboard box in Frankfurt one winter because you wanted to conceptualize a new way of living."

Jude left no time for replies as he talked on and on, while Hans took in every inch of Ivy's face. She let him look deep into her. His dark brown eyes, the aquiline nose and fully formed lips aroused her like nothing else in her short experience of men. There was no question or hesitation. She wanted him. No debates rolled around in her head about whether he was nice or dependable. She just wanted him. Reason played no part. Only instinct dominated in this instance and it felt good.

"Well, lots of t-shirts to screen tomorrow," said Jude. "So, I'm off. I'll let you two talk about art or whatever."

Goodbye kisses and hugs went all around and Jude then disappeared into the night. Standing on the sidewalk, Hans and Ivy waited for the other to depart. Neither moved. Hans only had eyes for her. She looked at him then up into the sky.

"It's so clear tonight. The stars are sparkling."

"Heaven is putting on a show for you, Ivy."

"Charmer," she responded.

"They really are," he said without pause. "Stars are truthful."

"If you say so, Hans, I believe it."

"Would you like to walk for a while?'

"Sure, why not," she said with a demure nod of her head.

Offering her his arm, Hans remarked, "I would ask why rather than why not."

She knew the answer to his 'why' but didn't share it, preferring instead to wrap her hand around the forearm she had brushed against earlier in the evening. As they meandered along, no one

seemed to be in Munich but them. Each street became narrower as they entered a series of back alleys.

"No streetlights, you see," said Hans. "I rely on the stars to guide me home, which is right here."

They came upon a crumbling stone gate topped by a rusting iron lantern. Hans unhooked the latch as the metal grille squeaked open. First, they walked down a long stone corridor and then into a courtyard with an gnarled old apple tree in the center.

"This is the monastery of the Benedictines. Deserted long ago. I squat here with a few other lonely souls."

Hans led the way up to a loft on the top floor. Darkness and silence enveloped the tumbledown place. When he lit a single candle, it illuminated a mattress on the floor as the only bit of furniture. He appeared to live like a modern-day monk with not a single possession except for the spare parts of bikes stacked in the corner and a collection of drawings pinned to the wall.

"John the Baptist, Hercules and some wildflowers. So, these are the things you sketch. Most revealing," said Ivy.

"Am I that obvious?" said Hans.

"Actually, you are not. Enigmatic is the word that comes to mind."

Ivy sat on the mattress and within minutes fell fast asleep. Hans stayed next to her, remaining wide awake as he kept vigil over her through the night.

"Good morning, angel."

Rolling over, her eyes barely open, Ivy reached over to the other side of the bed, but no other body shared the mattress. Looking up, wondering where the voice came from, she saw Hans standing before the bed, wearing only jeans, his hair tied back with a shoe lace and his hand offering her a cup of green tea. The light of day did

nothing to diminish the power of his eyes. In fact, it only enhanced his appeal. She sipped slowly, savoring the green brew and enjoying the sight before her.

"Mmmm, that's good."

"Seeing you in daylight reveals so much, Ivy."

She assessed his pose, how relaxed he seemed and the expression in his eyes, which exuded a piercing kind of knowledge.

"Well, what is revealed?" she asked.

"You are a powerful personality, Ivy, for one who at first appears so reserved."

"I am not as reserved as you think," she said. Finishing her tea, she leaned over and kissed him. "Actually, you are right. I am reserved but only because I am not bold enough to stand my ground. I don't do well with dominant types like my new boss and old boyfriend."

"That reserve is only temporary," said Hans. "It will fade once you find yourself and your own voice. Trust me."

"Trust you? Okay. That might be possible, in time. For now, I have a request for you."

"Anything for you, Ivy."

"Will you take me to see Durer today? I want to study it one more time before my meeting with Max tonight."

"Of course, angel, we will visit Durer if you promise me one thing."

Grinning, pulling the sheets around her, she retorted, "what could that be?"

"You spend the whole day with me until you have to see Max."

Smiling from ear to ear, she said, "like you even have to ask."

"But, before we take off, young lady, it is time to eat."

Watching him prepare breakfast, Ivy observed a rare

combination, the fluid body of an athlete and the gentle spirit of a saint. He moved decisively, every muscle in tune with its function, whether stirring a pot or balancing dishes on his arm. The sweetest vulnerability also came forth as he folded and refolded napkins, cleaned spoons twice and fussed over a small sprig of ivy he placed in a glass jar. Based only on her limited relationship with Jude and one other boyfriend, she had no idea men could be both strong and tender. The two attributes didn't seem compatible, until now. She sensed how comfortable he was in his own skin and how it affected her, in the best of ways, as she let her body fully relax and melt into the mattress.

"Where is your mind at this moment?" asked Hans as he presented her with a bowl of steaming oats.

"Oh, where it should be. Wondering what makes you tick."

His eyes twinkled as he licked his spoon. They both ate their breakfast, then tumbled into the bedsheets.

At noon, they took off to visit Albrecht Durer. On bikes made by Hans, the two rode to the Altes Pinakothek. Teasing one another, bantering, they careened through the streets. Darting in and out of old alleyways known only by Hans, Ivy witnessed another kind of city, grittier and edgier that the posh central district. This was no chocolate box version of Munich. Musicians, food vendors and independent artisans worked away in dilapidated stores and warehouses. As immaculate sidewalks, Chanel-wearing ladies and brass nameplates began to appear, they knew they were entering the historic heart of fashionable Munich.

"Hans, do you want to lock the bikes up?"

"Why? If someone wants my bike, they can have it. I can make another one."

"I suppose you certainly can," said Ivy as she wrapped her arm in his. "Let's go in to see the great man."

They leaned their bikes on a metal rack and walked up to the Greek temple front of the old museum. Ivy felt excitement welling up in her chest as they approached the room dedicated to the *Self Portrait*. She fully took in the moment when Durer and Hans came into contact.

"How does it feel to be the spitting image of a national treasure?" she said as the painting came into view.

Ivy was not the only person to see the resemblance. Other visitors began to stare at Hans as he stood in front of the painting.

"What do you wish to know, my angel?"

"Tell me how this portrait captures the artist's soul."

"It's in the eyes, Ivy. They are fixed intently on us. He is there for all eternity, looking only at us. The figure gives completely of himself. Nothing is held back. Honest, vulnerable, generous, the artist presents himself fully and without reservation to the world."

Just like you, she thought to herself as a shiver ran up her spine.

"Durer directly faces the viewer," said Hans. "Revolutionary for its time. Only Christ had been painted in this manner until this portrait came along. Artists traditionally depicted their subjects in a three-quarter stance or in profile, never revealing the full face. Durer forever changed that. Many say that his piercing gaze, long hair and thin features became the model for depicting the Saviour."

"Like you, Hans."

Sharing those few words sent another shiver through Ivy.

Is it too close for comfort?

Such concerns were short-lived when Ivy bore witness to Hans, with the tilt of his head and watery eyes, surrender to the moment.

"I believe Durer intended to present himself as truly human, not divine. He would never have presumed to think he was Christ. He is humanity itself gazing directly at humanity. I think that is the

central message emanating from the portrait. To be human and to be humane. To be giving regardless of the consequences."

How different this man is from every other man, thought Ivy as she took in his profile. When she could take her own eyes off of him, she followed his eyes as he searched the canvas, trying to see what drew him in.

"What is the inscription to the right of Durer?" she asked. 'My German isn't very good."

"Thus, I, Albrecht Durer, made an image of myself, in appropriate colors, in my twenty- eighth year."

Ivy stepped up closely to see the words he had translated for her.

"The ultimate image maker," she quipped.

Again, dazzled by the similarity between the man and the work of art, an idea hit her like a thunderbolt. She took out her camera and snapped a photo of Hans standing before the *Self Portrait*.

"I did not learn much of import about this painting during my research at the university," said Hans. "What I know about Durer, I came upon while encountering people in the street, on a fishing boat, herding sheep, walking in the desert and riding the bus. After looking into Durer's eyes, I sought out the eyes of my fellow men and women. That is when I learned about the *Self Portrait*, reflected in the eyes of others. His eyes say, I am here. I am with you. You are here. We are all with each other. We are the mirrors of one another."

Ivy gave Hans a long kiss while a group of onlooking school children giggled. She then stated in a very clear tone, "you have taught me much and inspired me even more."

"I declare, Ivy, that you have found your voice. Now you can proclaim your good news."

They left the *Self Portrait* and walked by the wealth of masterpieces in the galleries without stopping. Although sensitive to the beauty and power of the artworks, the couple were far too

engaged with each other for any diversions. As they left the Altes
Pinakotheka, Hans turned to the left with a look of disgust.

"What's the matter?" asked Ivy.

"Nothing, well, everything. That's the direction of the university.
I'm done with that world of the mind and all of its vanities. Let's go
to the Munich that has soul."

Hans directed them to turn right down a monumental avenue
laid out to satisfy the pretensions of Bavarian kings. Buildings
along the Ludwigstrasse presented them with a cold unwelcoming
classicism until the royal district eventually surrendered to the heart
of the old city. Here, in the Medieval center of Munich, streets and
squares played host to a multitude of heavy Romanesque towers,
lacey Gothic spires and soaring Baroque domes. The churches of
Old St. Peter's, Holy Ghost and those of the Augustine, Jesuit and
Theatine orders each stood watch over its own little district.

"Houses of worship envelop these crowded neighborhoods in a
cloak of divine warmth," said Hans as he put his arm around Ivy's
shoulder. "This is the holy precinct. I feel it in my bones."

Bells began to toll in unison. The ringing sounds led Hans and
Ivy to the steps of the Frauenkirche, soft lights pouring forth from
its doors thrown wide open and laden with lilies set in pots of ivy.

"The flower of purity rests upon your vine. Ivy is the symbol of
faithfulness."

"Is that what my names means?"

"Indeed it does, my angel. Ivy represents the wandering soul in
search of enlightenment. It also carries the warning to beware of
following our desires lest we be ensnared by them."

Ivy noticed a glow about Hans that she had not seen before.

"Are you religious?"

"No, no," he quickly and assertively replied.

"I don't have any patience for organized religion, yet I do believe in the force of the spirit. This part of the city feels sacred to me. Some say it's all of these churches and monasteries. I don't think so, though. I feel it's the memory of all of those who have walked before us on these paving stones. You can see them worn with the footsteps of the faithful."

"Are you originally from Munich?"

"I am from nowhere and everywhere. I don't stay in one place very long," he said with a wistfulness in his eyes.

His expression weighed heavily on Ivy's chest as deep blasts of organ music and the delicate chiming of choirs mixed in the air now that religious services were in full flourish across the city.

"It's dusk. While the faithful go to church, I have to meet with Max."

"So be it, Ivy. I will let you go."

Hans sat down on the steps of the Frauenkirche with the homeless who gathered to beg. Together, they mumbled the chants reverberating from inside the church. With a kiss on Hans' forehead, Ivy walked onward with a vigorous step.

Leaving the Medieval quarter, Ivy came upon the smooth sidewalks of the chic central district. Seeing her reflection in the high polish of black granite, she realized she was now a lone figure. No longer in someone's shadow, no longer the invisible assistant, she stood on her own now.

Walking to the Hotel Olympic for round two with Max, Ivy steeled herself for telling him what she had learned about the soul of Durer. If he liked what he heard, she would be spared. If her news displeased him, he would invite her to go home as a castoff. With a deep breath, she inhaled a dose of hope and went off to meet her fate.

Armed with only one photograph, Ivy entered Max's suite and

found him, as usual, dressed in black. This time, however, he did not look detached but seemed anxious.

"Have you brought me the soul of Durer?"

She took out her tablet, displaying the image of Hans in front of Durer's *Self Portrait* with 'Self, Image, Soul,' written along the top.

"A picture is worth a thousand words, Ivy. This is more than I could ever have imagined. You have unearthed a true soul. You are indeed the bearer of good news. No more needs to be said. It is done. You are New Semblance now. Congratulations. I see a bright future for you."

In only a few seconds, Ivy witnessed her life change. Now, she fully understood her own power. She didn't trust Max but he intrigued her. His discernment in all things captivated her even though he appeared to lack any form of true human connection. Success and excellence were the only things he seemed to value. *Good heavens*, she said to herself, *everyone makes a pact with the devil at some point. At least I will use art in the right way for this ad campaign. Rudy would have debased it. I will elevate it.*

"Go forth," said Max. "You know what must be done."

He nodded his head and turned his back on Ivy. The skinny assistant appeared and led her to the door. The meeting over in a few minutes, Ivy found herself on the road to success and riches as well as in the elevator bringing her back to the hotel lobby.

As she stepped out onto the street, a light snowfall began to blanket the city. Church bells announced the end of evening services. Ivy marched along as if the bells were sounding her triumph. Along the way, she stopped into a boutique and bought a bracelet of finely twisted gold with a small ivory cross.

Every store window beckoned now that she had much to celebrate. Easter eggs, champagne and the freshest vegetables and local cheeses filled her shopping bags. Knowing Hans cared

nothing for worldly goods, she purchased him a new box of tools for his bike-making. For herself, she bought a spray of ivy from a vendor in a tent hung with all the flowers of spring. Color and light filled the dark night and her good fortune illuminated everything she encountered. She put a single sprig of ivy in her hair just before entering the old monastery of the Benedictines.

"This is my day!" she shouted at the top of her lungs while bounding into the loft. Hans stood by the stove tending to a pot of soup. She threw her arms around his neck and kissed him.

"Max said my idea is pure genius. The world is mine," said Ivy as she showed her photograph to Hans.

"Ivy, do you see what have you done?" said Hans as he dropped his spoon into the pot. "My image and the *Self Portrait* in a marketing ploy."

Her heart sank as she heard the words come out of his mouth.

"It's, um, it's just an idea, Hans. It's a concept, nothing more, meant to capture the soul of Durer."

"Ivy, do you believe you can capture a soul?"

A searing pain pierced her chest. She realized he knew everything. He had the eyes to see.

"The soul exists in the air," said Hans. "It's in our hearts, but can never be caught on paper, on television, on a cell phone or any other kind of device. It's not the image that matters. Masterpieces don't matter. It's the spirit they embody. No matter how much he wants it, Max cannot have the soul of Durer, even with you as his deliverer."

Hans bolted out of the loft. Ivy chased after him. Running out into the snow-covered park across the street, he stopped and raised his head up to the sky. When he turned to face her directly, she saw indescribable suffering in his eyes. It made her shudder, yet he was more beautiful to her than ever in this moment. Behind him, a tree

towered as a black silhouette against the moonlit night sky, its tall trunk and long leafless branches invoking the image of a crucifix.

"You feel I have betrayed you. Oh, Hans, forgive me. Please, forgive me. Max tempted me and I fell for it. I did want success for just a minute. But I am so sorry now. Really, it was only for a minute. I am back now. I lost my head, but I'm back. I'm so, so sorry. It's killing me that I even thought of using you that way."

"No worries, Ivy. It's the way of the world."

She collapsed to her knees on the cold ground, her body a dead weight under her own shame.

"No, it's not okay, Hans. Please forgive me. I did all of this in a weak moment. I was so thrilled with my discovery of you and Durer's painting that I forgot what was right. I don't care about my career. I never did. I was just doing my job. All I care about is you."

Tears filled her eyes while her body shook.

"Hans, you showed me humanity in the portrait's eyes. I will never see the world in the same way because of you."

Hans raised her chin and wiped her face.

"That will be your redemption, my angel. Now you have the eyes to see."

He kissed her on the forehead.

"Goodbye."

He stepped behind one of the trees and disappeared into the night.

"Hans, Hans!"

Ivy couldn't believe her eyes. He was gone. She looked about, but he was nowhere to be found. Shivering, despondent, shamed, she lay upon the snow covered earth not knowing where to turn or what to do. A desolate silence pervaded the air. Then, in the midst of her agony, she heard the church bells toll midnight, ushering

in Easter morning. By the sounding of the twelfth bell, she found the strength to rise up. She took her cell phone and deleted the photograph of Hans and Durer. She sent a text to Max, typing the words, "The photograph is no more. I quit."

Ivy never saw Hans again, but his eyes remained with her. Occasionally, whenever or wherever she caught her reflection, she thought she saw him gazing back at her. She would then wonder, *is he there, or is he inside of me, looking out?*

Ivy did not seek an answer. She just stared, fixed on the eyes, the power of the eyes, how the eyes could inspire, forgive and, most of all, how she could see hope and redemption in those eyes.

Little Street

"You missed a spot. Several, in fact."

"I'll get there. Paint is a temperamental mistress. Yet, with a deft hand, it will take on a smooth sheen."

Violet slammed the wooden shutter closed, leaving the painter to his business. Within moments, however, she appeared at the front steps. Standing ramrod straight, as if about to command a battalion, she fixed her unwavering eye upon the man and his brush.

"This house needs to be painted by the end of the week. We need everything picture perfect for the sale."

Making a dot here, a smudge there, the painter dabbled in miniscule droplets worked into the curving grain of the wooden sill. About him sat white lead, yellow ochre, ultramarine blue and red madder lake in aged clay pots. Brushes of varying sizes rested neatly on a wooden table while graphite sketches of the house peaked out from a faded leather portfolio.

"Making things picture perfect is my vocation."

"You're not painting a masterpiece. It's only a house."

"No difference," said the painter. "They are all mirrors of color and light."

"It's a big difference," retorted Violet. "I'm an optician. I know how to look at things. Nothing is lost on me. Light, shadow, all the shades of a color. And my father was a house painter. So, what I see here is a job taking far too long."

The painter put his brush down and covered the pots.

"There are various ways to see and to paint."

"I didn't mean to offend," she said as her determined stance and unflinching gaze momentarily faltered. Uncertainty, an emotion that rarely came to call, threw her off balance.

"It's just that my sister and brother-in-law have to be settled in Amsterdam and I must get back home to New York. Nothing's been organized so I've taken charge."

The painter gave no response, focused on the minutiae of his task. He stepped back to take in a view of the house, a neat, orderly brick structure of the seventeenth century typical of the Dutch Golden Age with a stepped gable, generous windows and green and red shutters affixed by sturdy cast iron hooks. Simplicity lived easily on this old street comfortable with itself and its well-earned patina.

"I've not a second to spare," said Violet as she furtively backed up the front steps. "Time is not on my side."

Returning to the main parlor, she attended to her sister's treasures. Black and gold lacquered boxes, botanical prints and blue and white vases were set in precise order, buffered by tissue and cloth, for a dent or scratch in any of these precious items would have made this family of collectors shudder. Violet cared nothing for them as objects of beauty or interest. She took pride in something well organized and neatly packed.

As the decorative items disappeared from sight into their respective traveling cases, the serenity of the room emerged even more. Sun shone through the leaded glass windows casting their intricate patterns of circles, octagons, triangles and squares on ivory-

toned walls. The fireplace presented its unadorned mantel without fanfare while aged terra cotta tiles rested in mellow contentedness on the floor. Every timber beam and stone door frame, every quiet space and every antique beloved by her sister seemed a burden to Violet, working efficiently and without affection to vacate the old house in the heart of Delft. This city of her Dutch ancestors held no sentimental associations for she had never felt compelled to visit until her family called for help. The narrow houses and little streets proved an inconvenience, the lack of modern amenities an annoyance. As Violet stripped the hall, the dining chamber and the study of their contents, one-by-one, she felt herself one room closer to going back to New York. She banished light from the house with the closing of each wooden shutter. Heavy oak doors echoed in the empty corridors and metal locks clanked with a finality as she sealed off each chamber. No bright flower, no warm flame, no pleasant chatter now enlivened these spaces.

"Will this never end!" she exclaimed, seeing one small map remaining on the wall as an interloper. "How could I have missed that? Now I'll have to reorganize these boxes again. All for one crumpled piece of paper."

"A plan of Delft dated 1650," came a voice from the doorway. "On a very fine grade of parchment, if you please. The best in the collection."

Violet's sister stood on the threshold coddling a bunch of tulips and lilies in her arms.

"Flowers! For heaven's sake, Myrtle. We don't need more things brought into this house. We are moving things out, not taking in. You will drive me to the brink."

Myrtle removed a blue and white vase from one of the traveling cases, placed the flowers in it and wandered about searching for a table.

"As anyone can see, the furniture is gone," barked Violet.

"So it has," said Myrtle in a listless voice. "One gets used to objects being where they always have been. Even when they are gone, the memory is still there so I assume my things are still here in front of me."

"They are gone," said Violet. "It's time to face reality. Amsterdam is your life now. When your spouse gets a big promotion, there's no choice, if you want to be together. You follow him. And be practical. You can't keep two houses. So, it's time to empty the place, not fill it up."

Myrtle settled the little ceramic with its bouquet on the window sill.

"There. Now it still feels like home."

Violet slammed the top down on the last packing box.

"Good Lord, you really have no sense at all."

Doting on her flowers, Myrtle made no comment in return as she rearranged the blooms, placing variegated reds next to pure whites.

"So, what's the story with that house painter?" asked Violet. "He's an odd one."

"He is a wonder," said Myrtle. "I am so glad you met him. He worked on this house for our grandparents. And he's painted almost every building in Delft. The locals call him the 'House Angel.' He does everything with tender loving care."

Violet crinkled her nose and snorted, "this town is more like Daft than Delft. Is everyone clueless? That painter is fleecing you. Dabs and dots that take hours. And at an inflated rate."

"There is more than meets the eye with that painter," said Myrtle.

"Time will tell," retorted Violet as she made her way to the front door.

Stepping outside, she sat down on the steps while the painter began to prepare for his lunch. He made a respectful nod to her

then took a bottle of water, rinsed his hands and dried them on an immaculately pressed linen towel. The same cloth became a placemat as he spread it out on the end of the work table. Out of a woven basket, he took three tin boxes. From the first came a wedge of cheese; the second, plump apricots; and the third, seeded bread. A small bottle of white wine came next along with a pale green glass. In front of this miniature feast, the painter folded his hands together and gave thanks for the meal. Violet watched this ceremony, her squinting eyes betraying her befuddlement. Taking out a cigarette, she lit up and puffed away while throwing the match to the pavement. The painter reached over, took the match and stored it in one of the tin boxes.

"Must keep Delft pristine," she carped. "Good housekeeping is a religion to the Dutch, so I hear."

The painter poured wine into the green glass, raised it up, nodded to the sky, took a sip, returned the vessel to the table and nodded downwards. Upon breaking the bread, seeds scattered everywhere. He picked each one up by dabbing it with the tip of his finger, attaching one at a time back on to the crust. The apricots, sliced into small sections, adorned the center of the plate while the cheese, cut into equally sized triangles, were arranged in a pinwheel fashion around the fruit. Meditating on the fare, he turned the plate, moved the fruit to the side and the cheese to the bottom, the shake of his head bestowing approval on the newfound asymmetry of the composition.

"You dote on your food the way my sister arranges flowers," said Violet. "No wonder things never get done in Delft. Time stands still."

"Forms and colors are now in harmony," said the painter.

As he poured out more wine, the reflections of clouds rolled about in the glass, its green tones recording the movements of the weather. Raising the glass, he said, "look through this and see another world."

Curiosity got the better of Violet so she adhered to his request. Through the glass she saw the entire street flickering with patterns of light and shade. In an instant, the sun illuminated every detail of buildings from brick moldings to white trim. Moments later, all became half hidden under billows of dark.

"Sky, water, brick, mortar," recited the painter. "I've spent a lifetime watching them, recording them. One color is affected by the adjacent color. Light then plays itself against all of them. Through my wine glass, I observe these things in daylight, under the moon and in the rain. I find them different every time. Ever-changing yet eternal. Delft is a city of details. Sweet, unhurried details."

Snuffing her cigarette out on the step, Violet said, "thanks for the art appreciation class but I'm not interested in details. I'm here for one purpose only. To empty this house and leave Delft."

"Follow whatever path you must," said the painter as he folded his napkin and packed up his lunch. "I will keep painting Delft. It's my destiny, this little street."

"Whatever," said Violet as she stomped back into the house to resume her work. During the course of the afternoon, neighbors and passersby witnessed her shouting orders to her sister and brother-in-law. Packing went through the night, the lives of the owners relegated to a stack of boxes waiting to be picked up in the early morning, which came at its appointed hour.

As the sun rose over Delft, well before the little street came to life, the moving vans pulled away from the brick house, its shutters secured, its door, once open to friends and family, now sealed shut.

One person, however, still tended to the house. The painter arrived at seven o'clock. As the sun and moon came and went over the course of seven days, the painter dutifully worked his brush. Children and dogs played at his feet. Greetings were offered to the neighbors going about their chores. Each day, he dotted and dabbed,

lovingly touching each window sill and door frame with his brush. On the seventh day, he arrived at the house to find an open shutter revealing the figure of a woman arranging flowers. She looked back, gave a generous wave and unlatched the window.

"It is you, Madame. Welcome back."

Violet's eyes sparkled, glowing the color of brilliant purple-blue to match her name.

"I've returned."

"Evidently," remarked the painter. "What made you do so?"

"A painting called *Little Street*. My sister and brother-in-law dragged me to the Rijksmuseum when we got to Amsterdam. I told them we didn't have time but they insisted that we needed a break from unpacking."

"Jan Vermeer's masterpiece," said the painter. "Twenty-one point four inches high and seventeen point three inches wide. A small painting of a small world, a little universe captured on a little street."

"Right you are," said Violet. "Vermeer painted it between 1657 and 1658. A simple red brick house with green and red shutters, just like this one. A cobbled sidewalk in front and an alley on the side. An ordinary setting, like so many in any Dutch town."

"Made with lead white, yellow ochre, ultramarine, madder lake," said the painter. "Vermeer mixed the colors and applied them to the canvas in small pointed dots, each one blending with the other to create varying and subtle hues. The paint is laid on thickly to create the brickwork of the house. You feel you could reach out and touch the rough texture of real masonry. God is in those details."

"He most certainly is," said Violet. "I discovered that Vermeer used expensive pigments in his work and paid close attention to the smallest details. Reminds me of another painter."

Most pleased with herself, Violet knew she had put the painter on the spot. His raised eyebrow affirmed her little triumph.

"I did my homework," said Violet. "Vermeer lived in Delft and only thirty-five of his paintings are known. A girl holding a pearl, a woman pouring milk, views of the city. He made the extraordinary out of the ordinary. I asked the curator at the Rijksmuseum if he knew the location of the original house in the painting. He told me that the artist might have used one on Vlamingstraat Street, but it is no longer there."

"I believe Vermeer depicts not one house, but the eternal house," said the painter. "The place that is always home. That is why I keep painting houses. As long as I paint, Delft lives on."

"The house hasn't been sold," said Violet. "I'm moving in. So, you keep painting. You hear me?"

"Indeed, Madame."

The painter dabbed and dotted with his brush as the old brick house glowed red, light dancing on the window panes, the roof playing host to resting birds. Violet returned to her flowers on the window sill. She sat next to her little blooms and gazed out upon the street, watching the life about her. A cat wandered by, a boy chased a ball, a young lady rode by on a bike, an old gentleman ambled past with his newspaper. The daily doings of the little street moved serenely, as always, in step with time.

Holy Island

"Far be it from me to be seduced by the power of a legend."

Holly eyed the citadel rising from the sea on its rocky mount, its stern battlements dominating the Northumbrian coastline.

"Holy Island, so they say. A sacred place. It's buried there. A secret, a riddle. Something I can work with. I'll find it. You know me. Never a stone left unturned."

Accompanied by Simon, her dutiful assistant, Holly stood on the shoreline taking in the view of Lindisfarne Island with its village of sturdy whitewashed houses crowding around a derelict abbey and a restored castle. Wind and waves swirled about them. Clouds billowed overhead with the occasional breakthrough of sunlight bathing the meadows in warmth and lending sparkle to the North Sea on a bleak November day. Nature reigned here while Time watched patiently, nothing interrupting the slumber of seagulls and the daily doings of piping plovers. Holly focused on the vastness of the scene as Simon immersed himself in the details of a small book. While these two figures remained fixated on their mutual interests, seconds turned to minutes then to half an hour and more as the tide receded, revealing a sandy causeway.

"That is the ancient way known as the Pilgrim's Path," said Simon. "According to *Northam's Guide To Northumbria*, crossing it on foot is an act of faith. We have three hours to do so before the sea swallows it up again."

Taking her cigarette and flicking its ashes on the ground, Holly said, "go on. More. Give me more."

Turning the pages of his well-worn volume, Simon recited in a precise tone with exacting diction.

"Lindisfarne Island, also known as the Holy Island of Lindisfarne, is one of the most revered Christian sites in the nation. Its name is as old as the mists of time. Many believe it is based on the Latin word for 'healing' due to the abundance of its medicinal herbs and the holy men who lived among its rocks. Founded by St. Aidan in 634 A.D., a monastic community flourished here for centuries. St. Cuthbert used the island as his base to spread the word of God throughout northern England. The greatest spiritual and artistic accomplishment of this place is the masterpiece called the 'Lindisfarne Gospels,' one of the earliest known illuminated manuscripts in Britain. In the 8th century, Vikings raiders destroyed the abbey and laid waste to the land. By some miracle, the monks saved their cherished gospels, which are today housed in the British Library."

"Those saints and Vikings will come in handy," said Holly, who, with an impatient hand, discarded her cigarette and lit another. She inhaled deeply and exhaled with a dismissive air.

"Let's go."

Making her way down to the pebble-strewn shore, she began her march across the Pilgrim's Path. Simon kept three paces behind, crashing into her when she stopped without warning. Befuddled, he dropped his precious guide book in the mud.

"Oh, I'm so sorry, Holly."

"What a tragic excuse for an assistant," she quipped.

Holly waved her hand towards the mainland, directing Simon to their luggage sitting on the seawall. He scampered back to retrieved her three large bags and his one satchel, then lumbered under their full weight to catch up to the boss lady.

"Keep reading," barked Holly as she stormed ahead.

Simon transferred all the bags to one hand and balanced his guidebook with the other.

"*The Anglo-Saxon Chronicles* recount that omens of foreboding came over the land in 793. Inhabitants shook as whirlwinds and lightning enveloped the island. Fiery dragons appeared in the sky. Then came those who desecrated God's church at Lindisfarne."

"Heathens, omens, destruction," said Holly, her eyes ablaze. "Who could ask for more? It's the ideal setting. Much better than Stonehenge. It's going to be the ultimate festival. Start taking notes. I'm already envisioning this."

Simon dropped all the bags and fumbled about with his iPad. By the time he readied to act as scribe, Holly was standing on the island's main wharf.

"Inefficient and Ineffective. Why can't you keep up? I should have come on my own. Now, move those little stick legs and get over here."

They forged ahead on the uneven cobbled streets towards a small inn weathered by centuries of wind and rain. A crooked door painted bright green greeted them upon arrival. As it creaked open, Simon beamed upon entering the oak-paneled hall where he took care of checking in with the proprietor. Holly, to the dismay of an older couple taking tea near the warmth of a fireplace, snuffed her cigarette out on the stone floor.

"Leave the bags and just sign the register, Simon. We have no time for your niceties with locals."

Holly strode out, with Simon obediently in pursuit, as the guests of the inn watched with upturned noses. The occupants of the village held no interest for Holly as she marched through the center of town, its houses and shops clustered around a protected harbor. Walking along the waterfront, they passed fishing boats, piles of nets, stacks of lobster pots and the closed kiosks of local artists who peddled their wares to tourists according to the season.

"All of this will have to go," said Holly. "This place has the basics but it begs for a serious makeover. It needs to be stark and Medieval. That's it. I want to feel the blood running from the Viking raids. I want to hear the chanting of fisherman. I want to see the Maypole dancing of peasant girls."

Holly paced back and forth over the open ground. With her right index finger, she drew imaginary lines in the air marking out how to stage her once-in-a-lifetime happening. Raising her hand in a fist, she then announced, "yes! I have the concept! A clash between the pagan and Christian worlds here in the shadows of a ruined abbey and a war-ravaged fortress. Sex and sin, prayer and plunder, Celtic rock and merchandise galore. Ozzy Osborne invoking Satan. Sinead O'Connor praising the Lord. Electronic guitars and head-banger revival mashups. Steampunk art and beer stalls. We'll make a fortune."

Simon jumped for joy while giving a round of applause. His jaw then dropped and he began to murmur as he stared into the distance. Watching his fluttering lips, Holly grabbed his arms.

"What do you see?"

Unable to speak, Simon pointed to the hilly meadow at the far side of the village. Holly pulled him by the collar as they both ran to the end of the embankment and up a narrow lane. They scurried to the top of the hill and before them unfolded a panorama of windswept fields with the citadel above and the ruined abbey below.

"Yes! For once, Simon, you have the eyes to see something great. This is the exact location for the festival. I feel a cosmic force on this

spot, like we are on some kind of magnetic alignment."

Simon held his guidebook to his chest as his head moved back and forth. Holly shook him but he continued swaying to and fro in silence. With a stinging slap to his face, Holly brought him to attention.

"Enough of this!" she said. "You've gone into fantasy hyperdrive. Spare me the whole bewitched by the mystical island thing. We have work to do."

With a sigh, Simon put his book away. With another, deeper sigh, the iPad came out once again.

"Find out who owns this piece of ground," said Holly. "Reserve it, start on the stage, get the liquor licenses, etc. You know the drill."

"There are several limits on what one can do here," said Simon.

Holly gave him a glare that could have cut through stone.

"Limits? Ridiculous. Check on the web for any limits."

"There is no internet service here," said Simon, who, with his tongue in his cheek, took out his guidebook and tentatively pointed to a page of regulations.

"The island is listed as an Area of Outstanding Natural Beauty. There are 8,750 acres designated as the Lindisfarne Island Nature Reserve, the abbey is owned by English Heritage and the castle is the property of the National Trust. We will need to gain permission from all of these organizations for the festival venue."

Holly's annoyance announced itself in the tapping of her high heeled boots on the pavement. Better suited to the streets of London, her designer footwear betrayed a complete lack of sympathy and understanding for a storm-tossed island off the northeast coast of England.

"Stop telling me what we can't do. And don't bore me with local realities when I have a vision. Look, listen and learn. You know I am unstoppable, just like the Vikings."

Holly charged down the hill in battle mode. Simon scurried behind in the manner of a true flunky. As they made their way back to the center of the village, she rattled off a thousand details for Simon to arrange until abruptly coming to a halt at the site of a lone figure sitting at the edge of the shore. There he sat, a giant of a man, muscular, broad shouldered with a mane of curly blonde hair and a thick beard.

"That's my Viking," proclaimed Holly as she waved her hand. "Hey, you! I want to talk to you."

Rushing towards him, Holly tripped over a mound of fishnets.

"Damn it! You shouldn't leave this stuff around. Someone will break a leg."

The man worked on a large net, twisting and intertwining the cords in perfect rhythm. His fingers moved slowly and deliberately at precisely timed intervals.

"I am talking to you!" barked Holly. "Do you have ears to hear, eyes to see?"

Without responding, he watched the incoming tide, completing each knot at the very moment a wave broke on the shore.

"Are you unable to speak? Unable to gesture? Or just an imbecile?"

The making of the net proceeded in silence.

"I'm a festival planner and I'm about to bring millions to this pile of rock. If I were you, I wouldn't ignore me. My event could buy you a lifetime of new nets and a much-needed haircut."

Holly poked the man on his right shoulder only to receive no reaction. She poked again and again until her impatience boiled over and she kicked him in the lower back. Suddenly, a mighty hand grabbed her boot and pushed her upwards. She flew in the air and landed on her backside, laying on the ground in disbelief. Looking up at the sky, a ray of light poured forth from a break in the clouds. It blinded Holly momentarily. She then bolted upright in fighting form.

"How dare you! And who do you think you are?"

The giant remained silent, focused only on his net. With her hair disheveled, her cigarettes fallen to the ground, Holly peered at the him in astonishment.

"What the hell? Who does this? Are you like some Medieval thug who lost his way and ended up in the twenty-first century? Simon, call the police! Call the mayor! Call whoever!"

"Um, Holly, our cell phones don't work here."

Ignoring Simon, she huffed and puffed and paced back and forth. Most people succumbed to her high-handed orders and bullying. She didn't know how to deal with the giant man's immovable force.

"I need a drink."

Marching away, she shouted, "you will hear from me again and you'll curse the day!"

Upon arriving back at the inn, Holly sat down next to the hall fireplace, took off her boots and lit a cigarette. Simon knocked meekly on the manager's door. A stout lady with a dour expression came forth with her overly animated black Labrador.

"Oh, yes, um, how do you do? We are guests here. Might we have a glass of brandy for the lady?"

The dog ran over to Holly, who shooed it away. Back it came liberally dispensing its affection, nuzzling its nose between her knees and attempting to sit on her lap. She disdainfully rejected his advances. After flicking a few ashes on the carpet and seeing the dog lick them up, Holly chuckled and played a perverse game of feeding him more.

"A brandy for that lady?" asked the manager.

"Why, yes. If you please? Most appreciated," answered Simon.

The manager took out a bottle and poured out a small amount into a chipped glass.

"Doesn't seem to like dogs. Doesn't seem to like anything. I heard the yelling on the wharf."

Simon whispered, "a slight disagreement. All is well now. I assure you."

The manager put the cap back on the brandy and slammed it down on the desk while giving Holly a stone-cold stare.

"Folks don't yell on this island. It's a holy place. A peaceful place. We want to keep it that way."

Simon nodded in compliance while he noticed Holly dropping her cigarette ashes on the floor for the dog. Positioning himself so the manager would not see the scene, he said to the dour lady, "I assume you are familiar with everyone here. Do you know the name of the gentleman who makes the nets?"

"That's Peter. He's a rock. Very dependable. Will help anyone out when in need. Knows everything about the island, its history, all the buildings, the birds, the movement of the tides. Why do you want to know?"

Simon leaned over the desk so Holly could not hear him.

"We would like to keep this confidential, but my boss is a well-known festival planner, quite renowned actually. She is a real talent spotter and she believes he would make a perfect Viking."

"I cannot speak for him," said the manager. "But I am sure he will never agree to that. He lives quietly. Has a small cottage at the top of the hill at the edge of town. Makes nets for the lobstermen. Does odd jobs around the island. He's not your festival type. He's a simple soul."

With a bow of the head, Simon concluded the exchange and brought the brandy to Holly. Setting the glass before her, he pet the dog, who showered him with licks.

"Is the dog bothering you?" asked Simon.

"What? Yes. I mean, no," sighed Holly. "Whatever. He likes my ashes so he might be a fellow smoker, so I guess he's okay. But that dude on the wharf. Now, he really bothers me. I mean, geesh! I'm gonna get him. No one ignores me."

"May I suggest we not be so rash," said Simon. "I've learned a bit about him and he could be very helpful."

Raised eyebrows testified to Holly's disbelief. Simon clasped his hands together and whispered, "the manager says he knows everyone and everything about this place. That kind of person carries a lot of weight here. You know what small towns are like."

Downing the brandy in one gulp, she retorted, "no, I don't know at all. I'm not small town or small time."

"Right, right, right, of course, Holly. But if he doesn't like us, then he will talk, as people do, and then we will be defeated before we even begin."

"What are you thinking, Simon? I've had royalty and celebrities at my concerts. Why would I grovel in front of some net-making nobody who won't even speak to me? Forget it. I'm going to bed. Tomorrow we look at the field near the abbey and then we leave for London, where I will take on every office of historic or natural or cultural whatever and this concert will happen. In fact, my festival-goers will roll right over that net-making lout when the party boats dock on his wharf."

Holly offered her glass to the Labrador, who lapped up the last few drops.

"Wish he were a lad. He'd be right up my alley."

Flicking her last ash, Holly gave the dog a gentle pet on the head, rose from her chair, walked past the manager without uttering a word and went upstairs to bed. Simon followed with her boots, coat and packet of cigarettes, offering a polite bow to the manager.

Sunshine poured over the island the next morning. From the dining room windows, Simon looked out in wonder at the distant fields shimmering a deep green. He had a full English breakfast while Holly, disdaining food, drank coffee and smoked until the server informed her of its prohibition. Disgruntled, she left. Simon ran after her, leaving his half-eaten egg, bacon and tomato alone on their plate.

Stepping outside the inn, they found themselves in the middle of market day on the main square. People mingled on the open ground in front of the wharf, inspecting the newly arrived lobsters. Shoppers filled the streets and artisan kiosks burst with hand-made woolens and carved wooden boxes. Hurriedly making her way along the sidewalks, pushing through the crowds, Holly aimed for the abbey. Upon arrival at the red sandstone ruin, she surveyed the site and its views in every direction.

"The exclusive, high ticket concert in here, in the center of the old church, illuminated in red. Out there, on the meadow, will be the big music venue with the castle beyond floodlit in gold. Last night I read about Lindisfarne mead, made here for centuries. A secret recipe with the island's herbs. The monks used to drink it. We'll spike it with name brand liquors provided by sponsors. Party boats can dock along the beach. And merchandise. I've got to think about that. Something Celtic, of course. Knotted jewelry in serpent and monster motifs. Charm bracelets. Crystals. T-shirts silkscreened with Viking heads."

Recording all of these ideas on his iPad, Simon offered no more warnings on the difficulties inherent in Holly's plans. He organized every detail in neat columns along with his citations of places from his guidebook, noting the location for each event.

"I want pagan mystery and Christian imagery," said Holly. "I want an epic show. It's got to be apocalyptic. Thunder and the end

of the world and all that."

With a clap of her hands, Holly exited the church with Simon trailing after her. On the way out of the building, she took no notice of the fine Romanesque carvings on the remaining arches or the gracious goodbye offered by the ninety-year old volunteer who tended the abbey grounds. The remains of a venerable past and the niceties of the present had no value for Holly, only the vision of a commercialized future mattered to her. Every sacred old stone and fallow field was seen as a commodity. With Simon in servile tow, she spent hours walking the length of the island mapping out the areas for tents, parking lots, caravan camps and sales booths. Occasionally, Simon admired a bird or an autumn wildflower, but Holly squelched such enjoyments with one raise of her eyebrow.

"My work here is done," she said. "Thank God, I'm a genius."

"But, um, Holly, we don't have enough time to walk back before the tides come in. It's already late afternoon and the light will fade soon. And our cell phones still don't work so I haven't been able to tell the driver when to meet us."

"Why, Simon, do I always have to solve your problems? You call him when we get to the mainland while we wait in a pub or something. The point is I want off of this island right now."

She lit up another cigarette and proceeded to the waterfront while Simon collected the luggage. With every exhale of smoke, she scanned the upturned boats and the residents going about their chores. They smiled as they passed her but she gave nothing in return. Simon, on the other hand, cheerfully greeted everyone as he hauled the suitcases. Three old men offered help, which he duly accepted. He also nodded to a stout old woman.

"Goodbye Mrs. Pettigrew. Thanks again for recommending the book on the life of St. Cuthbert."

As more residents stopped to speak with Simon, Holly became steamed.

"How the hell do you know her?"

"Mrs. Pettigrew? I chatted with her this morning on my walk before breakfast."

"Morning walks," growled Holly. "Who are you? The guy who won't step more than three feet in London. Anyway, on the subject of walks, let's go."

They began their journey across the causeway. Simon watched the currents swirling at an alarming rate while Holly remained unaware. As they reached the half-way mark, waves engulfed them.

"It's too far to swim in either direction, Holly. There is a safety station up there. At least we can wait it out."

"This is all your fault, Simon. You have screwed up everything on this trip. When we get back to London, I doubt very much you'll be working for me."

As they arrived at the safety station, waste high in water, Holly puffed on her last dry cigarette while Simon shook from head to toe, the veins in his temples pulsating.

"You know, Holly. I have had it! We could drown right now and it makes me realize life is too short for this. You are selfish, self-centered and sadistic. I kill myself planning every detail of your life and you treat me like dirt. I love the concerts, the dances, everything about the festivals. I love how creative you are. But where is the fun? Where did it go? It used to be there. I am done. So done. Although it might not matter because we'll be dead any minute now."

Spitting out her cigarette, Holly took his hand.

"We are not going to die, you little fool. See, we can call for help," she said, pointing out the white and red emergency sign.

"Oh. Well, I still quit. I am done."

Holly put her arm around Simon's wet shoulders.

"I've been waiting for you to tell me off for some time."

With a violent jerk, Simon turned his back on her.

"Now, now. Don't pout," said Holly.

Simon perked up suddenly, exclaiming, "my God, I can't believe my eyes."

"Yes, you can believe your eyes, Simon, and your ears. I do forgive you this one outburst. But, don't do it again."

"This is not about you!" snapped Simon. "Who cares about you! We are saved. And here's our savior!"

Cutting through the choppy waters emerged a boat with Peter at the helm. He pulled up to the station and secured the vessel with one throw of his rope.

"Get in."

Thinking whether she might prefer drowning over owing a debt to the net-maker, Holly held back for a moment.

"You? Oh, Jesus!"

"No, I'm not Jesus. I'm Peter, a fisher of men, and women too, in this case."

Snarling at him, Holly said, "spare me the humor and help Simon first. He's had a tough day."

Peter hauled both of them into the boat with one single hand. They tumbled onto nets, a bucket of fish spilling onto Holly.

"God damn, you did that on purpose."

"No taking the Lord's name in vain," said Peter as he steered the boat through the strong current. Holly sputtered and spouted but no one could hear as waves crashed over them. Upon reaching the shore, she exclaimed, "you bring us to this godforsaken place when you could just have easily dropped us off on the mainland. We were half-way there!"

"I never go to the mainland. The inn is full so you will stay with me tonight. You can walk across the causeway tomorrow morning at the appropriate time."

"Stay with you? Never!" shouted Holly.

"Well, Miss, suit yourself, but no other place is open and the weather is going to be stormy."

"How do you know it's Miss?"

Peter did not answer. He pulled the boat up onto the beach and led the way to his cottage. Herb beds filled the front garden of his house along with heaps of hemp for making rope. He opened a weather-beaten oak door onto a room furnished with only a table, a stool and a bed. A slate sink, a one burner stove and a wooden ice chest sufficed for his cooking needs. Whitewashed walls formed the stark backdrop for rickety shelves bursting with books and stacks of writing paper

"Sit by the fire and dry off. I will loan you some clothes. You can take off those wet things while I get more firewood."

"Does this hovel have a bathroom?" asked Holly.

"Outhouse. Back of the garden," answered Peter as he left the cottage.

Peering out of the window, Holly saw the vine-covered weatherworn shack sheltering the toilet.

"Not even creature comforts. Oh well, we have no other choice."

Holly put on a baggy sweater and a ridiculously large pair of Peter's shorts. Simon donned a voluminous t-shirt and a pair of pants that fit in length but with a waist three sizes too big.

"Simon, remind me to never come to an island again. There's no escape. Now get yourself close to that fire. You are shivering like mad."

As they huddled by the hearth, Peter came in with an armful of logs and stoked the flames to a sizeable inferno. He offered beer

and assembled simple fare for dinner comprised of a thick brown bread, some leeks and fried fish scented with the last remnants of sage from his garden. The food and drink impressed Holly with its quality and freshness. Never had a leek tasted so good. The dense whole wheat bread enriched by a slab of the creamiest butter made her more contented than she could remember. Once warmed and fed, she began to see the room in a different way. No longer did it feel cold and spare. It had a beauty born of simplicity. Each of the objects Peter owned had a purity born of function and good craftsmanship. She wondered about the source of this refined type of austerity, suspecting a whiff of the sophisticated rustic about the place.

"So, were you born here, Peter?"

"York," he responded.

"You don't say. Old Yorvik, where the Vikings finally settled down. I knew I saw a Viking in you. But York is a good-size city. What brought you to such an isolated spot?"

Peter finished his fish and took one more swig of his beer. He leaned towards Holly, his eyes focused on hers. She sensed him searching for something, finding such silent directness both unnerving and engrossing.

"I dropped out of school at sixteen and began wandering. Did odd jobs, then became a bouncer at a London club."

"Really? Which one?"

"Apocalypse."

"Apocalypse!" Holly exclaimed in jaw dropping surprise. "You've come a long way, baby."

Peter took a long chug of beer and became very still, pondering the flames.

"I crippled a man. Threw him out of the club and one thing led to the next. I didn't mean to hurt him but it was still my fault because I lived in that harsh world. Spent time in jail for battery."

None of this shocked Holly. As a creature of the music scene and festival circuit, she knew that milieu all too well. As Peter's face glowed in the reflection of the fire, he seemed to her like a man who had paid a price.

"When I got out, I had to redeem myself. I asked the man for forgiveness. Helped him the best I could. Did errands for him, gave him every penny I earned. Brought him to his physical therapy sessions. Eventually he walked again, with a cane but at least he no longer needed his wheelchair."

Peter went over to his stack of books. Selecting a richly illustrated volume, he brought it to Holly and Simon and showed them the elaborately wrought details.

"I became a delivery man for a book distributor. One day, I dropped off the *Anglo-Saxon Chronicles* at a store near the British Library. They gave me this copy and I started reading it. Couldn't put it down. It traces the history of England from the Picts and Angles to the Saxons and Vikings. That led me to the Venerable Bede, who wrote in the 8th century about the saints and monks on the Holy Island of Lindisfarne. I read everything I could. It's as if I entered a new dimension. It inspired me to see this place. I arrived here five years ago and have never left."

Holly observed the passion in his voice when speaking of Lindisfarne. He reminded her of so many bouncers, bartenders, musicians and assorted club partiers who recovered from their addictions by channeling their compulsions into less damaging pastimes.

"So, you came here to specialize in net-making?"

Peter grinned. It pleased Holly to finally see a less serious version of him.

"I guess you know way more than my guidebook," declared Simon as he poured over the pages of the *Chronicles*, scanning every illustration.

"Not sure about that, Simon. But I can state that this island is both a natural wonder and a historic jewel."

"Would you tell us about the Viking invasions? Holly and I are obsessed with them."

You want to know about violence?" said Peter. "Okay.

Peter produced a manuscript bound in worn leather. He gently opened the cover and read aloud from the fragile document.

"Never before has such a terror appeared in Britain as we now have from a pagan race. The heathens poured out the blood of saints around the altar and trampled on the bodies of saints in the temple of God like dung in the streets."

Holly and Simon listened in rapt attention like children before a bedtime story.

"These are the words of the Northumbrian scholar, Alcuin, who wrote of the Viking raids on Holy Island in the year 793. They destroyed everything in their path. The monks fled taking the Lindisfarne Gospels with them as well as the body of their revered St. Cuthbert, who had spread Christianity throughout northern England. Eventually, the abbey was rebuilt but good and bad times visited here in equal measure. In the 1540s, Henry VIII dissolved the monasteries and did not spare Holy Island. The ruin you see today was the King's work. So was the castle in the distance on that rocky mound, built to exert royal mastery over one and all. The crumbling abbey and the mighty fortress still stare at one another wondering which will prevail, heavenly or earthly power."

Holly flew up from the floor and stretched her arms wide. Simon did the same thing. They embraced each other and spun in circles. When they finally stopped, Holly raised both of her hands as if in a salutation to Peter.

"That was pure poetry. You are a natural story teller. I see it now. You can do readings. My Viking reciting from the *Chronicles* in that

grave voice projected out over the landscape at night as we do a light show with the abbey and the castle. We can throw in Celtic chants remixed with electric harp for atmosphere. A Medieval and pagan rave. This is big, so big!"

Closing the book, returning it to its exact place on the shelf, Peter said, "no."

Charmed as she was by the fire, the food and Peter's love of the island, Holly became defiant again.

"No, you say? Peter, that's a word I won't accept. This festival is coming whether you like it or not. You love this place. Fine. But you can't keep it to yourself."

She took the *Chronicle*, slammed it on the table and went off to Peter's bed, not asking if he wished to give it up to her. Peter took the book and held it in his arms.

"Bring your festival here. It will be a fleeting moment that will pass as all things do. The island will remain. The wind, the water, the soil will still be here. They are eternal. Not even the Vikings could take those."

"Shut up," mumbled Holly as she turned over in bed.

"Thank you for your hospitality, Peter," said Simon as he curled up on a blanket.

"You are both welcome," said Peter as he cleared the dinner dishes and threw more logs on the fire. "Tomorrow you will need to cross the causeway at six in the morning."

"Don't you mean the Pilgrim's Path?" said Holly.

"Whichever is your pleasure, Miss."

"The sacred, soulful, historical, blah, blah, blah that you get off on," grumbled Holly as she fell off to sleep.

The sky darkened and the winds growled the next morning as

Holly and Simon left the island. Safely back on the mainland, their cell phones worked again. Text messages, voice mails and all the noise of their usual routine returned. Once the driver arrived and opened the car door, Holly assumed her old behaviors. She ceased speaking to Simon except to give orders. A tightness overcame her face while grinding her teeth. As she searched through information on her phone, naked ambition returned to her eyes. Vengeance occupied her mind.

Upon arrival in London, Holly did not follow her usual formula. She did not instruct Simon to organize her house, order her favorite coffee or buy fresh flowers.

"Reserve the tents and the vendors for the concert. You know the drill. Don't talk to me for a week. I will summon you when needed."

"Okay, Holly. Um, okay."

She left Simon on his own in the airport. With the forlorn look of an orphan, he gathered his few things together and made his way to the bus stop while Holly's chauffeur escorted her to a sleek black car. On the journey back to London, she neither spoke nor smoked, but stared ahead into the distance without moving, not even the blink of an eye. She had no thought of Simon, of her hundreds of pending messages or even of the need to take a bath after a long night in Peter's tub-less cottage. Only one objective occupied her thoughts as the car arrived at its destination, a characterless modern brick building on Euston Road. A gentleman with the grimmest of faces greeted her at the entrance and led the way down a long cold stone corridor. After security checks, they entered a vault where Holly took a seat before a book.

"I will turn each page, Miss, and you will tell me when you wish to focus on a certain detail."

Page followed page. Intertwined beasts, birds and foliage greeted Holly's eyes. Saints appeared framed in geometric borders of astounding complexity. She examined the intricate patterns in

search of a secret message, a riddle or any hint that might unlock a mystery.

"History. I need to know the history behind this."

"As you please, Miss. This book containing the four gospels was created in the monastery on Lindisfarne around the early 700s. Of unparalleled quality, it is truly a national treasure and one of the greatest objects here at the British Library. The monk Eadfrith is presumed to have produced it in honor of St. Cuthbert, a renowned Christian leader and a bishop of Lindisfarne. For all of his fame, he preferred being a hermit when time allowed. The pages are a fine calfskin vellum with superb calligraphy illustrated in what is called Hiberno-Saxon or Insular art. This style is a combination of Mediterranean, Anglo-Saxon, Germanic and Celtic elements, based primarily on a love of richly interlaced ornament. Note the borders with this Celtic spiral knot-work. I like to think it was inspired by the ropes of sailing vessels and the nets used by fisherman plying those stormy waters around Lindisfarne."

Page upon page revealed itself. Then came the heavenly image. Holly raised her hand and the man stopped. Spirals and swirls of intertwined foliage filled the page in brilliant blues and greens. The outline of a cross, in red, dominated the middle of the composition. She had never beheld anything so captivating, so intricate, so delicate. In the hope of being led to a secret, her eye followed one vine weaving sinuously across the fine vellum.

"I hear of a message embedded in this," said Holly. "If one looks long enough, one might find it. I have been told that no one has discovered it yet. Is this true?"

The gentleman sat down and his grim countenance lightened. He looked at Holly with a sympathy and understanding she found surprising for a stranger.

"After spending a lifetime with these gospels, I have yet to find a hidden message. Scholars and theologians remain hopeful but

still confounded. Like many things, maybe the process is more rewarding than the answer. Or maybe the answer is in the searching, not the answer itself."

He took out a magnifying glass and held it over the vines.

"This is called a carpet page. It is one of the gospels' most complex designs, meant to prepare the viewer for the richness to come, to lull them into a mystical state. Focus on the colors for a moment. The blue is lapis lazuli imported from the Mediterranean. It seduces immediately. Then there are those winding vines that draw one's eyes through the page. That journey, however, can be full of temptations. Many believe the eternal truth is hidden among this foliage. I advise visitors to beware of becoming obsessed with the purported secrets and riddles that dwell in the decoration of this sacred text. So, please be warned, young lady."

The gentleman carefully closed the heavy cover of the book over the carpet page.

"How dare you!" Holly shouted. "No one warns me. I will do what the hell I want when I want."

Although he and Holly were alone, locked together in the vault, the man glanced about furtively to be assured no one else was in sight.

"Then, I can tell you something, if you dare to know it.'

"I dare to know everything," said Holly.

"I have never shared this with anyone," he said, "but a scholar came here years ago and spent more time with this book than anyone in my memory. He unlocked the secret of the gospels. Although he never told me this, I could tell by his expression that he had discovered something. That very moment of his discovery became his last day here."

"Who is this man and where is he," demanded Holly.

"A doctoral candidate at the University of London working on

his dissertation about these very gospels. I heard he gave up his studies and went to live on Lindisfarne. He has not been heard from again."

Holly's pulsed raced, her heart pounded.

"His name?"

The gentleman tapped his forehead.

"Hmmm. It was a few years ago. Paul? No. Philip? No. Peter? Yes, Peter. Big man, very quiet."

Holly became wide-eyed. She rose, respectfully nodded and left the vault.

Sunshine burst on the Northumbrian coastline as Holly opened the car door. No longer the November chill of her first visit, a warmth filled the air as the flowers of May bloomed in the meadows and Lindisfarne shimmered in the light of a gentle sea. The castle still dominated its mount and the abbey slept in its grassy bed. With only a small satchel holding her worldly goods, Holly meandered down to the shore and walked along the Pilgrim's Path. Reaching the mid-point, she stopped to listen. The sound of wind, waves and birds melding together evoked a faint Celtic chant. She wondered if she imagined the tune, then decided not to question it and moved on. Reaching the main square of the village, she saw Simon waving enthusiastically.

"Holly, I got your message. Such good news."

She gave him an all-embracing hug.

"Yes. It is. Are you enjoying your new job?"

Simon straightened his name badge emblazoned with 'Holy Island Tour Guide.'

"I love it. Never been happier. Thanks for the suggesting it. Oh, excuse me, I better get going."

Assembling his group, Simon led them on to the abbey as he chattered away on the facts and fiction of Lindisfarne. Across the square, Holly saw Peter making nets at his usual spot on the wharf. She walked quietly up behind him so her steps couldn't be heard.

"Hello, Peter."

Without missing the making of a single knot, Peter said, "welcome back."

Holly sat next to him.

"I have received permissions from all of the preservation and conservation organizations to stage the festival."

Peter said nothing as he mended his net.

"I gained access to the Lindisfarne Gospels at the British Library," said Holly with triumph in her voice. "In fact, they were taken off exhibit for a half day so I could study them with a leading specialist, who says hello, by the way. Cost me a fortune to make that happen. But sizeable donations can do wonders. I developed all of the licensing for the most stunning merchandise based on the designs of the gospels. One-of-a-kind things worth a king's ransom in sales. I moved heaven and earth to make all of it happen."

She took a net and began to tie knots, ever so confidently twisting and shaping the cords.

"There will be no festival."

"No," said Peter.

Holly finished her knot.

"Never."

"Never is an eternity, Holly."

"Yes, it is, Peter. But once I saw the Lindisfarne Gospels, everything became clear. I saw you. I saw the island. I saw eternity."

They both looked out over the sea, not a wave or current stirring.

He placed his hand on hers as they watched ducks settle on the shore to bask in the sun.

"For the ancient Celts, the word 'holly' meant good luck."

Holly freed her hand to adjust one of his knots, then rested her head on his shoulder.

"And to the early Christians, Peter meant rock."

DREAM IN GOLD AND WHITE

GOLD SHIMMERED ON WHITE as Iris beheld the reflection of her fair skin and blonde hair, the canvas and frame for a portrait of a melancholy face. As sparkles of light danced on her glass of wine, memories of things past played upon her mind. Hoping to forget yesterday, a thousand yesterdays, in fact, she vowed to stay in the present, which found her standing in the center of the Secession House. She saw only white through the lens of her glass: the white jacketed servers; tables covered in crisp white linen; the stark white volume of the exhibition hall. Neither the chatter nor the posing of attendees mingling before photographs by Vienna's leading artists distracted Iris from communion with her white wine.

"Seeking eternal truth in your crystal chalice?"

She looked up to find a man standing far too close to her for comfort. His brown hair, thick beard and broad shoulders made him the picture of an Alpine mountaineer from days of old. A bit scruffy, underdressed for an occasion billed as so very chic, he struck Iris as a feral animal better suited outside in a forest rather than inside an architectural landmark.

"I've been watching you."

"Shouldn't you be watching the photographs on the walls?" said Iris, her pale blue eyes emanating frigid disdain. "They are supposed to be the reason we are all here."

"You are far more interesting, trust me," said the bearded man as he put down his large canvas bag.

"Trust you? I don't know you."

Sipping her drink and sizing him up, Iris stepped back to widen the personal space between them.

"I would be happy to have you know me," he said. "And, even more, to come to know you. I hear an American accent and wonder what brings you to Vienna?"

"It's always been a dream."

"You've come to the right city. Vienna is built on dreams. It's all fairy tale palaces, whipped cream and make-believe. After all, it's where Freud invented dream analysis."

"Yes, I know. I am a therapist."

Leaving him speechless, Iris swirled her glass of wine and wafted away. He followed her as she drifted from one photograph to the next, giving little time for each image. She ignored him. He did not take his eyes off of her. When arriving at one particular work, she stayed put, inspecting every detail.

"It's this very building," he said. "The Secession House. Vienna's finest work of architecture, I think. Do you like it?"

"I know it is the Secession House and, yes, I like it very much. Now, we've done this long enough."

Iris crossed the hall and headed for the hors d'oeuvres table. The bearded man did not pursue her. Between tasting bits of pate and a sautéed mushroom, she checked to see what he was up to. Relieved to be finally left alone, she became curious, however, when she noticed him unpacking his bag and arranging a camera and

a variety of accessories. Roaming about the perimeter of the hall, he took photos of people at odd angles then shots of the floor and ceiling. He zigzagged about, finally settling into a corner, crouching down, adjusting the camera and aiming it at Iris. Preferring not to be the subject of his zoom lens, she positioned herself behind fellow exhibit goers so the photographer would never, in her mind, have the ideal opportunity for capturing her. Once assured that he had missed his moment, Iris felt free to return to the Secession House photograph, drawn in by the white cube of the building topped by a sphere of gilded laurel leaves.

"You came back for a second look at my study in gold and white. So, you must like it."

Iris found the bearded man leaning over her shoulder. She was about to speak until he stopped her with three words.

"It is mine."

"Excuse me," she said with disbelief, bending down to read the label as he took the opportunity to fully examine the ivory dress clinging to her long lean frame. Bending down further, her buttocks became even more shapely. Iris caught his reflection in the glass covering of the photograph, noting how his eyes fixed on her silk covered behind. She straightened up immediately, assuming a rigid posture.

"Pure. So chaste in its simple form. So sensuous in its decoration. You have caught both precisely."

"Thank you, Fraulein. You have the gift of sight and a talent for analysis."

"You are Franz Held?"

No answer ensued.

"That is what the photograph's label states."

Seeing that the bearded man could not avert his eyes from the curve of her hips, Iris lightly snapped her fingers near his right ear.

"Oh, um, yes," he said, perking up like a boy who had been found out. "That's me."

"Well, your manners lack subtlety," she said. "But in photographs, you are certainly nuanced. At least God gave you some talent with a camera."

Placing the cap on his lens, he said, "now that you know my name. May I know yours?"

"Iris."

"And your last name?"

"Iris is enough."

"For now," he retorted with a gleam in his eye.

"Most likely, never," she responded. "No more chat. No more following me."

Franz furrowed his brow. Iris could not decide if it signaled disappointment or mockery. He then raised his hands in surrender and made one more attempt to speak, but a voice intervened.

"Good evening ladies and gentleman and all of you fellow artists who might not fit into either of those categories."

Some of the crowd chortled at the director's remark. Most remained silently maudlin, not a facial feature in motion. Franz sprung into action, freeing his lens from its cap and taking photos of the assorted expressions, the lurid stares of some, the pouting-lipped boredom of others, the bright-eyed wonderment of the few, the whole vanity fair that flourished in the opening of an art exhibit. He also snapped Iris in profile at close range, which prompted a frigid scowl as she turned to deny him another chance.

"The Viennese prize disinterest above all things," Franz uttered in a soft voice as his lips almost touched her ear. "An affected detachment, they believe, reflects their hyper-refinement. One is so bored because one is so cultivated. But where has the purity

of innocence and the charm of simplicity gone? I'm not sure, but I continue to seek them with my camera in the hope of finding redemption."

Leaning over her shoulder, Franz concluded his little sermon with a wink. Iris responded with the roll of her eyes and the slight upturning of her lips, which betrayed the beginnings of a smile she quickly restrained with a pucker. Any chance of their speaking ended with the director's taking center stage. Rail thin and sporting a tightly fitted white suit and gold tie, he posed in the middle of the room as if on exhibit himself.

"Welcome to the Secession House and our Spring exhibition aptly named 'The Place of Dreams.' To break with the past, to dream of the new. That was at the very heart of the founding of the Secession in 1897 by the radical artists of Young Vienna. Only a year later, in the very shadow of the Fine Arts Academy, that citadel of history and tradition, Josef Maria Olbrich built this serene white temple to modernism. Here the visionary works of Gustav Klimt, Egon Schele and others were shown to the world. Tonight, we unveil yet another generation. And it is my honor to announce the winner of this year's Golden Arc Prize for Excellence in the Arts to a truly gifted artist whose work brings humanity to the built environment. His eye for composition, genius for light and his framing of ornamental detail in the most tender, intimate manner elevates architectural photography to the level of divine vision. I give you Franz Held and his series on our very own Secession House."

Applause came forth without hesitation. No one held back as a rare enthusiasm exiled the usual ennui of Vienna's art seekers. Flashing a beaming smile, Franz nodded at Iris. He then strode forward to accept the handshake of the director and a golden trophy. Admirers engulfed him. Sycophants flitted about. Iris duly noted how the director's eyes grew avaricious, his nose flaring as, she assumed, he sniffed the possibilities a new star might bring to

the Secession House coffers. In the midst of his triumph, Franz searched for Iris. He finally spotted her, only to see the slim white folds of her dress disappear into the crowd.

"Herr Held, what is the secret of your photographs?" asked a reporter.

"God only knows," responded Franz as he dashed off. People kept shaking his hand, patting him on the back and singing his praises, which slowed him down immeasurably in his quest.

"Where the hell is she?" he exclaimed.

"Who?" asked a portly man surrounded by a bevy of skeletally thin ladies cloaked in black, decked in gold and marked in deep red lipstick. "Hell is full of she-girls. Plenty to choose from right here. Stay and have a drink or whatever pleases. You are the star of the moment. Wallow in it."

"No thank you," Franz said to the portly man. "I don't smoke or drink. My only pleasure is climbing mountains and admiring women in white."

With a wave of his hand dismissing the temptations on offer, he searched only for Iris, who he finally glimpsed descending a stair at the far side of the hall. Franz traced her steps down into a windowless chamber as dark and still as a catacomb. He found her among a congregation standing in reverence before a painted mural of golden swirls and faces filled with every emotion from despair to delight, all joined in a bizarre scheme of floating creatures and monstrous apparitions, part heavenly dream, part nightmare.

"The pursuit of happiness starts with noble intentions. It's a hero's venture ripe with hope yet tainted by ambition and sullied by desire."

Iris heard the words whispered into her right ear and knew that she was not yet free of Franz. This subterranean world offered her no escape. In fact, she now felt a prisoner with nowhere to turn.

"Looks like the crowd I just escaped from upstairs."

"Ha!" Franz shouted, causing the assembled viewers to perk up their heads. "I knew you were insightful," he whispered. "It's a story of humanity, so you are right. All the world's virtues and vices converge wherever people gather."

Without an invitation, Franz moved to Iris's left ear and continued in hushed tones.

"Gustav Klimt painted this, the Beethoven Frieze, for the 14th annual exhibition of the Secession group in 1902. At the very beginning of his career, at the threshold of fame, he produced this golden dream inspired by Richard Wagner's interpretation of Beethoven's Ninth Symphony."

Although believing his narrative to be more about seducing rather than enlightening her, Iris chose to listen for she was taken by both the image before her and the words bringing them to life.

"Those figures seem to be whispering to us," she said. "As if some prophecy must be shared before it's too late."

"They are the Genii," said Franz, moving closer to the mural, his barrel of a chest brushing softly against Iris's shoulder. "The spirit guides who float about inviting us on the journey. Here they are barely discernible in faintly drawn lines against a white background. They tempt us with the possibility of secrets to be unveiled. First, the Genii lead us to the naked figures of a woman standing and a couple kneeling, the very symbols of suffering who beg a knight in golden armor to set off on his quest to save them. There he is in all his purity, the eternal hero.

"Always a man," said Iris. "I have never met a heroic man. Quite the opposite, in fact."

"Always and never are strong words," said Franz. "Hope is always with us, if we allow it. Bear with me, if you please."

The raising of her right eyebrow signaled a tentative yes. Franz

gently took her arm and moved her a few inches so she would be directly in front of a section of the mural he framed with his hands.

"We now see two women behind the knight. They are Ambition and Compassion. Without them, he could not carry on. Each has a role to play."

"Women seem to be assigned the passive role in these epic stories," Iris said with a smirk. "We whisper in the shadows to inspire. We never speak in the light to assert. But, Franz," she said with a sigh, "do you not think they are limiting? Could they sometimes be reversed with women as heroines and men as muses?"

"I'm not advocating the roles, Iris, only imparting the story before us."

She laughed softly and a twinkle finally appeared in her eyes, making them a richer, livelier blue. His deepening dimple told Iris that he savored the moment and sensed approval, if only a tidbit. Not wanting to encourage too much, the subtle downward curve of her head tempered that tidbit but did not utterly distinguish hope.

"Understood, Franz. My apologies. You are merely the messenger and not to be blamed for historical misogyny. Not yet, anyway. Please, continue. The knight intrigues and the mural mesmerizes."

"I'm glad they do," declared Franz. "Tale and technique both conspire to bewitch the viewer. Klimt soared with this gem in his Golden Period. Here he is, in the vanguard of modern abstraction. Yet, he floats easily on the past with a background of triangles and flowing curves invoking the mysteries of some Byzantine icon. Old and new make a happy marriage, I dare say."

Iris turned her back to Franz on the pretext of examining the mural more closely and to avoid giving even the slightest sign of approval to his invocation of matrimony. She did stand in wonder, however, at the brilliant image before her and in wonderment at this burly giant who imparted knowledge with such ease. This man, who she thought a boob and a bore upon first encounter, now

baffled her. His wild beard and bounding walk had given no hint of the eloquent and poetic soul now in full sight.

"Let's take on the gathering of hostile forces," said Franz as he approached a scene of sinister stares and jaundiced complexions.

"Do you refer to the painted images or the living figures viewing them?" whispered Iris.

"I fall back on the dependable cliché. Life does imitate art and vice versa," Franz retorted as he used his sizeable girth to part the crowd, with Iris trailing in his wake. With outstretched arms, he cleared even more space as onlookers scurried away.

"The ape-like figure with fiery eyes is Typhoeus, the winged storm wind giant," bellowed Franz, bringing the entire room to a halt. His eyes aglow, he proclaimed, "the beast's three gorgon headed daughters pay court to him among the fawning likenesses of sickness, madness and death. Women to the monster's right embody lasciviousness and intemperance. See how they peek through their hair giving us the eternally long gaze of the 'femme fatale.' They hope to steer the knight off course. Temptresses, all of them, thirsty for destruction."

These last few words, so grave in tone, revealed a chink in Franz's armor of dimpled flirtation. The detached therapist in Iris warned herself against analyzing someone on first meeting, but the private personae felt the urge to play cat and mouse.

"Klimt appears to use females to portray all the world's evil and suffering," she said. "One wonders if he had an issue with women."

"He loved women!" declared Franz in a defiant voice. "Maybe a little too much. In paint, Klimt worshipped each pale-faced beauty invited into his studio. They were the seducers. He was the victim."

His face became flush as he drew back.

"I mean, well, I don't know, really," he said as he ceased ranting and began to pensively stroke his beard.

"Just a suggestion," said Iris, placing her hand upon her hip while swirling her wine glass, raising it to her lips as she observed Franz watching her every move.

"You have a point," he said. "Worthy of further investigation, especially by a therapist rather than an artist or an art historian, or a lowly photographer like me."

Iris made no retort, allowing no opportunity for point and counterpoint. Instead, she sauntered along the mural towards a cowering emaciated form with bulging eyes.

"Gnawing Grief," said Franz.

"An apt description," said Iris. "It is working its way down to her bones, slowly. Not the quickness of death but the unforgiving, plodding momentum of grief. I know that state all too well."

"There is relief, however," said Franz. "A genie appears overhead. She is the guiding angel who brings grief towards hope. Humanity must face all of the miseries lined up on this wall, but it seeks happiness. No matter how bad it gets, life goes on. The miseries don't triumph, in the end."

"Are you sure?" countered Iris.

"We can only hope," responded Franz.

A beeping noise came from his cell phone, which he furiously searched for in order to muffle the sound.

"I'm so sorry. I have to leave. Catching a plane for an assignment."

"At nine o'clock in the evening?"

"Yes. Early morning shoot in Turkey. But I will be back tomorrow night. Would you meet me here again so I can finish the story of the mural?"

Iris held back, saying nothing, her blue eyes turning pale again.

"Please. The best part is to come," said Franz.

"Maybe," said Iris.

"That's better than a no. There's hope in a maybe, and a bit of anguish too, but we won't think about that for now."

Franz bounded off then twirled back around.

"Walk Vienna tomorrow. Promenade, stroll, wander at whatever pace. Just keep moving. It will all make sense. All the pomp and pretense, the princely palaces, all the layers of the puff pastry that this city seems to be. See where it all leads."

He snapped one more photo of her, then ran up the stairs. Iris returned to the mural but found it strange to view without him, stranger still that she even had such a feeling. The figures reminded her of the pain of her patients and of her own past sufferings. These she did not wish to summon forth on this occasion, so she left the darkness of the underground chamber in search of light.

Once back in the exhibition hall, the festivities seemed less festive without Franz's interference so she made her exit.

"You are a dream in gold and white," came a crackled voice in the dark as Iris stood outside the Secession House, its white façade and gilded decoration acting as a mirror to her own fair complexion and blonde tresses.

A cadaverous old man, half-blind and stooped over, presented her with a bouquet of lily of the valley. Iris accepted them from his gnarled hands and opened her purse.

"Please, Fraulein. No charge. A gift for you. I've never seen such a vision. My evening is blessed. So, allow a poor flower seller a moment's pleasure."

"Thank you," said Iris. "They are my favorite."

"The symbols of Eve's tears, shed when the Lord forced she and Adam out of the Garden of Eden. They are sad blooms, but they promise redemption."

"I hope so," Iris said, clasping the lilies to her heart as she watched

the old man stumble off onto the sidewalk, greeting passersby and showing one and all his floral offerings.

From her perch on the steps of the Secession House, so very detached from the mundane in the abstraction of its pristine forms, Iris eyed a very different scene across the street at the Nachmarket, bursting with the riotous confusion of color and crowds. Tulips, primroses and assorted blooms posed on their metal stands. Fabrics, baskets and every imaginable trinket filled the stalls. German rotisseries, Italian cheeses and Turkish falafels scented the air. Making her descent from the purity of the modernist temple, Iris moved amongst the throngs of people on the sidewalk. The fin-de-siècle swirls of a gaslight became her viewing post where she leaned, half-hidden behind a cast iron goddess, and bore silent witness to the revelry before her. At one moment, she put a foot forward to join in, but then held back as thoughts overcame any action.

I wonder if all these souls are as happy as they appear? They shop and flirt and idle away the evening without a single care. Well, even if they aren't happy, at least they are pursuing it. That is more than I can say for myself.

Distressed by this last idea, she fled from the market revelers and disappeared into the night with her lilies of the valley.

Morning arrived gently. The hazy light allowed Vienna to awaken slowly. Iris opened her hotel window, relishing the sight of old buildings painted delicate shades of yellow and rose with stucco cherubs dancing on door frames and flowers overflowing from metal baskets. Cheerfulness, Vienna's specialty, welcomed the day. Deliveries of coarse breads, plump sausages and cheeses from local farms bespoke of a good breakfast to come while the smell of roasted coffee topped off this early hour's pleasures. Iris appreciated the easiness of the city. Nothing shocked. Everything seemed to be made for comfort. Putting on a yellow dress, burgundy jacket and

turquoise shoes, she went forth in full color to partake in a morning meal.

"Will you need a map, Fraulein?" asked the nattily dressed front desk clerk as Iris entered the lobby.

"No, thank you. I have no plan. I am going to wander."

His attentive gaze confirmed her hopes. She wanted to be bold. No pale ivory silks and reticent behavior would do for this day. A pleasing sparkle came to her eyes as she realized that brightly hued attire did not offend or invite ridicule.

Breakfast tasted especially good as she heartily ate two links of bratwurst, three slices of rye toast and a generous helping of caraway sprinkled potatoes. Once fully fed, she meticulously folded her napkin and departed from the room as a waiter sized her up from head to toe.

"You enjoyed your breakfast, Fraulein?"

"Indeed," she said to the waiter, "as you have observed."

"Then we will look forward to seeing you tomorrow at breakfast."

"Maybe," she said with a wink.

Upon leaving the immaculate confines of the hotel, the old city enveloped Iris as she wandered through ancient streets towards St. Stephen's Cathedral at the beating heart of a city once venerated as the seat of Holy Roman Emperors. Although not drawn to any organized religion, she loved churches. The multitude of Gothic spires and Baroque domes marking the skyline exuded for her a sacred magic. While houses of worship called the faithful, Iris journeyed on to the more profane realm of the ultra-fashionable Graben. Its array of boutiques, however, held no appeal. Even though she enjoyed making a statement with her outfit, modern day merchandise did not stir her while a more alluring past beckoned from every window sill, chimney and tower. Iris sought the layers of the city, the varied charms of its smaller corners, the forlorn majesty

of its monuments. Turning away from all of the promenading shoppers, she entered a maze of smaller passages opening onto an intimate Vienna replete with cats lounging on doorsteps and aged ladies watering potted geraniums.

"Beautiful shoes, Fraulein," remarked a woman leaning out of her second story window. "I once had turquoise high heels. They brought me to many places, happy and sad. Either way, it was worth it. Good luck with yours."

Before any response could be made, the woman disappeared behind lace curtains. Iris laughed to herself then jumped slightly when she felt pressure on the tip of her toe. A purring cat rubbed its chin on her shoe, its tale flirting with her ankle.

"You like them too," she said while petting the happy feline. "My footwear seems to please Vienna's critics, so far."

Only a few steps of her turquoise shoes carried her under a grand archway and into yet another Vienna, one of gargantuan palaces muscled onto narrow streets where the Austrian nobility once came to taste the delectations of an idle life. As she passed each doorway encrusted with coats of arms in faded gold, she recited names of their former owners.

Lichtenstein, Lobkowicz, Daum-Kinsky. All the power and panache of old Vienna.

Iris admired palatial exuberance but refused to be impressed. She did not wish to reminisce but these buildings made her fall upon her habit of dwelling upon the meaning of things, questioning, analyzing, critiquing and judging as she walked, observed and pondered. She could not escape the tendencies of her own mind. No matter how hard she tried, the memories poured forth.

A world built on make believe, a gilded dream. Not a formidable empire, but it endured for a thousand years coasting on glamour and glory. Just like Him. He seduced me for a while, but, like these stone piles, things are rarely as they appear. Everyone has to awaken from a dream, eventually. For some it's a shock. For others it's a salvation.

I still do not know which applies to me.

Her pace became more measured as she took stock of a personal history not worthy of remembrance, every painful moment registering with each tap of her heel.

I came here to escape Him but I keep meeting Him at every corner. Every beautiful thing reminds me of Him, the man who made all things ugly. This was his city but he never shared it with me. He kept it a secret, a myth. But now I am here, confronting it on my own. Nightmare or dream? Time will tell.

Relief from her obsessions over the man in her past came when the Michaelplatz showed its sunlit face. There she joined the sightseers who gawked at the architectural pageant while shoppers poured into the adjacent Kohlmarkt to take coffee and cake at Demel's and browse for expensive trinkets of the highest polish. Holding court over this scene of distilled chic, the Hofburg rested self-assured with its place in history. This former residence of the Hapsburg dynasty had seen triumph and tragedy in equal parts. Now, it enjoyed quieter times. Trumpeting angels sat aloft its main gate supporting a copper dome glowing bright blue-green with gilded accents duly accepting the admiration of all observers. Iris could not remain pensive in such a setting. It made her forget her own cares now that she took in a city determinedly designed for pleasure. Standing at the very epicenter of Imperial Vienna, she became excited yet apprehensive. She was about to meet someone, that one elusive figure who had haunted her for years, who had filled her dreams.

Walking between two embattled stone titans, Iris entered the mighty rotunda of the Hofburg. No gold braided guards of an Emperor stood at attention. No sleek carriages drawn by fine horses delivered nobles from a bygone era to a ball. Instead, tour leaders jostled with one another to line up their groups for visits to the Imperial Apartments. Heritage tourism now ruled the day. Iris had no choice but to slip into the labyrinth of ropes directing

visitors to the ticket desk. Moving in single file, the magic of her morning meander evaporated among the ticket counter and gift shop. Once past the obligatory commercial gauntlet, she ascended a marble stair, proceeded through one frothy Rococo room after another where Archdukes and Archduchesses once had lived out their exalted lives, and, finally, came upon the one who she had sought for so long.

Here you are, said Iris to herself. *Divinely beautiful. But why did your beauty become fatal?*

Wearing a diaphanous white dress, her legendary mane of brown hair pinned with golden stars, Sisi turned her head slightly over a bare shoulder to gaze at all who gazed upon her.

The Emperor adored you, but he couldn't save you. The fairest of them all who wandered aimlessly in search of happiness. What made you run away?

No answer came forth from Sisi. Iris shivered at the depth of the beauty before her and the curse it brought upon its owner.

Did the Emperor really know you? An exquisite possession. That's what he wanted and you let that define you. Then again, who am I to judge? I've been guilty of the same thing.

Still, Sisi said nothing. Iris felt resentful that the beauty offered her no words of wisdom, not even a gesture to convey her secrets. She envied Sisi her blessings and had once coveted them all regardless of the suffering.

Today, you would be labeled schizophrenic or bipolar. I think you just tried to live in a dream. But it exacted a price, did it not? You never dared awaken lest it all overwhelm you. So you played the romantic figure. Beauty and despair dancing into the abyss. All part of the dream. It is good for business, though. All those tour companies living off of the myth of the cursed Empress. But it suits you to be a legend rather than a reality. Winterhalter did you justice in this painting. Fixed in time at your most beautiful. Worshipped as a

goddess. Vienna's very own Venus.

As hordes of tourists swarmed about, Iris left Sisi's portrait in its gilded cage. Lost in a sea of visitors wearing audio tour headsets, stifled by the cloyingly heavy air of the Hofbrug's plush chambers, she searched in vain for an escape. Heart pounding, eyes watering, limbs aquiver, one of her panic attacks came in full force. Finally, a small exit sign gave a release. Down a small staircase and through one little door, she found herself in a foyer with a view to freedom.

Once outside, Iris followed the scent of roses to the velvety green lawns of the Volksgarten where she found air, light and space. With one deep breath, she took in the sweet aromas and with one long exhale, purged herself of the Empress's sadness.

Whew! I know how Sisi felt. A prison cell in gilding and gossamer. Nervous splendor indeed.

Iris sought relief in a row of folding metal chairs lined up in front of an arbor playing host to a cascade of yellow, pink and red roses. She sat down in a bower blooming to its heart's content. In Paris, she found the roses exquisitely disciplined on trellises of classical restraint. Here in Vienna, they were indulged children allowed greater freedom to wander and tease but never to delve into a tantrum. A petal kissed her cheek, a thorn poked into her seat. These were the innocent caprices of the Volksgarten roses that sparked a tremor.

This is Vienna. Beauty and wholesomeness with a bit of mischief. The essence of charm. But it can't be spoken of openly. To declare it so would be to kill it. If one says something is charming, it ceases to be. Intangible. That's what charming is. Like these impish roses and Sisi herself. Beautiful. Magical. And spoiled and reckless. Just like Him.

This last moribund thought prompted action. Iris rose from her seat, picked one flower as a souvenir and fled. The Ringstrasse beckoned beyond the garden so she journeyed on, leaving the memory of Sisi and of a Vienna that attempted to delude her with its delights. Iris knew the reality of it all as she glanced back at the

rambling Hofburg sporting statues of great men and great deeds now forgotten.

No fires or floods have disfigured you. So well cared for, frozen in time, just like Sisi. Elegantly preserved facades distilling the suffering inside, of hopes long ago surrendered. That's the weight of melancholy, is it not? A subtler form of sadness. He also knew how to inflict pain with no visible scars. He whose name I can never forget.

With a crunch of gravel beneath her feet, Iris left the confines of the Hofburg. Before her, the trams, cars, bikes and pedestrians of the Ringstrasse, the ring road encircling the old city, hummed with an energy that inspired faster steps as she encountered the landmarks of nineteenth century Vienna. The Parliament played the role of Greek temple, the Rathaus impersonated a Medieval town hall and the Burgtheater dripped with the sculpted excess of dramatic and comedic masks. Big, bold and bombastic, each building stood before her like a composition on sheet music, each making its high note rise towards a symphonic climax. This was the magnificent act of urban redesign ordered by Emperor Franz Josef, who decreed the ancient city walls demolished in the 1860s to make way for a new Vienna of magnificent boulevards. This ring road of public grandeur did not elicit the melancholy of the Hofburg. The opulence of the Ringstrasse sparked an anger born of a regret that flared up with a vengeance.

The museums, the theater, the opera. All so majestic, like Him. He was a monument of a man. Urbane, gifted, a god who walked among mortals. The prince of all narcissists, in love with only himself. And me, the fool seduced by it all.

Refusing to be a prisoner of her own bitterness, Iris rejected the lofty buildings in search of something else.

Keep walking. Franz said just keep walking. So, I will.

Once beyond the pastiche of the Ringstrasse's monoliths, she arrived at the university, for her the mother ship of all that was worthy in Vienna, one of the highly anticipated points on this

first visit to the city of her dreams. Taking refuge in the columned courtyard of the main building, she sat among the marble busts and bronze plaques of those she admired, the scholars who had turned the world for both good and bad.

You all burned with brilliance. I was seduced by His. The genius that became my poisoned chalice. My husband. Vain, promiscuous, self-indulgent. Every sin writ large and visited upon me. He, the victor. Me, the vanquished.

Remembered images flooded back as Iris mused on the double-edged sword of her past achievements: the awards ceremony for her writing; the letter announcing her prestigious fellowship; the circle of friends and professors who gave her both accolades and warnings, neither of which did she pay any attention since everything paled in comparison to Him.

But am I really beaten? If I were, I would never have put on these turquoise shoes. Therapy in a Viennese walk. Every step a memory. Every mile a purge. Freud would say revisit the dream, disentangle the nightmare. Face the beast. Stare it in the eye. See yourself in it and know why you followed in the first place.

In the quiet of the courtyard, a young man with a mop of wavy jet-black hair, an elongated torso and an angular face forcefully threw his backpack down and laid upon on a marble bench. His uncanny resemblance to the dead philosopher immortalized in bronze just above him struck Iris to the core. A young woman with tousled blonde locks, barely tamed into a loose twist by a blue pencil, joined the young man and twirled his hair in her fingers until he abruptly dismissed her with a wave of his hand. The woman pouted for a moment then stacked the books that had fallen out of his bag. She sat on the ground at the young man's feet and pet his arm while he dozed off. With the force of a thunderclap, Iris saw a flash of light before her eyes.

I knelt before Him just like this girl. I saw Him as a god, not a man. What a deadly match, a vainglorious god and a star-struck girl.

Contemplating her turquoise shoes, Iris saw them as the sole beacons of bright color among her sober thoughts and the somber arcades of the university. She appreciated the classical harmony of the surrounding architecture yet it annoyed her as well.

Perfectly proportioned but inhuman. It reminds me of Him. Crushed under his stone-cold cruelty. But I have a Savior. Freud is here. This place once gave him refuge as he explored the deepest recesses of the mind and heart. He tells me to embrace the trauma, to delve deeply and then find my way back, all necessary stops on the road to dispel Him.

In her agitated state, Iris fixed upon the young man still asleep while the woman, her hair free and flowing, leafed through a book and took notes with her pencil. The sight amused Iris as she rested her head back against the wall, grinning from ear to ear.

The false Hero sleeps while the obliging Muse reads. Time will tell who triumphs. I'm told so many things. Freud tells me to face the dark. Vienna is telling me to fill my day with light and color. And to be cheerful. Note to self, thank the Volksgarten roses. They are better than anti-depressants.

With a kick in her step, Iris left the stillness of the university. Intuition guided her as she entered without hesitation a tangle of streets. Shadows appeared in every door and window, receding as deep insets devoid of light. No flowers or sunshine enlivened the scene as she felt a force pulling her to the beating center of some fearsome thing. Passing through an alley barely one person in width, the darkest Medieval part of Vienna revealed itself. Then, with one more turn, she entered a large square dominated by the severe façade of a brick building with 'Kapuzinerkirche' emblazoned on a limestone tablet. The English translation next to it read, 'Church of the Capuchins.' Iris made her way into the sanctuary, following a group of nuns downstairs under a vaulted ceiling of crushing weight and into the netherworld of a crypt where black metal caskets held the remains of the Hapsburgs. Scores of emperors, empresses,

princes, princesses, archdukes and archduchesses slept for eternity, their tombs surmounted by metal skulls wearing the crowns of lost realms.

He would have loved this. Death as theater. Death as fetish.

"Maximilian, Leopold, Maria Theresa," Iris said softly as she read the name plates of all the great rulers of the past slumbering in the iron-clad glory of their sarcophagi, a series of chapters of Austrian history enshrined. One tomb, however, spoke of a gentler story. A single candle and a bouquet of roses sat at the base of the coffins of Karl VI and Zita, the last Emperor and Empress of Austria-Hungary.

Lovers in youth. Lovers in exile. Lovers in death. The perfect marriage. Through world war and a collapsing empire, you remained true, unlike Him. He demonized our marriage and then killed it with aplomb. Finding Him in our bed with my supposed best friend. A broken violin he swore was a metaphor for the state of his heart. A faked suicide to win me back. Mourning the loss of our alleged love, the despairing husband. His high drama just a tragic comedy.

Flowers at the base of the coffins reminded Iris of the Volksgarten roses and her vow to be cheerful. Thoughts of her former husband, like the imperial skeletons, would be left to an eternal oblivion in the dark while she returned to daylight.

The sun greeted her outside the church, where the square hosted a flower market. Alpine carnations, Tyrolean bellflowers, Hungarian poppies and Croatian iris sat happily among countless Spring blooms of every hue from the eastern and southern lands of the former Austrian empire. She bought a small spray of violets and cornflowers, pinning the little petals to her jacket.

As life abounded all around her, Iris felt hungry and saw a little shop that called to her like an old friend, even though she knew no one in Vienna. Sheltered within an ancient arcade, the shop windows featured a delectable tray of cakes. A young waiter

with golden hair stood in the front door and buoyantly greeted her. He showed her to a little red wooden bench before a table covered in an embroidered cloth and set with pansies in a tiny green glass jar. Iris nestled into the nook and ordered a cup of coffee.

"Mit schlag, Fraulein?" asked the young man.

"Excuse me?"

"Whipped cream. Mit schlag is whipped cream."

"Oh, yes. Plenty of schlag, please."

At the next table, a stout pug dog slept on a paisley cushion while its owner sat beside it with a dress of the same fabric and pattern. No gilding intruded on this café with its mellow walnut cabinets featuring hand-made paper, painted glass bibelots and lovingly arranged photographs of Vienna.

"Gemutlicht."

Iris turned to the lady next to her.

"I am sorry. I do not speak German."

"Gemutlicht means the good life," said the lady with a gentle nod.

The waiter set down a small silver tray with a cup of coffee topped by a pile of whipped cream and a golden cake smothered in apricots bathed in a honey glaze. Iris took her smoothly ironed linen napkin, placed it on her lap and proceeded to taste a slice of heaven. The aroma and the flavor made her forget all the day's musings about the past, about disappointments and recriminations. Sugar, cream and fruit were the angelic sources of her happiness now.

"That is the good life," remarked the lady as she took the last sip of coffee out of a gold rimmed white china cup. "Served by the sweet Franzl and in the company of Sisi."

"I beg your pardon," said Iris. "I did not mean to ignore you. This little piece of cake absorbed all of my attention."

"I understand. This is a very special place. It is the best café in Vienna. At least, I think so. In my long experience, those who have the eyes to see and the heart to feel tend to agree."

Iris duly admired the lady's softly waved white hair and porcelain complexion. In no way was this woman, who had to be in her seventies, dated in dress or deportment. A freshness and ageless quality pervaded everything about her.

"I can see Franzl," said Iris. "But where is Sisi?"

"Here she is," said the lady as she put her hand on the little pug snoozing next to her. "Poor thing. In dog years, she is about ninety. We come here every day and she holds court. She is most kind to us poor humans. We are allowed to pet her and make a fuss, which makes no impression on her at all. To be ignored by such a beauty can be rather beguiling, don't you think?"

Iris wiped the whipped cream from her lips and reached over to pet the pug, who raised its head and licked her hand.

"Just like her namesake, I think," said the lady. "Everyone waited for the smallest drop of attention from the Empress, even the Emperor. You are among the blessed. My little Sisi rarely gives such compliments."

"I've never been so flattered," said Iris.

"I think you have, if you pardon me saying so. Forgive a stranger who makes observations over cake and coffee."

"Good heavens," exclaimed Iris. "I've been a stranger in Vienna making observations all day. And I must confess. I've been rather judgmental."

"I am Eva. Now that you know my name, we are not strangers, so it is perfectly polite to share observations and make inquiries. Allow me to start. May I ask what you think of Vienna so far?"

Iris took a moment to dwell on the question, surveying the mellow toned walnut display cases and the red primroses in blue

glazed ceramic pots on every deep-set window sill. She savored the cakes, tortes, little frosted pastries and sugared almonds glowing on their golden stands, all to please and be admired in return. Immaculate, cheerful, homey, she felt the café embrace her, a feeling that had not visited her for years.

"What do I think of Vienna? It is a dream, like the whipped cream on this coffee. Delicious, delightful in the moment. It makes you happy for a bit but when it is gone, the melancholy returns. The dream is over and reality exacts its revenge."

"Is that a condemnation of the place?" asked Eva.

"I think it reveals more about me than Vienna," said Iris. "I wonder at the fantasy. All of the palaces and churches. All the angels and spires are out of a fairy tale with the ghost of Sisi everywhere. All so beautiful, one is seduced. Then I walked the Ringstrasse, which is like an opera set, all spectacle and opulence. Even death is treated as theater. But one has to awaken and that is a cold, hard moment. But reality has its blessings too. Seeing the clear light of day has been good for me."

"I am glad to hear it," said Eva. "But a little fantasy in the mix is so essential. What would we do without the fairy tale that is Sisi? The goddess who made a cult out of unattainable beauty in a city obsessed with it."

Eva took a small silver spoon, finely embellished with shell motifs and Rococo curls, and took a taste of the whipped cream on top of her coffee. As she placed the spoon back on the gold rimmed saucer, Iris admired the creamy whiteness of her delicate hand and the utter femininity of the lady in even this simplest of gestures.

"A woman blessed with everything but happiness," said Eva. "A wanderer who sought comfort in escape. But she careened towards the abyss, which, in that fateful year of 1889, was an assassin's knife on a train platform."

Delivering such blood curdling information without blinking

an eye, Eva turned to a portfolio next to her. Iris could only blink to try to muffle her own wide-eyed astonishment as Eva began laying out photographs on the table. Images of the St. Stephan's Cathedral, the Minorite Church and the Hofburg were followed by Art Nouveau apartment buildings.

"I have seen all of these," said Iris. "As a girl, I studied my father's picture book of Vienna. It was my first love and it has always been my dream to visit. So, finally, here I am and the layers of this place make me revisit my own past. I judge the city harshly because I am really judging myself. But then I found this cafe. It sparks no memories. I saw the cakes in the windows and Franzl bustling about and it called to me like a sanctuary."

"I am glad you feel that way. I own this café and shop. It has been in the family for generations."

"Grandmother, I need to be off in a minute," said Franzl, who came to clear the table. "Everything is cleaned up in back so you should be fine until Papa arrives."

He kissed his grandmother on the cheek and the pug on the head, then removed Iris's cake plate and cutlery. As he did so, she noticed a tattoo on his arm that read, 'Navel of the Dream.'

"May I ask what that is?"

"Certainly, Fraulein. It is the name of my band."

"And it's the core of Freud's interpretation of dreams," said Iris.

"Yes, Fraulein. The dream's navel is where it reaches down into the unknown. It's the place to encounter our fears, and our hopes, too."

"You sound like a future therapist," said Iris.

"Oh, I don't know," said Franzl, who smiled, nodded politely and carried his tray of dishes into the kitchen.

"Age old wisdom from a teenager," said Iris. "To top off whipped

cream and cake in the coziest place in Vienna."

"Franzl is such a sweet boy," said Eva with a rosy flush to her cheeks. "And such a comfort to me and his father, especially since the sad time."

"Sad time?" asked Iris. "I'm sorry to hear it."

"His mother abandoned my poor Franzl and his father. Drained the family's finances, had countless affairs, then disappeared. That girl possessed every evil and brought only despair and destruction. Sad to lose one's mother but Franzl is better off without her and so is my son."

Nothing more needed to be said so Iris returned to viewing the photos, leafing through each briefly until one image caught her attention.

"I saw this one at the Secession House. It is superb."

Eva took the photograph out of its folder and held it up to the light.

"Wonderful play of shadows. They show the inner melancholy that lurks behind the cheery surface of the city. My son, Franz, feels it intensely and captures in every picture. He won an award for this one."

Iris became wide-eyed and her heart sank. Surprise turned to disbelief, then embarrassment. She knew Eva could read every emotion flashing across her face.

"I met your son last night at the Secession House."

"Did you, now? The Fates must have decreed it. Did he annoy you? My Franz has no guile, so he comes across as rather blunt."

"Yes. Quite a bit at first. He told some very interesting stories about Klimt's Beethoven frieze and then ran out in the middle of it."

"Do forgive him for that. He is on assignment in the Middle East documenting the refugee crisis for the United Nations."

"He does more than architectural photography?"

"Much more, my dear. He is a crusader, of sorts. His work has always focused on people, especially those who plead for help. His photographs of Vienna were for me, so I could sell them in my shop. I also knew it might make him happy again after the sad times. He began to hate it here because of his wife's betrayals. Photographing the city made it feel like his home again."

Besides famous monuments, Iris perused Franz's shots of small street scenes, all infused with the spirit of life's everyday happenings. She then came upon a photograph of Franz and Franzl, father and son, sitting on the top of a mountain.

"They hike up to the heavens," said Eva. "Like two boys together. They get up to all sorts of mischief. That is when I know they have forgotten the sad times."

"I've known sad times too," said Iris. She stared down at the table and barely raised her lips to speak again when she stopped and began to meticulously fold her linen napkin. Eva rested her hand on Iris's arm.

"Speak if you wish. I will not force you, though."

Iris put her napkin aside and placed her hand on Eva's.

"I spent all day wandering and revisiting the curse of my former husband. He was so charming when we first met. I was seduced, then I became obsessed with pleasing him. It was a dream that became a nightmare. Now that it is over, I wonder what I was thinking, but there you are."

Eva gently squeezed Iris's hand. She detached a photograph from the portfolio and presented it to her.

"This is yours. The Secession House. See, next to the door, the words VER SACRUM. Sacred Spring. The symbol of renewal. Today is the beginning of Spring. The Secession House is open late in celebration. Go there tonight."

A lone tear dropped onto Iris's cheek while the beginnings of a smile emerged. She took the photograph and embraced Eva.

"Time to go. Bless you for this."

Walking out into twilight as lanterns cast their light on Vienna, Iris turned back to have one more glance at the shop with its generous windows framing Eva and Franzl tending to more patrons while the little pug slept. As the streets filled with people, she wondered about their stories, the trials and tribulations they all must bear. Then, she stopped thinking and allowed Vienna to simply exist rather than be a subject for analysis. No reminiscences or regrets filled her mind as her next destination appeared in the skyline.

The golden laurels atop the Secession House flickered brightly in the night sky as Iris proceeded with purpose up to the white temple to the arts. Franz stood on the main steps moving his head from side to side, searching the multitudes passing by. She enjoyed bearing witness to the all-seeing photographer unable to find her yet knowing she had found him.

"Good evening. I hope your trip went well."

"Iris. You are here! I've been living on hope. Wasn't sure you would return."

"I'm here, where I'm supposed to be."

As Franz made the heartiest grin, Iris saw the son's smile in the father's face.

"Let's finish the Beethoven Frieze, as I promised before I ran off on you."

"Yes, Franz. I'm all eyes and ears. Your mother told me you are an expert so I could not miss the opportunity."

Startled, he said, "you met my mamma. She is quite the genie,

always looking out for me."

As they went down to the lower chamber, Iris sensed the force of Franz's body. They did not touch, but she felt his height, his broad shoulders, his bounding physicality barely contained within the walls of the Secession House. Reaching the bottom of the stairs, Franz stood before a pedestal holding a vase filled with flowers.

"These are irises. Your blooms. The links between heaven and earth. In ancient times, they were planted over the graves of women to guide them on their journey."

He offered Iris his arm, which she took. They made their way past the genie, the knight and the monstrous imagery of the mural to a gentler scene.

"We arrive right in the middle of the story where we left off," said Franz. "Here is a lady dressed in gold and holding a golden lyre. She's the spirit of the poetic, the muse who fulfills humanity's yearning for happiness. Her poetry bespeaks of sorrow and despair, of joy and blessing. She is the witness to all. Next, a bevy of beautiful women lead our knight into the comforting realm of the arts, where all creative acts elevate humankind."

Composed of thinly sketched lines, the figures were highlighted by patches of shimmering gold. Theirs was a subtle beauty, faint and untouchable. No eyes were discernable on these otherworldly creatures. They reminded Iris of herself, standing aloof, a faint creature herself.

"You are the mirror image of a Klimt portrait like these from his Golden Period," said Franz. "Skin like alabaster, that far-away look in your eyes, the aquiline nose, the long jawline, so easily elegant, so effortlessly refined. A detached beauty in gold and white sent here to torture us hapless mortals."

Iris could not bring herself to look directly at Franz. She realized her former self, the person of only twenty-four hours ago, would

have scoffed at his overarching language and sweeping sentiment. Now, she found herself somewhere in between cynicism and hope.

"We now confront the climax," said Franz. "The mural ends with a finality so truthful it cannot be ignored or denied. In celebration of true happiness, a choir of angels sing 'a kiss to the whole world' as the man and woman before them enact those very words. Naked, the man's muscular back is turned to us, the woman's arms wrapped around his neck. The two melt together as one."

"Franz."

"Yes, Iris."

She turned to him. He faced her. They embraced.

Floating

"Timeless."

"Yes, sweetheart. But we have a timetable and, as your loving wife, I'm your timekeeper. So, let's move on or you'll miss your workshop. You don't want to disappoint the other woodworkers."

"Okay, honey. But take this all in for just a little longer. What's a few more minutes?"

"Time lost when we have things to do."

The man held his wife's hand as he watched the cherry tree branches, heavy with spring blossoms, bowing to the lake, its silvery sheen playing host to reflections of the sky.

"Beauty in bloom. Do you hear it?"

"I hear nothing," said his wife.

"My dear Bloom," said the man. "Everything blooms in your honor. The birds sing, the trees moan, the flower petals hum. Wait long enough and you'll hear."

With a pat on his shoulder, she said, "you're a hopeless dreamer."

Before them unfolded a contented scene. Houses of timber, paper and thatch nestled along the rocky shoreline and perched among bristly

pines on the hillside. Green and brown cast their hues upon the land. Whether under sun, moon, snow, clouds or rain, the gardens and buildings of the Imperial Katsura Villa nodded at one another in blessed harmony. Bloom looked only at her husband, studying his every move from the tapping of his fingers when he fixed upon a detail to raising of an eyebrow as he scanned the horizon.

"My tour finishes half an hour before your workshop ends," she said. "I'll use the time to reconfirm our schedule. Our car arrives at four fifteen to bring us back to the center of Kyoto. Dinner is at seven. Tomorrow we leave for the hike at eight. Are you listening?"

"Sure, honey. You bet."

"Mmmm, right," said Bloom as she rubbed his back. "Your comrades are waiting. Go along or you'll be late. And have a wonderful session. It's not every day you meet a Japanese master builder."

Kissing her on the cheek, he ran off to a nearby pavilion where his fellow craftsmen gathered, all greeting one another with the heightened energy of boys on the first day of camp. His enthusiasm made her happy until she realized she stood alone in a foreign place. Fear then visited her as it did in every quiet moment, opening the way to fixating on things unsaid and unresolved. Katsura's tranquility churned a well of pain, its silence a taunt, its stillness a torture. For Bloom, time needed to be filled with useful deeds. Doing nothing meant being nothing, so she reminded herself of her self-imposed duties.

"A tour of the Imperial villa and its garden. Record everything in my notebook for the husband. Good, good. That's my purpose. That is the day."

Setting off on a path of pounded earth, Bloom noticed her watch had the incorrect time so she reset it, giving it a gentle approving tap once it registered the correct hour. After taking a few steps into a bamboo grove, she saw the minute hand askew. Grimacing and

growling, she adjusted it. With time on her side once more, she proceeded towards her final destination but halted when hearing giggles rise from the greenery.

"No need to be angry with time."

A petite lady came forward from the foliage and pet Bloom's wrist.

"Hours, minutes and seconds are always with us. Old ones pass, new ones arrive."

The petite lady summoned two other women, who emerged through the leafy screen.

"These are my sisters."

A stout lady bowed to Bloom followed by a lean lady who smiled meekly. All three sisters huddled together, whispering intensely and bursting into laughter. They then made a circle around Bloom, examining her from head to toe. While being obviously observed, Bloom also partook in an inspection of her own, noting that each woman wore a dress of distinct color, the petite lady in striking blue, the stout lady sporting red and the lean lady swathed in a gossamer of white.

"Your blouse is a lovely shade of green," said the lean lady to Bloom. "You blend in with the foliage so you surprised us when you appeared among the leaves."

"The feeling is mutual," said Bloom.

The ladies erupted in giggles, hiding their faces together in a gaggle.

"Where do you come from?" asked the lady in blue.

"California."

"And what brings you here?"

"My husband always wanted to see this place. Visiting Japan has been his dream."

"So, love led you here," said the lady in red.

"And a dream," said the lady in white.

"I guess you could say that," remarked Bloom with a faint blush. Slight embarrassment increased to a fevered self-awareness as the three ladies each examined her more closely, one possessed of a piercing stare, one with sympathetic eyes and one casting a curious glance.

"What draws you ladies here?" she asked in hopes of directing their attentions away from her.

"The spirit of the day," said the lady in red.

"We stroll wherever a path might lead us," remarked the lady in blue.

"We float," added the lady in white.

Once mutual explanation had exhausted itself, the lady in red said, "to the Shoin."

Twittering and chattering like little birds, the ladies skittered across a path of rough-hewn stones. Bloom tripped and stumbled as she navigated the uneven surface. Asking herself why she had agreed to this venture into such strange terrain, she became drawn to a distant vision of spare elegance revealing itself through the trees. Set high on a raised platform, the Imperial villa's wooden posts and paper walls contrasted sharply, the immaculate quality of white surface playing against the rich grain of dark timbers. As the group arrived at the main entrance, a screen opened and an aged man stepped forward.

"Welcome. I am honored to be your guide."

The three ladies bowed. Bloom nodded her head after which she checked her phone and gave a fitful sigh when noting it had the incorrect hour, as did her watch.

"Gracious lady," said the guide. "Let time be of no concern. There is no such thing here."

I'll decide if time is important to me or not, she thought to herself.

With an annoyed jerk of her chin, she put the phone in her bag and turned her watch around her wrist so she could not see it.

The guide, his eyes aglow, gestured for all to enter. Once across the threshold, order greeted them in the form of a precisely organized grid of tatami mats lining the floor. No architectural twists or turns offended fine proportions. No flights of decorative fancy affronted the structure. Simplicity dwelt easily here with modest materials expertly rendered by an artisan's hand. Bloom marked out the space in her mind, judging each detail as a feat of mathematical exactitude. Her keen sense of measurement extended to the wooden slats dividing both walls and ceiling into neat squares, assessing within centimeters the unerring numerical accuracy of each compartment.

"This is the realm of princes," said the guide. "A father and son of the Hachijo-no-miga family created this world, which honors nature and the use of its elements with humility and reverence. The father acquired this land along the Katsura River where he could retreat in rustic solitude or, if it suited his mood, to entertain courtiers of the utmost refinement. His son added to it over the years, seeking to perfect the already perfect, however fleeting that state might be."

With only his index finger, the guide slid the lightweight entrance screen closed. He then led them through chambers flowing effortlessly one into the other as more screens yielded to the visitors. The same tatami mats and rice paper walls appeared throughout the building, yet monotony did not impose itself. Discreet changes in the scale of each room made for subtle variety. This series of contemplative inner spaces and soft hues generously gave way to an expanse of vivid color and light when the guide moved two panels.

"One touch of the hand and we are offered a picture onto a world floating on air one moment and kissing the earth the next."

A landscape of hills, a serpentine lake and rock-strewn islands came into view. Fresh blossoms meandering on the wisp of a breeze hovered over the water, birds pecked at seeds among the moss, butterflies flitted from branch to branch. Little pavilions peeked out over assorted pines both short and squat, tall and noble.

"Far away, in the country village of Katsura, the reflection of the moon upon the water is clear and tranquil."

The guide lowered his head and bowed three times to the view.

"I have spoken the words written by Lady Murasaki in the *Tale of Genji*, the most epic of stories which led Prince Toshihito in the 1620s to devise this heavenly place. He spent his hours copying passages from the text. The one I recited inspired his acquisition of this very spot. He built the Moon View Tower nearby and laid out the garden to recreate scenes from the tale."

The guide led the group on into a chamber deep within the villa. Bloom saw room after room disappear as an attendant, arising as if from nowhere, deftly slid the rice paper screens closed. The villa, only moments before so open and airy, communing with lush foliage and rippling waters, now presented itself as a folded-up box.

Kneeling down, the guide closed his eyes and pressed his hands on the floor. The ladies followed suit. Bloom remained standing, feeling out of place, not accustomed to this meditative type of action.

"Here the Shinto worship of nature meets Zen Buddhism's devotion to the essence of material," said the guide as his head touched the tatami mat. He then rose and stretched out his arms towards the walls.

"The evenly spaced wooden pillars form an unbroken rhythm. We know where we are at any moment in this sequence. No paint or decoration inserts itself into our communion with the wood. We follow the pattern of natural grain not knowing where it will lead us, swept away in the texture and pureness of color. Fluid grain,

solid pillars. A balance between energy and stillness."

The three sisters touched their heads on their tatami mats. Bloom acquiesced and, once on a mat, kept rigidly within her marked out rectangle of woven fiber.

"The tatami beneath us, three by six feet, are the ideal unit of measurement," said the guide. "Arranged on the floor, they are the standard units for the layout of the entire villa. I find peace in them since they are always here, waiting for us. Not demanding, not boasting. Humble servants to this Old Shoin, they assist the timber posts in surrounding us with the reassuring structure of lines."

"This is perfection," declared Bloom. "Everything in its place. No clutter. Everything makes sense."

"Order speaks to you?" asked the guide.

"No," said Bloom. "It sings to me."

"Now, that is happy news," said the lean lady in white.

"Indeed," said Bloom, who surprised herself with her own level of enthusiasm. Conscious of the quiet of her surroundings, she continued in a lower voice.

"I manage my family's lumber business. I'm the organizer while my husband is the artist. He would be worshipping the timber posts here, praising how the spirit of wood calls to him. I don't know about that. I just like balance and neatness. Although, there is something about this place, as if it's floated down to earth. I can't explain it."

"It doesn't need to be described," said the petite lady in blue. "It is beyond naming."

"This princely house and a peasant's hut spring from the same earth," proclaimed the stout lady in red. "They are both made of wood and paper. Only here, they are cut and tied with a divine precision."

"The regularity and order we behold here are illusions," said the guide. "Life is uncertain. Change comes with the slightest movement, much like our perceptions, as if a veil has been lifted. We believe we see things one way, then we see them in another."

The three smiling sisters gathered around Bloom. Two of them took her by each arm while the stout lady in red pushed a screen, allowing the guide to proceed into another long line of rooms.

"Prince Toshihito's son, Prince Toshitada, added this middle Shoin to the villa," said the guide. "These silent spaces played host to the ex-Emperor, the living god himself. When His Majesty visited here, he wished to be at peace with himself, with humankind and with nature. His eternal wish infuses every feature of the building."

In the midst of the spartan space, Bloom eyed a delicate hint of greenery from a crack in the far wall. The guide satisfied her curiosity by opening the screen onto a room devoted to the display of an ink drawing. While the three sisters purred with delight, Bloom studied the rows of bamboo rendered in thin green slivers that had once pleased a world-weary emperor. The grasses sat in harmony together, like a musical composition, each stalk a note on a page. Tender, melancholy tunes played in Bloom's ears as she began to hear the movement of these ageless forms in the wind. Only the shuffling of feet broke her union with the ethereal beauty of art on paper when the guide and three sisters moved on.

Before departing, Bloomed paid homage to the drawing with a nod of her head. She imagined how many people had gazed upon it, this vision of bamboo that made her truly hear the sounds of nature for the first time. Without words, it had welcomed her and in silence it now bid farewell.

"Here, noble ladies and gentlemen of the imperial house came to be simple," said the guide as Bloom joined the group on the veranda. "To be unfettered from their courtly elegance. To be even more elegant through simplicity. To sit here and view the moon just

as in the *Tale of Genji*. To live the life of those fabled characters in a place smiled upon by the gods."

The petite lady in blue whistled gently, several birds heeding the call and landing on her shoulders while a ladybug alighted upon her ear.

"The characters in *Genji* had no names," she said. "They were known only by their clothing or their court function. In the novel, Katsura is where one strolls, where one lingers, wanders, watches the plants, listens to the flow of the water."

"Foolish!" exclaimed the stout lady in red. "Lady Murasaki concocted a tale of power and promiscuity to amuse feckless aristocrats so they could fill their empty hours. It is a shameful story of the demoted son of an ex-Emperor who has failed love affairs and creates emotional turmoil wherever he blunders. Makes my blood boil."

"It is also a tale of redemption," said the lean lady in white. "We are none of us perfect. The hero in *Genji* learns lessons from life, as we all might. And it inspired this site, which is all peace and contentment. Maybe the garden will calm your blood, dear sister. Let us stroll."

The lean lady in white and the petite lady in blue joined arms and floated onward, succeeded by the fuming stout lady in red and the benevolent guide, their wooden soled shoes clacking in unison as they ambled on to a trail of extreme asymmetry. Since her sneakers made no sound, Bloom envied the ladies' footwear and wished she had dressed for the spirit and style of the occasion.

"Why must this path be laid out in such a random pattern when it would make more sense to have a straight line to the bridge?"

Her strolling companions slowed down, looking to their left and right.

"Did you see the clouds playing on the water?" asked the petite lady in blue.

"No," said Bloom.

"Did you see the rich dark brown bark of the small pine resting on its mossy mound?" asked the lady in red.

Bloom shook her head in the negative.

"Did you see pale green buds floating from their home on the Katsura tree across the lake?" asked the lady in white.

Bloom shrugged her shoulders.

"From each stone on the path, we are offered a view. We may accept the gift of seeing, or not," said the guide.

Whatever, thought Bloom to herself as she felt a form of reprimand in each statement of what they beheld and she did not. Although, as they proceeded, she did seek out the views she had missed.

Crossing the bridge, they made their way onto a serpentine path into thickset greenery, occasionally opening up to a panorama of the lake.

"Tranquility," said the guide.

"Sun dappled," stated the stout lady in red. "Light and heat on the water, brimming with life."

Dropping a few cherry blossoms, the lean lady in white said, "these pink petals kiss the calm water and turn it into currents, breaking and remaking the reflections of trees, buildings and clouds. The ever-changing scene."

Holding her sisters' hands, the petite lady in blue said, "the water is a mirror, where earth and sky may see themselves. A faithful servant to all who care to seek out its surface, reflecting its truth back to the observer. It is sometimes tranquil, sometimes not."

"And there is one constant," said the guide. "It is always fleeting."

Bloom found the scene beautiful yet artificial. She saw trees painstakingly twisted into shapes that complemented the curves

of the land as the work of tricksters. Instead of evoking tranquility born of nature, she snickered at the heights of human folly in rocks ever so carefully placed in imitation of the natural. Her practical, ordered mind had little patience for such conceits. She found her companions sweet natured, yet as contrived as the setting, all yearning for an exaggerated refinement in false simplicity. In their glances and phrases, she sensed a condescension that inferred she did not know how to see. In defiance, she pulled her watch out of her bag, hoping to find the magic hour of four o'clock, marking the end of the tour, but the timepiece had stopped yet again.

Looking up from her watch, she saw no one. Assuming the group had followed the path, Bloom made her way through the mass of trees and shrubs feeling more isolated with every passing second. The peaceful scenery had turned eerie now that she was on her own. Hearing a rustling in the foliage, she stopped, thinking the sisters might be there, but found no one. Immersed in a grove, with paths now leading in many different directions to ever darker woodland, she felt lost and increasingly nervous as her heart pounded.

Walking at a faster pace, she came upon an ancient tree and took refuge in a seat formed by its gnarled roots. Bloom realized that she had not felt this alone since her days in the orphanage at age ten. Her hands began to tremble, so she took hold of herself by putting her head back and closing her eyes. The orphanage loomed in the vision of a cold mist with lonely spaces seeking to be filled. Next, moving from foster home to foster home came to her, the pit of her stomach feeling the lack of place, the sense of being no one in the middle of nowhere. Her entire body began to shake until she felt the solidity and smoothness of the all-encompassing tree bark embrace her. Deep breaths brought a degree of repose.

As she inhaled more fully and exhaled more slowly, her mind no longer raced to the next thought. Images of the shelves at work, with lumber stacked and carefully packed, flowed before her, bringing a warming reassurance. The sound of account legers

opening and the rustle of immaculate spreadsheets grounded her. Paper and wood, everything in neat rows, flashed before her eyes until she saw her husband's face. His messy mass of curls, his thick beard and twinkling eyes visited her.

Shoulders slumped, head bowed down, Bloom felt sleepy. She continued to sit, breathing in measured contentedness, feeling her blood pulsing leisurely in her wrists, arms and legs. Soon, she sensed herself floating in a body as light as air until a single leaf falling from the tree made its home on her hand. Bloom opened her eyes and realized she still inhabited the earth. Little birds sat on her shoulder and a caterpillar inched along her thumb on a pilgrimage to a nearby plant.

While sitting with her new companions, she witnessed the land becoming a rich green as a cloud passed overhead. Once gone, brilliant yellow spots of sun shone down through the canopy of branches. A breeze came along and took the leaf from her hand. She watched it meander along until vanishing in the distance. When the birds scattered and the caterpillar reached its prize, she knew time decreed that she leave the sheltering old tree and journey forward.

Shadowy corners and sunny openings greeted Bloom as she traveled along a zig-zagging pathway towards the lake. Crossing a bridge, she arrived at a humble building of coarse mud walls.

"Greetings!" came a chorus of voices from nowhere.

"Good God!" cried Bloom as she reeled back from three heads popping out of the door. "You scared the hell out of me."

"Good news. That means there is no more hell left in you," said the stout lady in red.

"This is the Pine Lute Pavilion," said the guide. "We rest here among earth's bounty and enjoy the whispering of the trees."

He pointed to a stone water basin next to the entrance.

"Purify, if you please."

Bloom washed her hands and readied herself to stoop through the extraordinarily small door. Bowing low, she entered the pavilion, where the three sisters and the guide gathered on the floor around a stone fire pit. Hot water steamed away in a pot over a small flame and an array of tea implements were set out on a tray.

"So, this is a tea party in doll's house made of straw and dirt," said Bloom.

"Peace, reverence and pureness be with us," said the guide as he mixed water in a cup of green tea powder to form a thick paste. "Our lost friend has found the way on her own to this house of modest mud. We welcome her to this occasion adhering to the centuries old practice of Kobori Enshu, the most honored tea master and garden designer to the princes who created the paradise that is Katsura."

Adding more water to the green paste, the guide whisked it to produce a frothy tea and offered the cup to the petite lady in blue, who took it, nodded in thanks, turned it around to appreciate its form and crackled glaze, then drank the light brew. The other sisters repeated this ritual act and passed the cup to Bloom. With one sip, she found its delicately refined taste in striking contrast to the roughness of the primitive hut around her. Her body felt weightless as the aroma of the tea infused her nostrils yet, at the same time, the earth upon which she knelt held her in place.

"We relish the balance of opposites," said the guide. "Rough and smooth, hot and cold. Such is life."

Through the low-set windows came a light shimmering off of the lake. Bloom glanced through the opening, taking in the ever-changing patterns as currents moved about the little islands. The brightness of the scenery played against the dimness of the hut's interior as a beam of sun cast itself on the central post.

"It still wears its bark," remarked Bloom.

"The sacred post," said the guide. "It is the whole trunk of the tree, the earthly and spiritual core of the house. We honor it in its true state, touched by the builder as little as possible."

With the tea consumed, all sat in complete stillness around the post, so still that every slight wisp of wind and rustle of a maple tree could be heard and, thus, sanctified. Only when the guide raised the tea tray did human action occupy the pavilion again. All participated in the cleaning of the ceramic cups, pot and whisk. Once the objects were stored away with care, all bowed to each other.

They departed the pavilion one by one, walking single file along a path of variously shaped stones, each content in its mossy bed. Through this winding scenery the group crossed another bridge and arrived at a high point of land laden with a carpet of cherry blossoms.

"The Flower Appreciation Pavilion welcomes us," said the guide as another teahouse rose among the blooms. "It invites us to linger, to reside upon what is before us and what we see beyond."

As the group entered the single room, four tatami mats marked out the dimensions of the diminutive interior with one central pillar made out of a bent tree supporting a ceiling of woven bamboo.

"It remains in its natural shape as the spirit of earth intended," said the guide. "When building in ancient times, the raising of the central post made out of one single tree made for a sacred act. The power of wood gave protection to the house and all of its inhabitants. Whether a hut or a palace, every dwelling is thus blessed."

Bloom wrapped her hands around the post, feeling how the builders changed none of its original shape to conform to a straight line.

"It seems so unplanned, yet it's all so accurately measured and so expertly crafted."

"Beauty may dwell in that which appears imperfect, impermanent and incomplete," said the guide.

"I am imperfect," said the stout lady in red. "Like a flame I can bring warmth one moment and destruction the next, and I am

content in that."

"I am impermanent like the water," said the petite lady in blue. "I float and wander, never knowing where it might lead, and I am happy in that."

"I am incomplete like the air," said the lean lady in white. "I cannot be seen but I can be heard, and I am pleased with that."

The lady in white took a cherry blossom and presented it to Bloom.

"And you, my dear, are solid and steady like the earth. The last of the four elements. We knew it from the moment you emerged from the greenery."

"Well, I try to stay grounded," said Bloom. "The moss, the trees, the rocks all speak to me."

"You can give thanks for that, if you please, at the Enrindo, just over there," said the guide.

Set amid a soft veil of evergreens and surrounded on three sides by water, the shrine of the princely family presided over Katsura.

"A place of memory," said the stout lady in red.

"A place of reflection," said the petite lady in blue.

"A place of tranquility," said the lean lady in white.

"A place that floats on eternity," added Bloom.

A whistling sound came across the lake, bringing all of their attentions to the sight of Bloom's husband. His bright smile beamed across the water as his wife waved back. She raised her hand to show him the cherry blossoms the lean lady in white had gifted to her. He gave her two thumbs up then gestured for her to join him. Bloom turned to say goodbye to the guide and the three sisters but they had all vanished. She thought it odd but knew her little group was odd from the very beginning so she accepted the somewhat abrupt end to the tour and crossed a moss-covered bridge to her beloved.

"Did you have a good tour, honey?" asked her husband.

"Good? Yes. But that's not quite the word to describe it. Let's just say enlightening."

Her husband raised his eyebrows in amusement. Bloom winked and took his arm. As they walked along, she stopped when seeing a pavilion she had not yet visited.

"What is that?"

"Oh, that's the Shoiken where I met with the woodworkers and the master builder. It's called the Laughing Thoughts Pavilion."

"How appropriate for you," said Bloom. "You are always the happy one."

"And what do you think makes me so?" said her husband as he clasped her hand and leaned his head against hers.

"You never leave anything undone, unsaid or unresolved," said Bloom. "And guess what?"

"I could take a guess," he said, "but I prefer you tell me."

"In the strolling garden, I did the same," she said. "With a little help from a master, three spirits and an old tree."

He gave her a peck on the cheek.

"So honey, what's next? Dinner? Tours tomorrow? A list of places to see, things to do? How have you organized every hour?"

"Oh, I don't know," said Bloom. "Let's just float."

As they approached the bridge which led out of the garden, her husband glanced over his shoulder and saw the three sisters and the guide standing on a small island in the lake. They bowed. He nodded and whispered, "thank you," which the breeze carried on its way.

SANCTUARY

"BEHOLD THE SANCTUARY OF ISIS, the flower bedecked jewel of the Nile."

Dr. Walburg pontificated, the major donors listened, Lily scribbled. The luxury barge pulled up to the small island, lotus kissing the river's edge, papyrus reeds nodding their heads to the guests, the ruins of temples resting placidly under a cloudless sky. Scores of heron flew overhead while the thicket of palms clinging to the shoreline bristled with the chirps and chatters of warblers, little green bee eaters and a host of other birds busily attending to their day's work.

Pad in hand, pencil sharpened, Lily did her best to keep up with the torrent of legends and lore on Egyptian history and culture pouring forth from the eminent professor. No fluid speech, however, could match the enchantment of the setting. Her attentions diverted to sketching the scene, attempting to capture in faint strokes of graphite the fauna, flora and architectural forms of the site, which appeared to float ever so gently upon the river. Never had she felt more at peace than on this blessed spot. She did not surrender to her usual obsession with the passage of time and fears of her own time running short. Any worries seemed trivial as she looked upon a landscape devoted to the eternal. She had hoped for this, to be released, if only for a short while,

from the twists and turns of a taunted mind.

Lily perched on the edge of the barge, her beauty reflected in water and stone, her eyes the exact blue-green hue of the Nile, her creamy skin glowing with the same ivory tone as the sun-drenched shrines. Delicate shoulders, a tiny waist and long slender legs made her a statuesque figure worthy of an ancient sculptor's dream. Her loveliness, however enticing, did not elicit vanity, arrogance or any of the deadly sins for she never reflected upon her own image. In fact, she did not see herself. She focused only on her job. To be invisible, to be selfless, to be the silent recorder of all before her and to add no personal views in her writing made up the strict outline of duties provided to her by the university. This required state of detachment suited her well, allowing her to forget about that which so often haunted her. She happily lost herself in the task of turning this sojourn in the valley of the Nile into a worthy tale.

While words made up her officially sanctioned work, drawings served as private mementos and belonged to her alone. She believed them to be objective documents, aids in developing her story, but they revealed more than factual data. Completely unaware of their power over her, and others, and the past troubles they distilled and future triumphs they foretold, Lily simply followed her pen, pencil and chalk wherever they led.

"All hail the most sacred spot in Egypt, the land born of the river Nile," proclaimed Dr. Walburg, his arm outstretched, his hand sweeping across the panorama of land and water as if unveiling a theater set. As the newest writer for the university's magazine, Lily had been apprised of the professor's many habits, foremost among them his lecture pose. As a quick study, she ceased drawing and readied her hand to transcribe his florid oration.

"Founded by Pharaohs, rebuilt by Greek kings and adorned by Roman Caesars, this sacred ground wears its years lightly for this is the realm of the mother goddess, the font of all fertility, beloved of Osiris, the one and only Isis."

The words seared through Lily's heart. The atmosphere she found so peaceful moments before evaporated in an instant. Memories invaded her thoughts. Anxiety exiled tranquility. Regrets clouded her sight. Writing ceased as she resorted to the only comfort she knew, to sketch, to make things come to life on paper in the private realm of her notebook. It allowed her the appearance of focusing on professional duties while being the ideal excuse to avoid engaging with anyone.

The group of fifteen major donors did not retreat in the face of the doctor's soliloquy. Quite the opposite. They stood in worshipful wonder as their leader revealed the mysteries of the historic enclave. They had followed him to Gothic Cathedrals and Buddhist monasteries. Now, their latest pilgrimage called them to Egypt. The professor took their admiration for granted and occupied as a personal fiefdom the prestigious position as the Senior Professor of Art History funded by their donations to the university. With vigor and high purpose, the learned scholar directed his flock to follow him down the barge's gangplank and up the river bank to the awaiting shrine.

"Prepare yourselves, oh faithful ones, we are about to encounter a site with none of the awe-inspiring monumentality typical of Egyptian architecture. This collection of temples is not gargantuan like those at Karnak, Luxor and Abu Simbel, yet it is far more special. So intimate in scale, so delicate in its decoration. So appropriate to honor feminine virtues."

The donors formed a procession in single file behind the professor, who led them to pillars, posts and piles of stone rising above the greenery. As they moved ever closer, a temple forecourt revealed itself with a stately grace made manifest by two finely proportioned colonnades enveloping the visitors. These rows of noble columns framed two slanted towers, referred to as "pylons" by the professor, located at either side of a central gate which marked the entrance to the sanctuary. Lily kept at the back of the group, putting the

sketching pencil down and taking up a pen as she began writing the introduction of her essay.

Two thousand years of feet have trod on this very spot. Pharaohs and priests raised the temples to the glory of the gods and to themselves. Poets spread the sanctuary's fame in eloquent verse. Archaeologists marshalled science to resurrect its greatness. But let us honor the memory of the simple souls who came to venerate the goddess. Among them let us praise the woman hoping for a blessing of the baby in her womb, the farmer praying for the fertility of his fields. Impressed they may have been by the majesty of the architecture, for superb it is, yet it is the spirit of place that reigns here, rising from the earth and ascending to the sky.

To accompany her words, Lily turned again to drawing. After making the initial line of a pillar, her hand faltered. Her prose had unleashed a despair so deep, she could not move. Thoughts of the true meaning of the island left her desolate. The faithful from centuries ago, souls who Lily never knew, welled up in her head as she imagined those who came to beseech the gods for help. She could not accept as real the voices who called out to her, but the slow dull ache in her chest and stomach spoke a deeper truth. She felt the pain of all those who came before as it resonated through the soil of the sanctuary into her very being.

Lily closed the notebook in quiet resignation and set her sights on the two pylons soaring sixty feet high. Carved with sacred images rendered in precisely contoured forms and exacting detail, the towers demanded the homage of all who came before them. The clear hot sun enlivened each figure, crisply illuminating every gesture.

"Pharaoh smites his enemies on the western pylon," proclaimed the professor. "All in the presence of Isis, Osiris and their son, Horus. Here, mighty kings worshipped the almighty gods. The ancients called the sanctuary the 'Unapproachable,' believing its soil to be only worthy for the footprints of Pharaoh and priest. But

the power of the place is too great. For thousands of years, humans have come here in search of the divine. And here we are, today, doing the same, taking in its beauty, seeking answers to eternal questions."

The arrival of a photographer to immortalize every moment of the tour prompted the professor to move from words to actions as he postured with dramatic flourish once the camera focused on him. Such a convoluted stance made Lily laugh, which she quickly stifled to avoid giving offense. Observing Dr. Walburg's all too human foibles did have the beneficial effect of setting her mind and hand free. The notebook opened and the pen found its way to sketching again. Lily's demons could not resist the picture that came to her. With an impish glee, she drew the professor in the guise of a high priest shepherding a flock of hapless meandering sheep.

"Quite an original interpretation. Artists have a unique way of seeing the world, do they not?"

Lily glanced up from her pad to see a lady, of about seventy years old, wearing a white linen blouse complimented by luminous hair. A finely woven straw hat protected the delicate pink cheeked face from the sun and framed her just as the colonnade did the pylons and gate before them.

"We try," said Lily. "Although our perspective tends to color things even if we strive to be objective."

"Color away. Objectivity is admirable but it lacks spirit. And where are my manners? I am Issie. And you are?"

"I'm Lily," came the answer as she pressed the notebook to her chest to cover the drawings.

"No shame in sheep," said Issie with a wink. "And it's a good likeness of the almighty professor."

"Just a bit of fun," said Lily.

"That's what we all need, my dear. Especially someone as young

as you. Please don't be offended, but your dour expression struck me when we were getting off the barge. Good to know there is a comic mind behind that stern mask."

Lily lowered her notebook with a sigh of relief and a faint smile.

"I'm not all that young. The clock is ticking."

"No need to set the alarm, yet. We all move to the same timepiece. My advice is to relish every second, joyfully."

Issie waved to a gentleman and a lady, who with a spring in their steps bounded forward.

"Speaking of joy, this is my husband, Oscar. And our friend, Hattie."

The elderly trio exuded jolly, cherubic smiles with twinkles in every eye. Petite and trim, Issie fluttered about like a petal in the breeze. Tall and distinguished, Oscar stood motionless and as straight as could be. Stout and bosomy, Hattie easily embraced a fleshy vibrance, her feet resting solidly on the ground.

"May I make another observation on your drawings?" asked Issie.

"But of course," responded Lily as she placed her notepad so all could freely see.

"In your sketch of the columns, you left out the lotus shaped capitals so cherished by the Egyptians. Every day, the petals close with the setting sun and reopen with its rising so these water-born flowers became symbols of eternal rebirth. I'm a horticulturalist, so my eye went first to the lotus. We often see only the things we wish to see when they suit our own tastes and desires. And we can miss other things that are equally, or even more, valuable if they don't fit with our wants."

Lily quickly made notations accompanied by a pale gray outline of the delicate floral forms as the threesome crowded around her to watch the progress, so much so that they cast a shadow on her pad.

"Terribly sorry," said Oscar. "We bring darkness to your light. A thousand pardons."

"No worries," said Lily, with slight annoyance masked by a demure grin. "Thank you for your interest."

"Oh, my dear," said Oscar. "Anything to do with lotus calls to us. At home, they brighten our reflecting pond. My Issie dotes on them like grandchildren."

"Fuller, richer, lines, my girl," added Hattie. "You must capture the lushness of the flower."

"This is only a sketch for reference when I write my article. It's not meant to be a fully realized work of art."

"Never do anything by halves, my pet," said Hattie. "With something so lovely before you, giving it your full attention will bring you blessings tenfold."

Lily caught a glimpse of the professor straining his neck above the crowd. By the veins popping in his forehead, she knew he required her immediately. She drew one last petal and marked it as the 'The Lotus of Three Friends,' which sparked approving nods from her newfound admirers.

"Excuse me, duty calls," said Lily as the cover of her notebook closed over the flowers. She rushed off in the direction of the professor, whose steely eyes remained fixed upon her until she stood before him.

"Lily, I know this is your first trip, but you must keep up. Need I remind you that you are here to serve me at all times, capturing every one of my quotable quotes. Think of the gravity of the situation. Your story will be the main feature of the university's magazine. And it will be used to promote my forthcoming book and the exhibit opening at the museum next month. All of this needs to be infused with my thoughts, my vision, my voice. Now, stay close to me and act as a proper scribe."

"Yes, Dr. Walburg."

"You've been to enough of my lectures to know my style. It's why I asked specifically for you to do the article. I hope you appreciate it."

Lily cringed at the remark but said nothing. She needed the job and had been told of his so-called trinity of vanities: first and foremost, his vision of himself as a scholar of god-like abilities in the hermetically sealed world of academia; second, an infatuation with a gift for words spoken and written; last, but in no way the least, his love affair with his own form of conventional handsomeness.

"Pen to paper," said the professor as he wrapped her notebook with a heavy gold ring bearing his initials. Tilting his straw hat at a rakish angle, he raised one arm as a signal for his group to follow. They dutifully marched on through a gate into yet another courtyard lined with colonnades and dominated by a set of towering pylons featuring a host of kings, their hands raised in praise to a pageant of deities. Eyes closed, Dr. Walburg began to meditate as his flock stood in obedient silence. When he finally opened his eyes and spoke, he used a reverential tone rather than the bombast he had displayed at the main entrance.

"This is the court of Isis. Beyond these walls is the inner sanctum of the goddess, daughter of earth and sky, protector of children, friend of the downtrodden. Approach this gate adorned with the immortal sun disc and encounter the holiest of the holies."

Lily felt the hush of centuries among the carved figures of an ancient people watching her, presiding over the millennia as if they were mere seconds.

"Before we pay homage to Isis," declared the professor, "we must bow to the remains of the adjacent Birth House, known as the Mammisi. Its columns are topped by plants and flowers, symbols of nature's life-giving force supporting the head of Hathor, goddess of motherhood and protector of women. Before entering, we lower our heads in respect."

All followed suit except for Lily, consumed by her writing and drawing, until she caught the professor's condemning eye setting upon her. She quickly took the worshipful pose. The professor returned to his bow, then glanced at her one more time. She felt his stare but dared not look back at him. Even as he rose and led his entourage onward, Lily averted her gaze to avoid him. Relief came upon entering the inner chamber of the Birth House, where she became invisible in the deep shadows, only a thin sliver of light from the door penetrating the shrine. The space neither oppressed nor frightened her with its monumentality. Instead, she felt its weightiness sheltering and coddling each occupant.

"This is the noble house of Hathor," said the professor. "The cow-headed goddess watched over childbirth as midwife to humanity. Here, enriched by the carver's hand, the walls portray Isis carrying the newborn Horus before witnesses and protectors. Amun-Re, supreme among the gods, blesses the newborn's arrival. Wadjet and Nekhbet, in the guise of vultures, symbolize the realms of upper and lower Egypt honoring the young one. Ibis-headed Thoth fulfills his duties as scribe and the keeper of holy words by proclaiming the glory of Horus in poetry and prose."

Without asking for questions or commentary, the professor directed the group out of the Birth House while Lily remained behind to sketch, focusing on the depiction of Isis nursing Horus among the papyrus reeds of the Nile. She ran her fingers along the curvaceous outlines of the goddess's physique and wrote in the margins of her drawings.

I touch mother and child and the fierce symbols protecting them. The scarab, in the form of the humble beetle, and the jackal, who moved stealthily like a ghost upon the desert, guard this chamber of fertility. Woe to anyone who comes here to do harm to woman or infant. A curse on anyone who defiles the sanctity of birth.

Suddenly, Lily dropped her pen as she felt a pang in her stomach. Doubling over, she fell to the ground and writhed with a burning

sensation so great it rendered even a moan impossible. Curling into a fetal position, the piercing pain in her abdomen immobilized her until she passed out. There she lay alone in the darkness, her drawings scattered, her writing implements shattered.

Regaining consciousness, she saw Issie taking her pulse while Oscar and Hattie lay their hands upon her stomach.

"What happened?"

"No worries, Lily, you are fine. I have checked your vital signs."

"It came out of nowhere," declared Lily. "It happened so quickly and now it's gone."

"Maybe too much sun, I think, for someone on her first trip to Egypt," said Issie. "You must wear a hat from now on."

The three faces reassured Lily. The kindness in their eyes gave comfort, their touch somehow familiar even though they were strangers. Oscar helped her up and the two ladies took her arms as they escorted her out of the Birth House.

"Let's get you back to the barge," said Oscar.

"This is all so bizarre," said Lily. "But I do feel fine now."

"You've had a shock," said Issie. "How about taking refuge under a palm?"

"I need to find the group," said Lily. "I cannot miss a word the professor says."

"I advise a rest in the shade but if you wish to find the professor, so be it," said Issie.

The three companions led Lily to the inner temple where they passed through three chambers, each smaller than the other, resonating with the sounds of Dr. Walburg's practiced diction and dramatic inflections.

"Only the high priest and Pharaoh would have been admitted to this final room where Isis dwelt."

Lily and her three angels caught up with the group to find the professor casting a piercing stare upon all who listened.

"Upon this stone pedestal sat the vessel of the goddess. The journey to the afterlife began on a boat carrying the deceased on the river. One came from the water and departed by it, just as we, poor mortals, arrived here by the gift of the Nile. This is the message of this place, to be aware of all that is sublime, salutary and sacred."

Lily saw the image of a hissing snake at Dr. Walburg's every invocation of the letter "s." Taking the one intact pen out of the sleeve of her pad, she drew the professor with the head of a serpent and the group as helpless mice about to be devoured.

"Those are my thoughts for the day," said the professor. As he approached her, Lily covered the sketches with her hand. "I wish to see the draft of your article later to be sure you've done justice to me," he said in a hushed tone. Not waiting for a response, he walked out of the dim chamber.

Once in the sun-drenched courtyard, Dr. Walburg proclaimed, "good people, I leave you to go forth better informed than before. May further enlightenment find you among the sacred stones."

The group scattered, wandering about the environs of the sanctuary seeking out the gates and shrines erected by countless pharaohs and Roman emperors from Augustus to Diocletian. The layers of history and architecture were writ large across the island, yet, in its sunlit stillness, its flowers, shrubs and swirls of birds and bees seemed unconcerned with the passage of time and the course of human events. Some of the bedraggled pilgrims sought out the shade of trees. Laughter, gossip, bickering and the sound of occasional snoozing filled the air as they took a break from the professor's lofty speeches and heavenly visions. Weary from her stomach attack and deliberating on the direction of her story, Lily sat under a generous palm to rest, reorganize and review.

Dare I hope that this might be my finest work, she wondered to herself as she perused her sketches. *Yes, I do dare.*

"May I take refuge with beauty?" asked Oscar as he joined Lily and fanned both of them with his floppy cotton hat.

"I have a story for you. A best seller. It's about Issie."

Lily put her pen down, realizing the futility of any attempt at being productive.

"Issie is my Isis," said Oscar. "We met in the hospital. I had been attacked and left for dead, my body riddled with stab wounds. I was like the god Osiris torn apart by his brother, Set, and then put back together again by Isis. Issie did the same for me. She was my surgeon. Saved my life. When I came to, I asked her to marry me."

"We did go on a few dates before I accepted," declared Issie, who joined them under the palm.

Oscar put his arm around Issie's shoulder and kissed her on the cheek, the roseate tone of her skin evidence of a timeless crush on her husband.

"Our first date. Dinner in Issie's garden. Pure paradise. She made her own ointments, scents and soaps from lavender, rosemary, you name it. Every herb became a remedy in the hands of this healing angel. When I popped the question under her apple tree, she said yes."

"Oscar is a healing angel himself," said Issie as she poured water for everyone. "Although he would never tell you. After I put him back together, he put me back together. I had lost my only child and first husband within a year. Along came Oscar and then we had a son, Horace. Life began anew."

"That's when I came into the picture. Me, the midwife," said Hattie, who squeezed under the palm, now so overcrowded that Lily found herself mostly in the sun. "I delivered Horace. And we've been friends since then."

"Hattie is our Hathor," said Issie. "She heals with the slightest look and the simplest touch."

The group ceased their banter to take in the rare breeze that occasionally bothered to stir in the scorching heat. Issie and Oscar nodded off to sleep while Hattie ambled into the greenery. Lily remained with her notebook and studied the palm that swayed overhead.

Each green leaf is eternal. It is born, withers, then blooms again. It is reborn, reaffirming the eternal rhythm of life. Maybe I will do a series of these statements accompanied by my drawings. Only one problem, the professor demands his voice, not mine, in the story. He wants the textbook version of this place: dry, academic, lifeless. I prefer to be short on words, using only a few to capture the essence of this island, and let the images speak for themselves. Of course, he will prevail but nothing he does will bear fruit.

In the middle of her ruminations, Lily felt several slight knocks on her head. She found herself surrounded by dates and apricots as Hattie showered them down from the branch of a nearby tree.

"Partake of the bounty of the gods," said Hattie.

Awakened and aware of the treats before them, Oscar and Issie tucked into the little feast.

"Where did you find these delectable tidbits?" said Issie.

"I confess, not from the trees," said Hattie. "I had them with me the whole time, knowing we would need to be refreshed at some point."

"Bless you. Always the caregiver," said Issie as Hattie beamed and stuffed her mouth with figs, their juicy goodness running down her chin.

"What else were you up to as we slept?" said Oscar.

"I explored that building in the distance clinging to the edge of the river," said Hattie. "The guidebook states that it's known

as the 'Pharaoh's Bed' and served as a gateway to this side of the island. Some call it "Trajan's Kiosk" because the Roman emperor is depicted on the walls making his offerings. Others say it stored the sacred boat of Isis. I like to think of it lit up with torches by night with those floral columns flickering like stone flames. Drums and harps playing, chants being sung. And lines of white-clad priests carrying garlands of flowers as they made their way to the nearby temple of Hathor. Only a few columns remain but it doesn't matter. Hathor's spirit pervades this place. Now, that's where I would be. Feasting and partying in honor of the life-giving goddess. She is the patron of midwives, so she's my girl."

"I can easily see you as Hathor," said Lily.

"And I can easily see you as a mother," said Hattie. "Do you have children?"

"No, I don't," said Lily as her shoulders slumped and her hands went limp.

"I didn't mean to pry," said Hattie. "I'm very direct. Can't help myself."

"It's alright" said Lily, shutting her eyes and resting her head against the palm while feeling Hattie's eyes upon her

"I can't seem to keep a boyfriend or begat a baby," said Lily, covering her mouth with her pen, biting her lips in mortification that she had just revealed her deepest secret to strangers.

"No shame in that, my dear," said Hattie.

"I've never told anyone this. Maybe it's the heat or something about the three of you makes it very easy to confess."

"We've seen life, my dear," said Issie. "There is no shock or shame in our world."

"I've always wanted to be a mother," said Lily as she opened her eyes and looked out upon the sanctuary. "It haunts me always. And I have only so many years left. I have tried to become pregnant and

have failed again and again. Time is just not on my side. I have had to accept that fate refuses me what I want most of all."

With a wink and a grin, Oscar retorted, "fate is up for grabs. We never know what awaits us."

"True," said Lily in the weakest voice, exhausted by having to acknowledge what made her so sad.

"Motherhood is a mystery," said Hattie. "It visits you in its own time, on its own terms. Its magical, wonderful, painful, frightening. In the midst of giving birth, one forgets the magic and pleas for good midwifery and modern medicine. Once over, we look in amazement at the infant. We ask, did this really happen? Who is this tiny person? How is it that we feel we have always known him or her? But it is true. Life born and reborn. Every little baby is a Horus, without the falcon head, usually."

Hattie pointed to Lily's sketch pad with the head of Horus looming large in graphite pencil.

"A coincidence, I'm sure," said Hattie

"It's a rendering of one of the temple carvings, said Lily. "I want to build my story around Osiris, Isis, Hathor and Horus. And how one feels the power of this place as a thousand-year old center of birth and rebirth in every stone, tree and flower."

"And this is what causes you to obsess about your own hopes to bring forth a life?" asked Hattie.

"Yes," said Lily as she strained to hold back tears. "And, I confess, I think of it every day and with every man I meet. Silly, I know."

"Not silly, just human," responded Hattie

"Faith!" exclaimed Issie. "Have faith in the future and all will be well. But I won't lecture you. We've had enough of that from Dr. Walburg. It's getting late and we should return to the boat. Me thinks a nap is in order before the gala dinner tonight."

The threesome left while Lily stayed behind and savored having

the island to herself, except for the birds who flew overhead and nestled in the shrubbery. She laid back and remained motionless, doing nothing but taking in the scenery, watching the honey colored stone turn orange-pink in the late day sun, feeling the warm breezes against her skin. No tasks occupied her head or hands. She simply melted into her surroundings as minutes turned to hours.

"Excuse me, Miss. The island is closing."

A guard in dark khaki with a very official cap bent down next to Lily.

"Oh, sorry. I didn't know," she said as she wiped her eyes. "I've lost track of time."

"The sanctuary closes for three hours then it will open again for the illumination at 9 o'clock."

"Yes. Thank you," said Lily as she gathered her materials and left her protective palm. She ventured forth over the remnants of shrines until she saw the barge teeming with people beginning their cocktails on the deck under a flower strewn canopy. Knowing Dr. Walburg might have his scotch by now and would be expecting her to dance attendance on him, she hurried along in order to change clothes and be once again on duty.

Emerging from her cabin at twilight, Lily felt relieved by the coolness of the advancing evening. She saw fish darting about in the waters around the boat and ducks hovering among the papyrus on the river bank. All flora and fauna seemed content. Now, she had only to see what moods and humors occupied her fellow humans.

"Lily. A vision indeed. You look as if you have walked straight out of the past."

"And what past would that be, Issie?"

"Don't tease me, young lady. You are the modern vision of an ancient Egyptian maiden with that sleeveless white dress and gold jewelry."

"I see a royal trinity of stones in your bracelet," added Oscar. "Carnelian is the eye of Re, god of the sun, while the pieces of turquoise and lapis lazuli are associated with Hathor. And the protective eye of Horus in black obsidian is the ideal charm. You are in sinc with this setting. And I know what you are about to ask. How do I know such things? I am a mineralogist. Stones are my profession, their symbolism my personal hobby."

The university group took their places under the dinner tent, brilliantly set against the backdrop of the now illuminated temples. Lily sat with Issie, Oscar and Hattie. All applauded as the ship's staff paraded out a feast worthy of the Pharaohs. First came braised leeks followed by poached fish covered in roasted almonds. Duck seasoned with herbs comprised the main entrée along with cheese-stuffed dates and cakes dripping in honey. Music floated about the deck. Savory and sweet smells permeated the air. Everyone seemed in high spirits, including Dr. Walburg, now with three scotches to his credit. His eyes fixed upon Lily and sought out her table.

"Good evening all. Lily, you look especially enchanting tonight."

Unaccustomed to anything but curt commands from the professor, Lily cautiously nodded in thanks.

"I must make a statement with your three dinner companions as my witnesses. Impatience has dogged my every word with you. I have had the pressure of work on my mind. None of it was your fault but I took it out on you. Please accept a heartfelt apology."

Issie, Oscar and Hattie all raised their eyebrows at Lily, whose cheeks flushed a light shade of pink.

"Of course, Dr. Walburg."

"Oden, please. Call me by my first name, if you would?"

Although the request made Lily feel awkward, she agreed with a slight bow of her head. Oden smiled. She had never seen him express the slightest amount of joy or levity. With a few words and a

more modest countenance, he had become less pompous and much more personable. The apology did work a sort of magic upon her. As he took a seat next to her, everything about him seemed at ease. She found him increasingly appealing now that he ceased to lecture. He bantered with the threesome and glanced at her, brilliant flashes of blue filling his eyes as he laughed. She wondered silently to herself, *could this be my husband, the father of my baby? One never knows.* Then, she came to her senses and composed herself lest her inner thoughts be discovered. Oden winked at her. She suspected he had read her mind.

"A recitation, my dear flock, in honor of a lily," said Oden as he stood up and tapped his glass with a spoon. He spoke with his usual deep voice but in a softer, gentler manner than his daytime speechmaking.

"Come, my soul, swim to me.

The water is deep in my love

Which carries me to you.

We are in the middle of the stream,

I clasp the flowers to my breast

Which is naked and drips with water.

But the moon makes them bloom like the lotus.

I give you my flowers

Because they are beautiful,

And you are holding my hand

In the middle of the water."

Applause poured forth. Oden bowed to the crowd, plucked the lotus floating in a bowl of water in the center of the table and handed it to Lily, who hesitantly cupped it in her hands. He then took the flower and placed it behind her ear.

"The lines I spoke are from *Under the Protection of Hathor*. There are many more Egyptian poems of that genre, which I could sing all night, but the evening's illuminated tour is beginning. So, we are off."

Oden offered Lily his arm. With an increasing willingness, she gave him hers and they proceeded to the shore, followed closely by Oscar, Issie and Hattie. The island luxuriated in the glory of a full moon shedding its blessings on each tower and colonnade. Faces of the gods and goddesses gazed out over the scene, making Lily wonder if they were showering praise or blame upon them or taking no notice at all.

"Oden, do you think they cared about mere mortals? They seem remote as if they are here only to be worshiped, giving nothing in return."

"Sometimes remote, sometimes intimate," he said. "Gods are fickle. They personify people's hopes and fears. And they give their blessings to humans if it pleases them."

Oden wrapped Lily's arm within his and squeezed ever so tightly.

"In short, when a divine being shines his favors upon you, be grateful, for it rarely happens."

The stone figures reigned over their sanctuary as Lily and Oden walked among the ruins alone while the group from the boat began to disperse.

"Lily, I have a special treat for you and only you," said Oden. "Consider it a thank you for putting up with me. It's a secret place, which no one knows about except for me and a few guards."

Oden led her to a narrow slit of a door concealed behind a column. Winding their way through a series of chambers, stepping over broken architectural fragments and a heap of stone that once formed the sculpted torso of a king, they arrived at stone structure sitting in majesty beside the Nile, its posts framing a view of the moon across the water.

"This is Hadrian's gate," said Oden as he and Lily sat upon its steps. "He built it in honor of Isis when he toured his empire. Probably the most cultivated and learned of Roman emperors. I imagine him arriving here on a night like this with his lover Antinous, which makes me sad."

"Why so, Oden?"

"His lover drowned in the Nile. Some thought the beautiful young man fell into the waters, others thought it foul play. One thing is for sure. A true lost love is a tragedy."

As Lily watched the moonlight dance across the river, she suddenly felt Oden's tongue in her ear and his hand press against her thigh.

"Oden, no."

"It's fine, Lily. It's me."

She moved away gently. He leaned into her heavily.

"It's your time, Lily. Fate is shining on you."

Oden's hand slid down over her right nipple as he kissed the side of her neck. She shoved his head away so firmly that he tumbled over. Getting up, she brushed off her dress and straightened her bracelet and hair. He jumped to his feet and came back at her, folding his arms around her waist.

"Lily, we want each other. Admit it."

He kissed her. She reeled back. He kissed her again, shoving his tongue down her throat. She repelled him again. Grabbing her by the neck, he licked her ear, his saliva dripping down her lobe."

"Oden, stop!"

She writhed her way out of his hard embrace and ran down the steps to the river's edge. Oden raced after her.

"You know you want me. I see it. I smell it. Come on, look where we are. The most romantic place in the world and you go all prissy.

You'll never get that husband or baby this way."

Lily felt as if a knife had sliced her in half.

"Yes. I heard you under that palm, whining to those three old cows."

Lily began to walk away but Oden seized her. She shoved him with all her strength, causing him to trip back and stumble down the steps. Failing to get a grip on the stone made ever so smooth and slippery by the constant lapping of the waters, he continued to fall until he went directly into the Nile with a mighty splash.

"How goes that poem you spouted at dinner?" said Lily. "Come, my Soul, swim to me."

She marched back up the steps. At the very top, Lily turned around and glared down at Oden.

"Don't bother," she quipped. "Swim to anyone but me."

Oden sputtered and floundered in the river. Lily left Hadrian's gate, striding up the path towards the temple, where she found Hattie seated upon a stone fragment of Hathor's head.

"A fallen god," said Hattie with a chuckle. "Oden believed he had the powers of Thoth, Lord of Words, but at dinner he used that love poem without sincerity in his attempt to conquer a mere mortal of a woman, who paid him back with a dump in the river."

"Well," said Lily, "I was wrong about yet another man but I've come to my senses, this time."

Lily left Hattie and wandered the island on her own, letting her anger subside and allowing her sense of triumph to prevail. Shoving Oden in the Nile had emboldened her and made her feel reborn. Watching the ensemble of shrines against the bright light of a full moon, she now saw the island as hers. No longer did the professor's words reverberate among the ruins. No longer did it present itself as his pile of dead antiquarian rubble. Under night sky, it showed itself as the heart of a living, breathing blessed spot under the sparkle of

the stars. Approaching the temple of Isis, Lily's reverie ceased upon seeing a stark shadow against the wall.

"Excuse the disturbance but the sanctuary is closing."

Lily caught the shimmer of a badge in the darkness.

"You startled me. I thought you might be one of these gods come to life."

"No, Miss. No god, just a guard."

The man standing before her appeared every inch a soldier with a calm countenance as if nothing could unnerve him. Broad shoulders and strong legs filled a khaki uniform ill prepared to contain the muscular frame. Black wavy hair slicked back for duty and a strong silhouette from forehead to torso reminded her of every god and pharaoh cast in stone. His quiet form of masculinity grew ever more obvious. He did not steal the light or dominate the space. He simply commanded the spot upon which he stood.

"May I escort you to the dock? You are the last visitor here."

"Oh, my apologies. This place has a way of making me lose track of time again and again. So sorry to be an inconvenience."

"Not at all, Miss."

As they left the temple, Lily heard the lapping of water against shoreline.

"I haven't heard the water before," she said. "Now, it's so quiet, the sound of every ripple is clear. All so gentle yet you can sense the force."

"The currents are powerful, Miss. It's deceiving. We fished a man out of the river earlier tonight near Hadrian's gate."

"Oh, is he okay?"

"Yes. A little angry, but fine."

"My apologies for that. I'm the one who put him there."

"I know. I saw you."

"I confess, I enjoyed it," she said, gleefully twirling the protective eye of Horus hanging from her bracelet.

"He desecrated this holy place with his behavior," said the guard. "If anyone asks, I will say the gods used you to exact divine retribution. They protect this site. That is why it still stands. The professor does not grasp what is truly important. He is a lost soul."

As the electric lights slowly diminished, allowing the sanctuary to sleep, the guard escorted Lily to the waterfront, where the barges were beehives of activity.

"I wish I could stay here all evening," said Lily. "It's so peaceful."

"That's my job. I am the guard for night duty."

"Well, it's a magical time to be here. By the way, I'm Lily. Thanks again for the escort. Good night."

"I am Omar and you are most welcome."

Lily walked down the embankment but stopped half way. She turned back towards Omar, who had taken a seat on a large stone where he could stand sentry over both the waterfront and the temple.

"What did you mean when you said the professor is a lost soul?"

"He is a lonely man in love with only his own voice," said Omar. "I have heard his lectures in front of the temple. He relays all the memorized trivia he is about to publish in his book. But his vanity does not allow him to see the truth, to discover the truth of the place."

"And what would that be?"

"My father shared it with me as a boy. I had forgotten about it until I returned here, then it came rushing back."

"Did you grow up here?"

"Yes, I did. My father worked here as the superintendent so I

grew up in this sanctuary. When I left for a career in the army, it was so painful to be away from the island. I did my duty in the military but something felt wrong. The past called out to me so I resigned my commission and won a scholarship in archaeology at Oxford. My wife divorced me and married a fellow officer. She said I had nothing to offer her as a civilian. But time took its own course regardless of my plans. I had to give up Oxford when my parents became ill. That brought me back here, where I sit and watch the island. Time is my teacher now. As the days go by, I see something new in every stone and in the movement of every bird and flower."

Lily saw the sharp outline of the guard's profile repeated in the carved figures on every pylon and column. The stillness of his expression embodied the very essence of the sanctuary, so enduring in the face of eternity.

"I'm writing an article on the temples for a university magazine and I need to learn more than the professor's list of gods and goddesses. I'd like to hear your version of this place"

"With pleasure," said Omar. "The story here is simple. It is one of birth and rebirth, the entire cycle of life. The island is in eternal bloom, the cradle of all that is fertile, so legend states that the land was born here from the sacred waters of Nun. It is the womb of Egypt."

Leaving his rock, Omar escorted Lily to the temple, passing by its colonnades and coming upon the second pylon gate of the inner courtyard. Not a creature or breeze stirred. Only the temple's graven images held nightly court.

"Pharaoh offers Hathor and Horus a garland of flowers. The all-powerful king of earth puts nature's bounty at the feet of the rulers of the heavens. Lotus plucked from the Nile shoreline are the symbols of human life and rebirth."

He pointed out crosses carved into the gateway to the temple and the defacement of Isis, Osiris and Hathor.

"This sanctuary was the last site to offer pagan worship in the Nile Valley. The early Christians destroyed the images of the gods and converted it into a church. They did not obliterate the face of Horus, however, because he was the symbol of rebirth."

Omar brought Lily through a series of smaller gates, leaving the temple enclosure and arriving at the river. He plucked a lotus from the water. The petals were closed for the evening but they still radiated a soft white tinged with purple. He presented it to Lily.

"This is not the original home of the sanctuary. In 1902, the Low Aswan dam caused the island of Philae and these shrines to be submerged for several months out of the year. British architects and engineers reinforced the island but it did not help. When the government built the High Aswan Dam in the 1960s, Philae was about to be permanently under water so UNESCO led the effort to move all of the buildings to this island, which is called Agilika. They reshaped this spot to be in the same form as Philae. To this new home, workers transported each lotus carved column capital, every sacred image and wall carving, stone by stone. My father feared that the move offended the gods. My mother assured him that the deities would bless the saviors of the temples. All that matters is the sanctuary and its celebration of life. It remains intact and the domain of Isis is preserved."

"Isis, the eternal wife and mother." said Lily.

"Yes, that she is, with or without monuments in her honor. She is everywhere if one looks, but it does seem easier to find her here on this island."

"I found her through my sketches," said Lily. "I couldn't draw at first. Then, with the help of a few angels, I saw the lotus and my pencil finally came alive. The meaning of the island as life born and life renewed became clear. It took time, though."

"All things in good time," said Omar.

Offering Lily his arm, he guided her back to the wharf, bid her good evening and returned to his post. Lily stood on the deck of the barge watching Omar and the sanctuary behind him enveloped by the darkness of night.

THREE MONTHS LATER

Lily placed a lotus in a small vase on her desk. Besides this flower sat one of her sketches and a letter from the university's magazine editor, which read, "Dear Lily. I am so pleased to feature your drawings in the article on the sanctuary of Philae. The details you render in pencil enhance tenfold the words you have so poignantly written in pen. I see great things in your future!"

Additional drawings filled a portfolio, each image labeled by Lily in preparation for a gallery exhibition. Also arranged on the desk were thank you notes from admirers of her recently published work, invitations to lectures and receptions for emerging artists and the to-do-lists for the many tasks required by her burgeoning career.

Seated before this collection of papers, Lily opened her computer to check on messages from near and far.

"So, Fate came to call. It is your time. Much love, Hattie."

"It did indeed, in its own good time," Lily typed in response.

She checked the next message, which read, "this is the best news I have ever heard. I feel reborn."

"Yes, Omar," wrote Lily. "It is. We are going to have a son."

MYSTERY OF THE MAIDENS

"PEEL AWAY THE LAYERS AT YOUR PERIL."

Carefully raising her hand from the painting, Rosa looked up and beheld a man whose posture and gaze bespoke an innate confidence bordering on arrogance.

"Unmask the mystery of the maidens and one never knows what furies will be unleashed. They have been at rest for well over three hundred years. I doubt they wish to be disturbed. So, tread lightly, young lady."

Removing her plastic gloves, Rosa switched off the lamp on her work table and adjusted the mirror used to magnify the few inches of the canvas upon which she had labored for hours.

"Good afternoon, Dr. Obrega. At my peril, surely. I might never get out of Spain alive if I damage one of the finest paintings in the world. Right now, I am only examining the layers, not peeling them away."

Tall, elegantly tailored, well groomed, the gentleman before her posed as the perfect portrait of himself, a renowned authority on Spanish art and chief advisor to the Prado. Among all of the museum's treasures reigned the canvases of Diego Velasquez, whose

Las Meninas, or *The Maids of Honor*, held the highest place. It now lay in the deft hands of Rosa.

"My colleagues at the Louvre are jealous," said Dr. Obrega. "Those at the Vatican are intrigued and the poor souls at the Ashmolean are fussing. They would give anything to have this moment. We are the center of the world right now. All wait with baited breath at the outcome of your work."

Rosa had heard the rumors. Her colleagues buzzed about Dr. Obrega's penchant for creating suspense and excitement in order to promote his projects and, by association, himself. She, however, did not succumb to such antics. His fastidious scholarship impressed her; his purported wit and showmanship did not. A technician who prized empirical data and scientific process above all else, Rosa had no time for the innuendo and no patience for the intrigues she had to endure when laboring in the realm of high art.

"The royal family shivers at the thought of what might be discovered and journalists hope for a controversial story," said Dr. Obrega as he turned her work lamp on and moved the mirror in order to see his own reflection. "So, I am the one who is truly at peril." He then pointed the mirror at Rosa. "Your discoveries will either shed light on my theories and ensure my triumph or plunge me into the dark recesses of infamy."

As he clicked the light off, he leaned down and whispered in her ear, "my reputation is in the hands of an American conservator, of all things. Your science born of hard facts. My theories, nursed on study and nurtured by good faith. Will they support one another, or will they be at war? Which will prevail? I wonder."

With a blank expression, Rosa conveyed no interest in his musings. Instead, she methodically organized the objects of her profession. Every pencil, pad and assorted conservation gadget had its exact place in her well-ordered universe. She glanced at Dr. Obrega with a silent defiance as she loudly clamped down on the

latch of the box containing the investigative instruments that were the tools of her trade.

"These hands once held a Madonna by the divine Raphael, so I think you are safe."

"You are your father's daughter," retorted Dr. Obrega. "I worked with him at Harvard. No greater art conservator ever lived. Now that he is gone, it is up to us to carry on."

With a courtly bow, Dr. Obrega offered his arm.

"Shall we be on our way? The press awaits."

Gods, kings, saints and virgins immortalized by the great masters from Titian and El Greco to Goya loomed over the two souls as they made their way through the Prado's galleries. Rosa never passed by this lofty array of images without casting a critical eye, observing them with clinical skill, deducing the kinds of pigment used in the paints and assessing how time, climate and human contact had affected the canvases. Her focus on art conservation ceased upon reaching the Great Hall, where members of the press waited for the revelation of a big story.

Letting her arm go, Dr. Obrega banished Rosa to the background while he commanded the foreground. His stance became arrow straight, his chest pumped up and his shoulders went back with the regal haughtiness of an opera star striking a pose to tease an audience before rendering an aria.

"Ladies and gentlemen, the elusive maidens are at the forefront of art again. Today, I present to you the acclaimed paintings conservator hailing from America. Genius is in her blood since we all know the towering figure of her father, sadly gone to his heavenly reward but giving us this angel to carry on his mission. Trained at the Getty, her expert fingers have caressed too many masterpieces to be recounted. Her youth and beauty might lead one to think she is a novice but, I assure you, our maidens are in good hands with this maid. She is heaven sent."

Rosa bore such hyperbole with a pained restraint. She thought of herself simply as a craftsperson with a respect for materials. After so much publicity around her recent projects, she had affected a look of polite distance so no one might guess what she really thought. The press generally believed her to be modest. Some viewed it as disdain. She did not care. Dr. Obrega could relish the limelight with his speech-making while her only wish was to be alone with her paintings.

"With recent technological advances, it is advisable to once again examine the much-loved *Las Meninas* by our national hero, Diego Velasquez."

Waiting as reporters wrote down his every word, Dr. Obrega began again once iPads ceased to record.

"This most enigmatic of paintings still holds many secrets that scholars, curators and conservators have sought to discover. They have all failed. We will succeed."

Dr. Obrega's voice commanded the center of the Great Hall as he held a form of royal court in his palace of the arts while cameras flashed to immortalize this moment of declared intention. When a reporter with a hunched back, hollowed out cheeks and a nervous twitch in his eye stepped to the front of the crowd, the doctor gestured to him.

"You may ask the first question."

The little man's hand shook violently as he grasped onto his frayed journal. His fingers rustled through several wrinkled pages until he stopped at one point and raised the notes to the tip of his nose. Out of his pocket came a red pencil, which summarily dropped to the floor, its tip breaking as it hit upon marble paving stone. Chuckles came from the assemble crowd while Dr. Obrega raised his hand.

"I see you are like a scribe of old using the time-honored practice of writing in your own hand rather than the useless devices of your comrades. Well done, thus far. Now, speak, oh chosen one."

The little man bowed slightly to the doctor and put his journal and broken pencil away. His back straightened. His eyes sharpened.

"Dr. Obrega, in 1981 John Brealey restored *Las Meninas*. We understand an uproar occurred when he dared to touch the revered picture. Are you tempting fate by doing so again?"

Tightening his stance, Dr. Obrega remained bodily still and verbally silent as the crowd snickered.

"Or do you see yourself as the master of fate with art as your handmaiden?"

With a cold glare filling his eyes, Dr. Obrega said, "I tempt no one. Not the fates, not the gods."

He made a fierce side glance to the other reporters and another towards Rosa, then closed his eyes. Upon opening them, he smiled a forced smile created by the biting of his lip. His mouth then relaxed and his expression softened.

"I merely seek the truth, with all humility."

The crowd began to laugh heartily. Rosa's slight grin betrayed her pleasure at the grand man being outmaneuvered by one he mistakenly deemed harmless. She received the doctor's stare, now shot in her direction, as an implicit order to behave and support him.

"I beseech you all to listen carefully," said Dr. Obrega, shoulders now downcast and his hand on his heart. "Brealy conducted a restoration deemed impeccable. The public initially expressed concern at anyone disturbing the canvas. At first, the brighter colors and hues shocked viewers, but now we enjoy these as central to the brilliance of the painting. As I said in my introduction, new technologies have been developed. It is certain that Velasquez reworked *Las Meninas* so further investigation is necessary to shed light on his technique and aesthetic. It has been over thirty-five years since the last restoration. High time for another look. Fate will reward us for doing so. I assure you."

Accepting no further questions, Dr. Obrega took Rosa's arm and escorted her out of the Great Hall. His meticulously dressed figure towered above the tourists as he marched on with shoulders back and head held high. Rosa found his mannerisms overly practiced as if he had made an art out of cultivating an otherworldly image, the all-knowing who dwelt in some ivory tower musing on Old Master paintings until coming down to earth to receive homage from mere mortals, whom he treated with disdain. Yet, she admired much about him. The force of his personality had created this project she so dearly loved. He had a soaring intellectual curiosity and, what she found most compelling, an unbridled passion for art, even if it led him to heights of hubris.

"An abrupt end to the press conference," said Dr. Obrega. "But that little gnome of a reporter was the devil in disguise. He and the rest of his type would only fish for more information to distort in their inflammatory articles. That is what they are really seeking and I am not disposed to give it to them. I will simply tease them with the mystery that is *Las Meninas* until we are ready to reveal all. Excitement is brewing. I've achieved my aims, for today at least."

"But are we tempting fate?" asked Rosa. "That reporter may have a point."

Putting his arm around her shoulder, Dr. Obrega said, "leave fate to me. Your job is to secure our good fortune."

Rosa furrowed her brow at both his touch and his tone, then became happily distracted when she glimpsed, over the doctor's shoulder, the soft glow of Fra Angelico's *Annunciation* altarpiece. Leaving the doctor's embrace for the comfort of the painting, she took out her magnifying glasses and inspected the bright blue robe worn by the Virgin Mary, noting the degradation of the painting's pigment.

"You've no time to delve into the enigma of the Virgin's cloak. The mystery of *Las Meninas* is your calling."

"Dr. Obrega, with all due respect, I don't believe in enigmas or hidden meanings. Mystery is always put to rest by the discovery of empirical data."

"True, Rosa, but such clinical words do not make for good sound bites. The mystery of the maidens is what draws people in. Art is more than its materials. This *Annunciation* you admire transcends mere paint. Those who are moved by it respond to more than color and composition. They are struck by a spirit as the angel Gabriel tells the Virgin Mary she is to be the mother of God."

Rosa shrugged her shoulders as if to say "whatever," but she began to wonder how a spirit might be identified through hard facts. It posed an appealing challenge. No immediate answers came to her, only the feeling of being pulled even further into a mystery. For the present, she put aside the impulse for investigation and focused on returning to her apartment for a break from the oppressive atmosphere of art experts and the press. Such freedom beckoned to her the moment Dr. Obrega said his goodbyes and proceeded alone down the shimmering marble corridor to the inner sanctum of his office behind a bronze door guarded by two Medieval knights rendered in stone.

Rosa made her exodus from the museum via the crushing grandeur of a colonnaded temple front reigning over the tree-lined majesty of the Paseo del Prado. She crossed the vastness of the sun-drenched boulevard lined with monuments to imperial times past and entered the densely built up neighborhood of Las Letras. Her demeanor immediately changed within this district of crooked streets and back alleys. The formal bearing of the eminent conservator, presented in the cold authority of the museum and among its grandees, gave way to the unassuming young woman who enjoyed people and places without pretense.

Meandering along the Calle Lope de Vega, she bowed her head to the plaque honoring the burying place of her favorite author, Miguel de Cervantes, at the Convent of the Barefoot Trinitarians.

Making this ritual act every time she encountered her hero's plaque, her heart sank under the weight of his imagined sufferings. Las Letras did not allow much time for sad musings, however, since the district gave Rosa a riot of things to entice every one of her senses among neon-lit boutiques, bars and specialty food stores nestled among churches and devotional chapels. It all struck her as a constant dance between the sober and cheerful, the intense and easy going, the sacred and the sensual. Each of these contrasting moods played off the other in this liveliest of neighborhoods, which distilled in its faded brick and crumbling stucco the moodiness of Madrid. After only a week in the city, she had already become known in Las Letras with shoppers and shopkeepers alike giving her cheerful calls and flirtatious grins on her daily wanderings.

With a wave and a smile to her newfound friends, Rosa turned on to the Calle de Leon and approached a house faced in orange, blue and green colored tile. It made an ideal setting, at reasonable cost, for those in search of a supposedly authentic Madrid experience. With no elevator, the stone stairs sufficed for her daily aerobics workout as she climbed to the fourth-floor apartment. Upon arrival, she pushed open the creaking cast iron door and threw herself on a white sofa in the middle of a stark white sitting room.

"Oh, these cushions feel like heaven after a day in those stone vaults."

A girl came out of the kitchen with a precarious hold on three glasses of red wine.

"How was the press conference?"

"Ohhh, Poppy," sighed Rosa as she sunk further into the sofa. "A chore. That sums it up."

"More to the point, has Dr. Obrega seduced you yet?" asked another girl who appeared with bowls of green olives and almonds.

"Now, Primrose," said Rosa "He has no interest in me whatsoever."

"Don't be so sure," countered Primrose. "I think he'll be interested in all three of us."

"It's only week one of our fellowships," said Poppy. "Give him time. We will be on the project for one year."

Throwing a cushion at Poppy, Rosa exclaimed, "you are up to no good. You stick to Baroque art and Primrose can focus on Spanish literature. I will mind my business with paint conservation. My only romance in Madrid is going to be with Velasquez."

"I think he has a thing for you," retorted Poppy as she threw the cushion back. "Primrose and I are merely the supporting cast. You hold the keys to the mystery."

Rolling her eyes in disbelief and waving her hand in dismissal, Rosa focused on sucking the juice of an olive.

"Our first Fellows seminar with Dr. Obrega is tomorrow," said Poppy. "But you've already had the privilege of meeting with him while we've had to wait and wonder."

Rosa spit the olive pit into a small dish and curled her right eyebrow upwards.

"Let's take stock," said Poppy. "I'm a red head, Primrose is a blonde and you have jet black hair. Wise man. He made sure to select a variety of flowers for his garden this year. And we're all Americans. I hear he usually mixes it up a bit more. A Brit here, an Italian there."

Rosa blew her a kiss and sunk ever more deeply into the sofa for a nap. Primrose shrugged her shoulders and began to leaf through a manuscript while Poppy scanned her phone for possible tapas bars in the neighborhood.

"We little blooms are ripe for the picking," said Poppy. "Consider the facts. First, Rosa is single but presents herself as all business and totally impenetrable. A challenge but also an ultimate trophy just waiting to be scooped up. The daughter of an art world legend

venerated by Dr. Obrega. By winning you, the crown princess of conservation, he would bask in glory by association. Second, my boyfriend dumped me just as I got on the plane for Spain so I'm ready and willing. And, third, Primrose has been swooning over the doctor's photo since she first saw it. Hero worship at its most extreme."

"I know," sighed Primrose. "I over-romanticize everything."

Poppy groaned, followed by a generous grin.

"Such is the theater of life," said Primrose. "If I may quote my true boyfriend, Lope de Vega."

From her place deeply burrowed into the sofa pillow, Rosa replied, "you're dating a dead playwright from the 17th century. So, you've fallen in love with the subject of your dissertation on the Golden Age of Spain."

"Too true," said Primrose, "but that's how far I have to go back to find a solid dude. Lope is the man."

"That's pretty futile," said Rosa, "but I'm sure you'll find a living look-a-like in the form of some waiter in the neighborhood."

Poppy went to the balcony to investigate the noise coming from below where young men were congregating outside a local bar. She picked a few petals from the flowerboxes and showered them on the gang, who responded with cat-calls and whistles. After gaining their attention, she returned to the room leaving her admirers yelling for more.

"If Lope de Vega were here, he'd say life is a theater and we all play a role," quipped Poppy. "I'm a bit of a cynic, just like him. Primrose is an idealist and you, Rosa, are a pragmatist. Emotion doesn't seem to color your perspective. Dr. Obrega may not know these things about us yet, but he definitely senses it. That's why he has assembled us as a team to solve the mystery. Primrose offers up the cultural and literary flowering of Spain at the time of Velasquez,

I decipher his place in the history of art and you play the detective."

Rosa sat up on the sofa, straightening her blouse and gathering her hair into a neat bun. She put on her reading glasses and took up one of her many conservation reports, scanning the notes in the margins.

"Call me Nancy Drew. I want to investigate the facts behind the illusion, all those little techniques and details that make the magic. Then, I prevent the decay. My only purpose is to save the art work."

"A Saviour!" exclaimed Primrose.

"A lofty calling," added Poppy. "Like Don Quixote, the supposed fool who embarks on a knightly quest to do good, at least in his mind if not in reality. Hmmm. Food for thought, Rosa. Your good intentions might not always pair well with the detached reason you rate so highly. Idealism and pragmatism don't get along well. The two can often be in conflict, but they make for a great story."

Primrose held up a weighty book, caressing its cover in hand tooled leather decorated with faded gold.

"Cervantes knew it when he conjured up the ideal hero. A man of noble aspirations even in the face of a cynical world."

Grasping the book out of Primrose's hand, Poppy opened the volume to an engraved portrait of Don Quixote and handed it to Rosa.

"Now, that's your perfect boyfriend. It's a bit of an irony that you, the pragmatist, should be so enamored of an idealistic hero crafted by a cynical writer. So many conflicts there."

"Maybe I am an enigma," said Rosa. "Keeps you guessing."

"Or you are a repressed romantic," said Poppy as she gulped her remaining wine and left the room with Primrose following after in an excited flutter.

Only a few minutes later, both girls returned dressed for their

night out on the town. Poppy wore bright red shorts and a sleeveless black t-shirt that framed her generous assets, a tenuous balance of edgy and chic. The tight clothes tempted, yet revealed nothing. No jewelry or makeup interfered with the flawless pink skin and the luscious red hair pulled back into a loose chignon. Primrose's golden locks flowed freely over her little white cotton mini-dress, a gentle combination of the sensual and the sweet.

"Velazquez would have loved this," remarked Rosa. "You would be his twenty-first century meninas, all fresh faced and prettified. Except you lack one essential thing."

"I'll dare to ask," quipped Poppy.

"Mystery."

"Oh, you!" exclaimed Primrose. "Are we that obvious?"

"Most decidedly," said Rosa. "A lesson in subtlety might be beneficial, especially when dealing with men in Madrid."

The girls appeared not to listen as they left the apartment, the creaky door slamming behind them. Poppy then popped her head back in the room.

"I have learned one thing you should know."

"And that would be?" asked Rosa.

"A forensics specialist is being brought in to work with you. I heard it from Dr. Obrega's secretary today. Enter the villain. The plot thickens in our little play. Bye!"

Poppy shot out the door leaving Rosa mystified. Never had anyone ever interfered with her work. She didn't like the sound of it. Tightly holding the sofa pillow, she mulled over this new tidbit in a mind now beginning to swirl with inner chatter.

What can a forensics person discover that I won't find out myself? Why didn't Dr. Obrega tell me? Hmmm. Very odd. Now I'll never sleep tonight.

"Uh, oh. Where am I?"

Rosa covered her face to shield out the morning sun. She awakened confused and in disarray on the sofa. Laying among the pile of cushions, she recounted faint memories of a dream where a painting loomed before her. It was *Las Meninas* with a little princess staring out directly at her as if pleading for help. Sinister figures hovered about in a dimly lit background. Rosa saw herself standing in the cold museum, a man in shadows receding, a man bathed in light coming towards her. None of it made sense and she had no time to dwell on such things. The clock struck eight thirty, shocking her into the reality that the Fellows seminar would begin in thirty minutes. She began stumbling about, searching for clean clothes and banging on the bedroom walls.

"Poppy! Primrose! Get up! We overslept. And on this of all days!"

Grabbing at a crumpled blouse, she fell over her shoes and smashed down face-first on the floor.

"Oh, Good Lord," she shrieked. "We win the most prestigious appointments at the Prado and this is what we do? I'm late and you are both hungover."

Rosa pulled herself up, found a skirt draped over two empty wine bottles, tied her hair back and tore down the stairs. As the lead Fellow on the Velasquez Project, and ten years older than Poppy and Primrose, she felt she had to appear as the competent adult even if it meant running at breakneck speed in the blazing heat of August to get to the meeting on time. She arrived at the museum with ten minutes to spare and retreated into the bathroom to compose herself.

"Today. It has to be today that I meet the forensics specialist when I am totally discombobulated. Ugh. Okay. Calm down. I know what I'm doing. Remember that."

Drenched in sweat from her mad dash, Rosa took off her blouse and wrung it out under the hand-dryer to the bewilderment of two nearby ladies assiduously reapplying their lipstick. They helped her back into the blouse and insisted on redoing her pony tail. She thanked her two voluntary maids with grateful hugs. Assuming a cool expression to play the role of a professional, she strode out the bathroom door. Enroute to Dr. Obrega's office, she encountered a relentless number of slain warriors and Christian martyrs on the walls.

They are trying to tell me something, she said to herself. *Bad omens, I know it. Oh Lord, Yaweh, Zeus, Mercury, Venus, Jesus, Mary Magdalene, or whoever, please get me through this.*

Upon entering the meeting, Rosa saw Poppy and Primrose seated alone at a table. Nattily dressed, iPads and notebooks precisely laid out, they were the picture of immaculate order.

"How did you two pull this off? I got here only a few minutes ago, exhausted and a total mess."

"Uber," said Poppy. "It was no day to run."

Rosa had no time to be chagrined. Dr. Obrega threw open his office door and marched ahead. Behind him followed a man exuding a self-assurance that superseded any kind of authority. Dark features and a chiseled chin drew the girls' attention first. His broad shoulders and trim waist, evident under his fitted brown jacket, made up the next attraction. The devilish twinkle in his eyes provided the final touch. Poppy and Primrose made no attempt to hide their swooning as they fell into the primal behaviors of flipping hair and moistening lips. Just by the sparkle in his eyes, Rosa thought him far too enamored of his own handsomeness.

"Signor Colon, I present to you the Velasquez Fellows," said Dr. Obrega.

"Alvaro, please," he responded while offering a hand to each of the girls. "Everyone calls me Alvaro."

Poppy and Primrose each raised their delicate hands, draping

them faintly downwards as if waiting for a kiss, while Rosa held hers firmly forward.

"You must be the conservator with a steady hand like this," said Alvaro.

Rosa gave his hand one shake and then withdrew without saying a word. One knock of Dr. Obrega's gavel on the table ended the welcomes and began the meeting.

"It reigns supreme," declared the doctor as he unveiled *Las Meninas*. "The great work of art up close, removed from its honored place in the galleries so we may study and ponder its mysteries."

High resolution color prints, scans with enhanced details and every sort of state-of-the-art scientific microscopy image accompanied the painting in order to serve the assembled company's review and debate.

"We must approach *Las Meninas* from every perspective, covering the historical, cultural and literary and combining these with the technical and scientific. Each will inform the other. In no other way can the mystery be solved. This is more than a painting. It is an icon. Velasquez has his little maids floating between reality and illusion. It is the most elusive work of art in the western European tradition. But we will finally capture it. We will decode the enigma."

Dr. Obrega nodded to Rosa, Poppy and Primrose. Required to prepare opening remarks on their area of inquiry, the three Fellows had to use this first seminar as proof of their worthiness to participate in such a lauded project.

"Before I ask each of you for commentary," said Dr. Obrega, "let me begin by revealing the essence of *Las Meninas*."

He held his hands as if in prayer and bowed to the work of art.

"A master of composition, Velasquez shows the world how to organize a picture. We come upon a scene in the royal palace, in the

studio of the artist, where he stands on the left side of the painting before a large canvas. Members of the court are assembled around the central figure of the little princess, Margarita Theresa, only five years old. She is attended by her two maids of honor. Dona Maria Augustines Sarmiento de Sotomayer is to her left, kneeling and offering her a drink from a red cup on a golden tray. To her right is Dona Isabel de Velasco, making a curtsey. Also, to the right is a dog, a Mastiff to be exact, still sleepy from its nap, along with two dwarves, the princess's chaperone and a bodyguard. The figures are life-size and they twist and turn, caught in the action of a moment like a photographic snapshot. The little princess gazes directly at us. Why? What is she telling us? I do not know."

Taking out his golden tipped pointer, Dr. Obrega mapped out the organization of the canvas, marking out how one should view the whole scene.

"Softly shaped figures occupy the foreground while the background is rigidly arranged with depictions of paintings on the far wall. But where is the vanishing point? Where does the painter lead our eye? Is it the mirror at the very center of the back wall, showing reflections of the King and Queen? Or is it the open door on the right where the royal chamberlain leads us into a distance space? How he taunts us. Where is he bringing us? We do not know, yet. But, the answer to the mystery is in the composition."

Alvaro brushed by Poppy and Primrose on the way to the front of the conference table. Both girls fluttered their eyelashes in rapture. He lowered the window shades to darken the room and flashed a light back and forth across the canvas, illuminating faces and details.

"Reflection. That is where I believe the answer lurks. Reflections of light in a mirror, reflections of the truth in someone's eye. See the way light softly shines on the princess, bathing her golden hair and white dress. The remainder of the room is in brown and black tones. Velasquez is using his figures to act as the subjects of light as it falls

on a face here, a piece of cloth there. He places the King and Queen in the hazy atmosphere in that central mirror. Imagine crowned heads in 17th century Spain not in the foreground and awash in the full blaze of divine light? Such rule breaking. Revolutionary. The secret is in reflections, holding out answers if we care to see them. Most definitely. So seductive. The reflections draw you in. They own you. There is no way out. And why would you want to get out?"

Alvaro raised the shades and glanced at each fellow. Rosa kept a purposeful distance while duly noting the wide-eyed fascination of Primrose and Poppy. With a nod of his head, Dr. Obrega signaled to each of the Fellows to speak.

"I am bewitched," said Primrose. "If my task is to decipher *Las Meninas* as a window onto Spanish culture during its Golden Age, then I see a haunting message. It all centers on Margarita Theresa, the girl in white, who is everything a princess should be. Pretty, pampered, pure, a prize for some worthy prince. But something is not right."

Taking out her laser pointer, she traced the outline of the princess's golden hair, the delicate features of the face and every red bow on the dress. Primrose's own blonde locks and white lace blouse affixed with a red bow mimicked those of the little princess. Rosa saw it a trite play to gain attention, finding Primrose's tendency towards over-identification with the subject of her research to be a flaw, one born of romantic sentiment that clouded reason. Once finished posing before the portrait, Primrose marked out how every sight line converged on the tiny royal figure.

"Princess Margarita calls for help. She carries the weight of past glory, present splendor and future destruction in those probing eyes. They are all-seeing. At the time of the painting, in the year 1656, she was the King and Queen's only surviving child, who they referred to as their 'angel,' the object of all of their affection but also a pawn in the game of dynastic marriage alliances."

Stepping away from the painting, Primrose leaned against the wall and placed her hand on her hip, accentuating the voluptuous silhouette of her figure at its very best.

"What a poignant image of the royal family at the zenith of its power but also aware of impending doom. For all was not well with the Spanish kingdom. Its glory days were long past. I wonder if the princess somehow knew that at age fifteen she would marry her uncle Leopold, the Holy Roman Emperor, bear him four children and die at twenty-one. This painting, through the innocent gaze of that young girl, tells us to beware."

Tapping her lips with the laser pointer, she gazed at Alvaro. He winked, which made her cheeks flush pink and Poppy's jaw tightly clench.

"Such artistic and psychological theories are fine, but far too vague and leave us wanting," declared Poppy. "It is the sheer technical brilliance that bewilders. In art historical terms, it has been hailed as the 'theology of painting,' a revelation of everything from composition to color and light. To look at it is to experience an epiphany. Velasquez places himself prominently in the picture. He is the largest human presence in the room and on intimate terms with his patron, the King of Spain. Maybe he is actually painting the royal couple who are standing before him and reflected in the mirror? Or has the royal couple walked in on their favored artist holding court in his studio?"

Poppy took out an 8 x 10 frame and held it up to the painting, moving it along the canvas to focus attention on the artist's self-representation. She allowed her skirt to rise high up on her thighs while pointing out her chosen detail of the painter's face.

"The answer lies with Velasquez himself. He is the key, standing tall, announcing that he is THE artist. He only allows his little princess and the dwarf, Maribarola, to look at us directly. Everyone else curtseys, serves and fades into the background while Velasquez

is the master. Here we see the person who rose from humble birth to become the King's favored court painter, curator of the royal collection and, finally, a member of the honorable Order of Santiago, usually reserved only for those of noble blood."

Turning her back on the painting, Poppy leveled the frame squarely at Alvaro.

"The answer here is the man. What motivations fuel the hearts of men? Desire? Ambition? Lust? I don't know yet. But I'll find out. Such things are my specialty."

Putting the frame down on the table, she lowered herself just enough to reveal a small amount of cleavage in Alvaro's direction.

"Velasquez is the all-powerful artist providing a lesson to the world. Consider all those who have been inspired by the little maidens. Francisco Goya, John Singer Sargent, and, especially, Picasso in *Fifty-Eight Interpretations of Las Meninas*. Then there is Eve Sussman's 2004 video re-enactment in *89 Minutes at the Alcazar*. Once an artist encounters the painting, he or she embarks on a life-long obsession."

"I am bemused," stated Rosa. "I find everything said thus far to be interesting and enriching, but it's too vague. I cannot indulge in conjecture until I have done a thorough physical examination of the canvas. I don't live in the realm of theory. Facts are my foundation."

Poppy and Primrose glowered at her. Rosa did not care. She found their presentations a cheap premise for flirtation and fumed at the thought of accomplished scholars turning into vapid girls at the sight of a man too obviously aware of his own charms.

"Bemused," said Alvaro. "You use that specific term to express your present condition. It means confused, or 'possessed by the Muses,' those seductive Greek goddesses who whispered into men's ears, inspiring them to create art and learning in all its forms. Not a very scientific basis for things."

He leaned back into his chair with apparent nonchalance. Rosa strained to be unaffected by him. Yet, their eyes betrayed them. Alvaro grinned, unleashing the power of his dimples while his eyes twinkled. Rosa remained stoic, not a facial muscle in motion, but her eyes became larger and darker. Regardless of expression, they remained fixed upon one another.

"The painting does move between reality and illusion," declared Rosa. "The observations made thus far by all of you are very sound. The role of Velasquez, his triumph over strict court etiquette and the impeding doom of Spanish power all play their role in the work as does the brilliant use of composition, light, color and form. It's a real room with real people at a real time in history. It is also a mystery of meanings. I see both."

Alvaro held up a piece of paper, showing his notes on the theories proposed by each member of the group and his sketches of the painting. He ran his pencil along the margin, pointing out quick scribbles of the various solutions to the mystery before them.

"The three Graces before me have presented their views. Poppy is bewitched, Primrose bewildered and, Rosa, last but by far not least, is bemused, while I remain bothered since none of you has provided a path to what I seek."

Rosa stood up, very self-consciously straightened her blouse and made her way to the painting with a small magnifying glass. She waved it slowly across the canvas, focusing on the features of the figures and the details of their clothing. She then held the magnifying glass to her own eye and examined the assembled group.

"Life is a mystery. Life is a dream."

She looked directly at Poppy.

"What is life? A frenzy."

Winking at Primrose, she said, "What is life? An illusion. A shadow, a fiction."

Rosa approached Alvaro, took his piece of paper, crumpled it and deposited it in his hand.

"And the greatest good is small; for all of life is a dream and dreams, are only dreams."

She placed the magnifying glass in her skirt pocket. Dr. Obrega looked quizzical. Poppy scowled and said in a low voice, "you're invading my territory. Literature and poetry are my expertise."

"All things are my territory when I search for answers," said Rosa as she left the room. Alvaro jumped up and pursued her down the hall. He caught up with her in front of a sculpture of a female, triumphantly clad in a helmet and breastplate, wielding a sword.

"Rosa, wait."

Before she could speak, Alvaro said, "how appropriate. We are standing in front of Athena, Greek goddess of wisdom and war. Your personal deity, maybe?"

Rosa was about to walk on until Alvaro raised his hands in surrender.

"Please, wait. I will make no more sarcastic comments about deities and muses, I promise."

"Don't bother making promises. Your comments are of no interest to me," said Rosa.

"Right you are," said Alvaro. "But your comments do interest me. What was that all about back in Dr. Obrega's office?"

The quick turn of her head and the stiffening of her neck signaled that she was poised for battle. Then, she immediately softened her stance and sweetly smiled.

"Life is a Dream. It's a poem by Lope de Vega, written in the early 17th century at a critical time in Spain's power and prestige. It captures the spirit of the age. Who knows? That work of fiction might lead to the facts that unlock this so-called mystery you are

all so taken with."

With this last word, Rosa walked away abruptly and strode down the gallery hung with the very Raphaels and Rubens acquired by Velasquez himself for the royal family. She suddenly stopped and proclaimed, "maybe a Muse told me a secret. They whisper in women's ears too, you know."

"Bravo," said Alvaro, clapping slowly and firmly. "I see you can play the game when it's called for."

Raising her right eyebrow, she walked on, her heels making a decided noise on the stone floor with each determined step. Alvaro watched her lone figure, so petite in frame yet powerful in motion, as she moved among the remnants of the past.

"I've no doubt they speak to you, Rosa," he remarked with his signature grin. "I will see you later, in the lab."

Three hours after leaving Alvaro, Rosa heard a knock on the door. Wrapped in brown cloth rather than regal purple, the museum installation staff, with great care, if not with formal ceremony, delivered *Las Meninas* to Rosa. Surrounded by every instrument to examine and assess a work of art, she began her study in the antiseptic stillness of the conservation lab. Alvaro never appeared. As she labored away, she wondered what had happened to him. She reassured herself that she certainly didn't need Alvaro, but she did wonder.

Day after day, week after week, month after month, Rosa scrutinized the painting, recording every pigment and the many restorations done over the centuries. Every day, she waited for Alvaro. He never came. Every day, Poppy and Primrose asked about the charming forensics specialist. Every day, Rosa answered that he had disappeared. Dr. Obrega would not comment and she would not ask, so she proceeded dutifully with the project on her own. A

conditions report, a proposed treatment plan and other documents poured forth in her methodical hand.

One day, like so many others, Rosa passed her magnifying glass over the painting. This time, unlike those many times before, the eyes of the princess came into sharp focus. They acted as mirrors to Rosa herself, who saw in them things past: a life dedicated to achievement with no place for pleasure, the boyfriends who she barely new and never missed, the father who prized intellect and reason above all things and after whom she modeled herself in every way. She had been the apple of her father's eye and now she beheld him in the princess's gaze. The image seared through her like fire. No one had ever measured up to the god-like figure of her father. She knew in a heartbeat that she had always been a mere reflection of him.

"Alvaro was right!" she exclaimed. "Reflections are the answer. Light reflecting on surfaces as illumination. Light emanating from within as revelation."

She sat motionless, seeing how she had been a prisoner of her father's greatness, an unthinking foot soldier of his strict method of gathering knowledge without soul, without passion. Rosa felt a deep pain well up in her chest at the realization that she had never questioned her own life and actions. She had projected myriad inquiries onto works of art, but never at herself. Now the painting threw questions back at her. The princess's eyes would not allow her to avert her own eyes to the truth. In that moment, she said goodbye to her father and acknowledged that she, too, had been in the way of her own reflection. She now understood that her search for facts had blinded her to the answers offered by the canvas.

With a faint smile, she said to herself, *for all of your arrogance, Dr. Obrega, you are right about spirit soaring behind the surface of the painting. Now, if it will only reveal itself to me.*

As her eyes honed in on the thickly applied colors of the canvas,

Rosa sensed that the key to the whole mystery might lay in the makeup of the pigments and the way in which Velasquez combined and layered them. The brown tones of the little princess's eyes finally provided a piece of the puzzle. Something lent sparkle to the pupils but Rosa could not deduce the actual substance. Working late into the night, she came up with nothing and became evermore frustrated until she turned her work lamp off and left *Las Meninas* in the dark. Night enveloped her on the walk home, her only hope being a fresh set of eyes the next day.

I'm nowhere close to solving the mystery, Rosa said to herself as she walked into the lab in the full blaze of morning sunshine.

Focusing on her notebooks, she prepared for a critical review with Dr. Obrega. All of her observations were in order, but anxiety took its firm grip upon her.

"Where are you?" she proclaimed out loud. "You spoke of the reflections in the eye of the princess, but what does that mean? I can't believe I'm saying this but I need you, Alvaro. We need to do this together."

"High praise indeed."

The words shocked Rosa out of her rant. Even more shocking was the sight before her. Alvaro stood at her desk in all of his bodily heat, flesh and color.

"Wondered where I had gone?"

"Um, well," said Rosa. She could not lie, so she did not answer.

"Aww. You did. I'm flattered."

Removing her glasses, her heart beat faster and faster as she felt both thrilled and confused at Alvaro's return. She took comfort in the only thing she knew, arranging her reports in color coded files.

"Well, today I'm meeting with Dr. Obrega to discuss what to

do with the painting. The study is done so now it's time for action."

Flipping through her lists and charts, Alvaro scanned each entry Rosa had made in painstaking detail.

"Page upon page of empirical data, but is there an answer?"

"No, Alvaro. I know it's there but I just can't find it. Lord knows, I have searched. I feel like Don Quixote tilting at windmills."

"That's an intriguing image," said Alvaro. "You, the avowed empiricist devoted to hard evidence likening yourself to a delusional anti-hero."

"Don Quixote is our true selves," said Rosa. "Poor mortals hoping to find something but often failing. But he gives me a sort of hope to carry on."

"Both a cynic and an idealist. You are indeed a mystery, Rosa."

Slamming her notebook shut, Rosa exclaimed, "where have you been? And why did you leave?"

"I was sent away. But the Chairman of the Prado then decided I had to be involved with such a national treasure. So, I'm back. No offence to you. They just want more than one person to decide the fate of *Las Meninas*, as I'm sure you can understand."

"Called in, called away, called back," said Rosa. "The whole thing seems a bit odd to me."

"I am accustomed to odd," said Alvaro. "As a forensics specialist, I deal in the odd, the awkward, the distorted, the macabre. The list goes on."

"We don't have much time," said Rosa. "I meet with Dr. Obrega today for a review and then I have to submit my final report to him in three days."

"No worries," said Alvaro. "It is all the time I require. You have done the hard work which I will merely build upon. Now, let us discuss all of this over a drink."

"Um, well," responded Rosa as she stacked and restacked her lists.

Alvaro put his hand firmly on the pile of paperwork.

"That appears to be your standard answer, which I take as a 'yes.' I will meet you at ten o'clock tonight."

"Can't we meet here tomorrow during office hours?"

"No, Rosa. We cannot. That is not how it is done here. I will pick you up at your place."

"That's it? Jeans and a white t-shirt. No jewelry, no make-up?"

"It's not a date, Primrose. We are colleagues," remarked Rosa.

"You may be an expert with a microscope, but you can't see what's right in front of you," said Poppy.

A firm knock announced the Spaniard's arrival. Poppy beat Primrose to the door to win the coveted chance to do the first welcome.

"Alvaro, it's an honor."

"Oh no, Poppy, the honor is all mine."

"It's a delight," said Primrose.

"That and more," retorted Alvaro.

"Let's go," said Rosa, her stomach turning at the sight of such flirtations.

"Alright," said Alvaro. "I see we are not observing formalities here. Off we go."

"Where are we going?" asked Rosa as she ran down the stairs.

"The Calle de Huertas," said Alvaro. "For tapas."

"Fine," said Rosa, not allowing him to finish as she darted ahead.

"The other direction," said Alvaro.

Rosa averted her eyes in an attempt to hide her embarrassment. Alvaro's grin made her feel even more self-conscious. She walked briskly. Alvaro sauntered. Reaching the bar, he took seats outside and ordered wine and four selections of tapas. They sat without speaking. Alvaro seemed to enjoy the quiet; Rosa appeared suspect.

As the food arrived, they delved into the best of Madrid tapas. Under the guise of savoring her grilled brussell sprouts, Rosa examined Alvaro in her clinical manner, noticing every minute detail. He did not present the slick image she first encountered in the museum. Instead, he had stubble on his face and wore old jeans. His unremarkable brown t-shirt clung to a powerful torso. The hulk of his body seemed so at ease while she perched hesitantly in her chair.

"What is life? A frenzy? What is life? An illusion, a shadow, a fiction. For all of life is a dream."

After finishing the recitation, Alvaro sat back and drank his wine.

"What about those words, Rosa?"

"You didn't recite them accurately," she said.

"No surprise. But I am waiting. You said those lines provided the answer to the mystery. Has it? I did not see it in your reports."

Rosa ate her seared scallops as she pondered an answer. She knew the forensics specialist had her cornered.

"I read those lines in one of Primrose's books. It all made such sense. In a heartbeat, I felt those words might unlock the mystery. I made such progress on reflected light and pigment combinations but I couldn't make the connection. So, I have failed."

Alvaro took her hand and gently squeezed it. He gave her a sympathetic smile, not the flirtatious smirk she distrusted when they first met.

"Your instinct about the poem. Pure genius. It is merely a

question of method. I can help you, if you let me."

Struck by Alvaro's turn to modesty, Rosa began to find him less loathsome, but she still retained her reserve. Although enjoying herself, she wouldn't allow this more casual version of Alvaro to seduce her.

"Where are you originally from?"

"Sevilla," he answered. "My ancestors served under the Emperor Hadrian, who was also from Spain. But they eventually returned here. Rome, emperors, generals, none of them was to their taste. They preferred their orange groves."

"You have the look of a Roman bust in the Prado. I noticed it the other day."

"Really? I could do worse. You flatter me, Rosa."

Averting her eyes from him, she focused on her tapas.

"Alvaro, you said we would discuss the reports."

"Did I? Alright. Let me begin with my concerns about you. I see only facts in the reports. They are holding you back and are the source of all your frustrations."

A waiter came by the table to offer dessert. Rosa shook her head in the negative but Alvaro intervened and ordered for both of them.

"Time to sweeten the evening with flan and a proposal. Rosa, your science is flawless and it is a good foundation, but it isn't giving us the final answer. We are detectives, of sorts, searching for sound evidence but we must rely on instinct, in the end. So, let's observe the obvious data and then consider the more elusive atmosphere around supposed facts."

The dessert arrived and Rosa gave it a try. Smooth and creamy yet with a slightly burnt sugary taste, it instantly won her over. She took a spoonful and offered it to Alvaro.

"Going on instinct defies the methodology of forensics and the principles of my conservation practices. It won't stand up to

scrutiny."

"Consider balancing analysis with imagination in your thinking," said Alvaro with his mouth full. "Illusion and reality, remember? The lines in the poem. Poppy and Primrose made excellent points. They led us to notions of haunted images and hidden meanings. We will find the tangible evidence that captures the intangible quality of those things. It will be like trying to capture air in a bottle, but it is a worthy challenge. And at the Fellows meeting, you said that the painting hovered between reality and illusion."

"I only stated that to get even with Poppy and Primrose for their posturing. My recitation of the poem proved that I'm not just some laboratory wonk."

"Oh, you cannot evade me that easily," said Alvaro. "You meant every word you said. It is undeniable."

Rosa offered no comment and continued to eat her flan while Alvaro's laugh told her everything. He was right, but she wouldn't admit it.

"And Dr. Obrega knows what he is doing," continued Alvaro. "He is onto something. *Las Meninas* has a greatness that transcends its own paint. This will be the first time science is harnessed to discover the spirit of art as well as its physical properties. But Dr. Obrega also suffers from his own greed. He dismissed me because he wants to control the project. He will not share the stage."

"That's no surprise," said Rosa. "He is famous for his brilliance and infamous for his ego."

"Those two traits devour each other," said Alvaro. "Dr. Obrega speaks of the greatness of the painting but wants only to bask in the reflection of his own glory, not in the higher meanings of art. That severely limits him and it will hinder us in the end. But let's not think about such things now when a treat is before us."

Alvaro took a bite of Rosa's flan. She pushed the plate toward

him. He pushed it back, taking both of their spoons and filling them. Finishing dessert at the same moment, their eyes met.

"The streets are calling," said Alvaro. "Time to investigate."

"Investigate what?" said Rosa.

"You'll see."

As they walked on the crooked pavement, crowded with young and old alike taking in the cool night air, Alvaro pointed out iron gates leading to inner courtyards. Madrid presented itself to Rosa as half-hidden, like herself. It didn't refuse to show itself but it also didn't give of itself immediately.

"The city is an enigma," she said. "Everyone is very warm and friendly, but there is more. Just as I think I find what makes it so special, it eludes me."

Alvaro stopped at the entrance to a house with dim lights flickering through weathered window shutters. He pushed open a nail-studded door revealing a series of interconnected arcades among rows of old houses. They walked onward, moving in the shadows of ever darker streets as church bells struck midnight.

"This is the place that produced *Las Meninas*. Imagine that," said Alvaro. "At night, eerie corners, mysterious characters, the faint chimes of the mystical old religion. Then in the daytime, it's all sunshine, bursts of color and warm greetings. Keeps you guessing. Creates tension. The illusion keeps you coming back for more. Same with the painting, isn't it?"

"One city is an illusion, the other a reality," said Rosa. "Under the moon, the emotions reign. In sunlight, all things make sense."

"Well said," remarked Alvaro as they arrived at Rosa's building. "You see both sides of things."

"I always do, in time," said Rosa as she shook his hand and then ran up the staircase. Once in her apartment, she peeked through the window shades to see Alvaro, who remained on the stoop. She

quickly moved away to avoid being seen. Moments later, she peeked again and saw him meandering slowly down the street, his broad shoulders still evident in silhouette.

At the moment dawn filtered through the bedroom curtains, Rosa awakened and lay among her sheets fondly remembering, for a fleeting moment, the previous evening's flan. Immersing even more deeply in the mattress, she also dwelt on the dark beauty of both the streets of Madrid and Alvaro. Such musings halted when the clock struck eight o'clock. Once out of bed and dressing for the day, she dispensed with dreamy visions and became the pragmatic version of herself as the morning progressed and business occupied her mind.

By the time she left the apartment, walked to the museum and began her work, reason and method reigned once again. When Alvaro entered the conservation lab, all of that ceased. Leaning over the painting, laid flat on a large work table before him, he waved his hands over the images of the maids, closed one eye, and began to recite some faint chant as he examined the work.

"We are the agents of science, the servants of empirical data. Yet, we can't always remain earthbound. Oftentimes we must rise to the metaphysical since only it can give us what we seek."

"So, you propose to ascend to the heavens for the answer to the mystery?" said Rosa.

Alvaro directed her attentions to the microscope, which he focused on the left cheek of Princess Margarita.

"Note the change in pigments, which I am sure you have already recorded since you know this painting was damaged by fire and restored in the 18th century. However, do you see how the pigments cluster when we look to the right side, just under the rosy-toned upper cheek of the princess? There is a strange relationship between the color tonalities here. Do you see how they interact when I shine

this specific light on it?"

Upon seeing the illuminated canvas, Rosa felt a lump in her throat.

"I can't believe my eyes!" she exclaimed. "It's the mixture of pigments and their fusing with that strange substance I've never, ever seen. I labor for months and find nothing. In a moment, you reveal everything. It's a miracle."

"Actually, you did all of the work, Rosa. Your investigation documented every last color and brush stroke. That narrowed down the options so I was able to focus. I merely shed light on the truth, the truth you carefully laid out."

"It's a truth I could not see," said Rosa, "even when in front of me. But what is the substance that binds with the pigments to create the divine light?"

"Do the alchemy and all will be revealed," said Alvaro. "You will arrive at the formula in no time. Now, I have to be off. I will check in with you later."

Rosa barely heard his words. She went deep into investigative mode to devise a solution. Working late into the night, she finally achieved her aim. Putting the last notations on the final page of the report, she held it up in awe. The answer had been in plain sight, but she couldn't accept the art of illusion. Alvaro had finally shown her the truth in spite of her resistance.

Rosa walked home in a daze through streets shrouded in darkness yet offering her the occasional beam of light through a shutter left ajar. She felt Madrid and *Las Meninas* had also finally left themselves ajar, just enough for her to see. Proudly, she considered how to share the news in the morning.

"Rosa, you are truly the messenger of the gods!" exclaimed Dr. Obrega. "We have done it. The mystery of the maidens unlocked.

Divine light revealed."

"Thank you, Dr. Obrega, but it's Alvaro's doing. He showed me the way."

Holding the report close to his chest, the doctor grit his teeth and wrinkled his forehead.

"Alvaro? What was he doing here? I dismissed him after the first Fellows meeting. We decided his services did not align with our objectives. You should have told me."

"I'm sorry Dr. Obrega, but I didn't think it was my place to ask or tell, only to do my work."

Regaining his composure, Dr. Obrega gave the report back to Rosa and a smile flashed across his face.

"This is all fine, Rosa. You take the rest of the day off. Tomorrow is Friday so make it a long weekend and we will reconvene on Monday to discuss our next steps."

He escorted her to the threshold of his office, bowed and then shut the bronze door, sealing himself in his inner sanctum. As a metallic echo rang in her ears, Rosa felt an overwhelming sense of doom. She also realized the report, which she meant to leave with Dr. Obrega, was still in her hands.

Oh well, she thought, *thank goodness for small favors, this gives me a chance to check any typos.*

Rosa returned to the lab and stayed until late in the evening. In the solitary glow of her work lamp, she revisited the physical evidence, reconsidered her research methodology and scrutinized the meaning of the words on every page. Upon closing the report, unanswered questions haunted her. This uneasy mood followed her home.

Passing through streets now so familiar, she saw that all courtyard gates and window shutters were closed. No lights shone in the houses. Madrid had returned to its elusive self. Upon arriving

at her apartment, she found Alvaro waiting on her doorstep. A grimness marked the place of his usual dimpled grin.

"Alvaro. Is everything okay?"

Without speaking, he took her by the arm and led her upstairs. Closing the creaky apartment door behind them. "Don't speak, yet," he whispered. Checking all of the rooms, finding them empty, he gestured for her to sit on the sofa.

"Rosa, Dr. Obrega is the devil."

"What? Are you serious, Alvaro? What's going on?"

"Dr. Obrega dismissed me months ago."

"I know that. He told me today," said Rosa. "Why didn't you tell me?"

"Because you seemed to admire the doctor so I thought you were one of his loyal disciples. And you didn't seem to trust me at all."

"Well, there is some truth to that," said Rosa.

"I came back because my gut told me something was wrong," said Alvaro. "And as we spent more time together, I knew you would see the truth, even if it came from my lips."

With a smile, Rosa took the report out of her bag and put it on the table.

"Here is the truth. The only copy of the truth, in fact."

Alvaro breathed a sigh of relief as he saw the enormous folio.

"I went in to the office after you left your meeting with Dr. Obrega," he said in a low voice. "His secretary has a thing for me and agreed to let me see him to argue my case to get back on the project. She was out when I arrived, so I waited. That's when I overheard Dr. Obrega on the phone. He told some reporter that he had discovered the mystery of *Las Meninas* and he would soon reveal its secrets to an awestruck world. We can't let that happen, Rosa. Trust me. This is more than just a national treasure going

on a world tour. It can't leave the Prado. If it does, the divine light will disappear. The light of day will destroy the little maidens. They need to be left in peace."

Rosa kissed his forehead and pet him on the cheek.

"Bless you. All will be well. I now have the answer."

Rosa went to her bedroom, sat at the desk and opened her laptop. Alvaro followed her and leaned against the door. He watched her sitting with perfect posture as she made a detailed list.

"Alvaro. You are exhausted. Go home and sleep. Meet me in the Octagonal Gallery of the Prado tomorrow evening just before it closes."

The next day burned hot. Temperatures soared and the pavements of Madrid crackled under an intense sun. Animals and people took shelter from the heat. The deserted city sweltered. Few living things dared moved until twilight, when Alvaro made his way up to the grand portico of the Prado at the appointed hour. Visitors filed past him to the entrance. The café and museum store cashed in their last sales for the day. Only a few guards stood at their posts waiting for closing time. When Alvaro reached the Octagonal Gallery, he saw *Las Meninas* back on the wall in its honored place. Rosa stood beside the painting and gestured for him to come forward. While taking his first step, he heard an ear shattering moan.

"Dr. Obrega is not pleased," said Rosa. "In fact, he has condemned me for all time. I consider that an honor."

"What happened? What have you done?"

"I lost my report, somehow. Not a paper or electronic copy to be found. No research findings remain, not a single note. They all disappeared. Quite a mystery."

"Noooooooooo!" came the voice of Dr. Obrega, echoing from his cavernous marble chamber.

"I had the installation crew move *Las Meninas* back here," said Rosa. "Oh, and I also contacted the Chairman of the Prado to inform her that Dr. Obrega leaked confidential information to the press and made arrangements to send the painting on a world tour without permission. Considering themselves guardians of the sacred object, the Chairman and her fine arts committee were none too pleased. They have ordered the wayward doctor's resignation on the grounds of falsifying data and countermanding a government statute on national treasures."

Alvaro grinned from ear to ear, not one of his flirtatious affectations, but the grin of a boy impressed by a dangerous feat well done.

"Rosa, you are the savior of *Las Meninas*."

"It wouldn't have happened without you, Alvaro. You were the messenger, leading me to the link between reality and illusion. You unlocked the mystery."

"You are a bit of a mystery too, Rosa. And as you know, I like them."

They both gazed at the painting. Velasquez, the dwarf and the little princess gazed back. The gallery lights dimmed and *Las Meninas* became enveloped in shadow. Rosa kissed Alvaro. She then glanced at the painting again.

"I think they approve," she said. "I see it in the little princess's eyes. I'm sure of it."

They left painting but turned around one more time before exiting.

"Let the girls keep their secrets," said Rosa. "The mystery remains, just as it should."

Lost City

"Not now, Benny. Not in my ear."

Blossom put down her notebook and peered over her horn-rimmed glasses.

"I am in no mood tonight. This essay critique is due first thing in the morning and I cannot overlook one misplaced letter."

Chagrined, Benny left the sofa and moped towards the kitchen.

"Beep, beep, beep."

Grabbing her cell phone, Blossom crinkled her nose in annoyance.

"Yes."

"That's a nice greeting for your favorite colleague."

"Sorry, Cassandra, I am editing and everything is conspiring to stop me."

"Benny being needy again?"

"How did you know?"

"Oh, honey, he always needs a lady's attention. But enough about him. Guess where you're going tomorrow?"

"What are you about to drop on me?'

"Tikal."

"What!" Blossom yelped, throwing her papers on the floor as she jumped up off the couch.

"No. It cannot be."

"Oh, yes it can. You are to be the resident expert for The Maya Project. The institute's advisory committee voted unanimously, on my recommendation, of course."

Pacing back and forth, Blossom tugged nervously at her right ear.

"But, Professor Stultus is in charge. I am to stay at the institute while he is in Guatemala. What happened?"

"Just a total scandal, a project in collapse and a bit of international outrage. Dr. Stultus has been fired. We'll see him no more. And his second in command, Dr. Pettifer, is no better. I think he'll see the axe soon. You are the last hope."

"Why me? What collapsed? Who is outraged? What will I be responsible for? Where will I live?"

"Slow down and listen to me. You are the most qualified person. And don't roll your eyes."

"How do you know what my eyes are up to?"

"I'm all seeing, as you well know."

"Can you see that I am wholly unsuited."

"Oh no you don't!" exclaimed Cassandra. "Who else has advanced degrees in mathematics and history and a Ph.D. in linguistics? You're a freak genius and you'll be the savior of the project even if you are an obsessive compulsive shut-in. No one else has your mastery of codes and ciphers. And you need to start knowing that because I'm sick of telling you. Now, deal with it and get ready."

Blossom paced in a circle around a pile of laundry, precisely folded, in the middle of her living room floor.

"I cannot do this. I cannot go on a plane. I cannot save this project. Me, of all people!"

"All you say is 'cannot.' As the institute's new director, I say you can and you will. It's my job to see that the mistakes of the past are put aside and we forge ahead to a solution. And you are going to find that solution."

"What about Benny? I cannot leave him. He is having a really rough time of it lately."

"Oh for heaven's sake, he'll be fine. For once, think of yourself and seize the day. Trust me, Benny knows how to take care of himself. He's the most selfish dude I've ever laid eyes on. Now, go pack the two pairs of pants and the only two god-awful blouses you own. Night, sweetie."

Blossom stared at the wall. Not a single photo, painting or print graced her apartment so she faced sterile white surfaces. Books and magazines, neatly arranged in stacks, lined half the room; the other half occupied only by a sofa, a desk, an office chair and a reading lamp. Pulling her ear with one hand, she recited a litany of fears as her stomach began to cramp, nauseous at the idea of the unknown. Never did she leave the confines of her neighborhood or the Linguistics Institute at the university, only a five-minute bus ride from her front door, for she neither drove a car nor rode a bike. In fact, she had never left Chicago. The thought of traveling made her shiver and shake. To calm herself, she took out a pad, purchased from the discount dollar store, and began to make an inventory of necessary supplies and things to do from turning off light switches to emptying the refrigerator. Her hand quivering, she scribbled items and ideas down then scratched them off and started again. List making brought momentary comfort quickly followed by anxiety and, in turn, terror with the advent of a single thought.

"I have no toiletries bag. This is a disaster. Where do I get one? Maybe I can put them in a plastic container. Yes, yes. I will do that."

She went into the kitchen and took stock of twenty-three boxes of plastic bags, all in varying sizes, lined up in a row on the top shelf of the cupboard.

"Largest for socks. Next size for toothpaste, shampoo and soap. The smallest for pills. That should do. Well, maybe not. Let me think."

Blossom arranged the bags on the floor, measuring their dimensions and mulling over what objects would fit into them, until Benny appeared at the door.

"Meow."

"You are going to be on your own for awhile."

Blossom gave him long pets from head to tail while he rubbed against her leg.

"Big baby."

With Benny taking playful whacks at her ankle, Blossom scurried into the bedroom. She folded two pairs of shorts, two t-shirts, a rain coat, hiking boots and one skirt, placing them on the bed alongside a broad brimmed hat. Owning no suitcase, a battered travel tote left behind by her mother had to suffice. Nothing made its way into the bag, however, since she could not decide which item to put in first. After spending three hours rearranging her clothes according to color, then material, she laid on the bed and stared at the ceiling until the clock struck midnight.

"Chosen!"

The shrill sound sliced through Blossom as the face of a woman gushing blood from mouth and nose hovered at the foot of the bed. Unable to call out, Blossom remained motionless. The image of the woman's face then receded into the darkness but her voice resonated throughout the room.

"You are the chosen."

Blossom gasped for breath. Tears trickled down her cheeks and lips. Once she summoned the strength to turn the bedside light on, she saw not tears but blood pouring forth from her mouth down over her neck and chest.

"No! No!" she shrieked as her voice returned with a fury.

Running into the bathroom, she encountered the most gruesome reflection in the mirror over the sink.

"Oh, my god! My god, my god, my god!" she yelped while scrambling through the medicine cabinet to find sanitized wipes. Vigorously she cleaned her face and arms, but to no avail. Nothing stopped the bleeding as the sink overflowed with a never-ending current of red. Under the weight of her own horror, Blossom collapsed onto the tiled floor. There she laid, eyes closed, barely breathing.

"Purrrrrr."

One eye shot open as she felt Benny's warm fur against her leg. There he lay, cuddled in the bend of her knee. Looking about, she saw not a drop of blood anywhere. Not even the sanitary wipes were in evidence. Her bathroom sparkled in immaculate white, as always.

"Whew," she blew out in a long exhale.

Blossom pulled herself up from the floor. Daring to catch her reflection again in the mirror, she faced the exhaustion in her eyes.

"It must have been a nightmare. Or a premonition."

Popping two sleeping pills in her mouth, she returned to bed, noting that the clock on the dresser registered one o'clock in the morning. Scanning the room from corner to corner in search of the woman's face, Blossom's eyes darted about with the tick of every second on the timepiece. By remaining awake, she believed no nightmares would arise. She counted every minute and took account

of every inch of the room to form a mental barricade against fearful imaginings. Unable, however, to summon up the energy for an all-night vigil, she eventually fell off to sleep, one hand covering her eyes, the other grasping onto the sheet.

Only a few hours later, a petulant Benny and an alarm announced that a new day had dawned. Blossom awakened and stared at the ceiling light for an hour while the clock and the cat both rang and raged. She finally hit the alarm button and pet the fussy feline. With a burning stomach and an aching head, rising from bed felt like the last act of a final day on earth. Unwilling in spirit, she went through the motions of readiness. Showering, packing, ordering and reordering her few worldly goods made up an attempt to play the part of the traveler preparing to leave, but she didn't know the sequence to follow since she had never gone anywhere. A knock came at the door as she dabbed sunblock on her cheeks and nose.

"Blossom, it's time!"

"Cassandra, is that you?"

"Of course it's me. Who else would it be? You never have company."

"What are you doing here?"

"Um, the first thing I'm doing is telling you to let me in."

En route to open the door, Blossom tripped over her tote bag and fell onto one of her many piles of papers. Struggling to get up, the sunblock rubbed off on a stack of reports. Furiously she undid the mess she had made while Cassandra varied between pounding on the door and pressing the buzzer. Shaking and quaking, Blossom finally let her guest in.

"Sunblock in Chicago in February?"

"It will be hot in Guatemala," said Blossom.

"Yes, but you're not there yet, you noodle. Get that off your face. I'm taking you to the airport."

Blossom went to the bathroom to clean up while Cassandra navigated around mountains of books to reach windows concealed behind thick curtains.

"So this is where you live. It's beyond dark in here. No wonder you're as pale as a ghost."

"I get nervous," called Blossom from the bathroom. "Someone might see inside."

Cassandra rolled her eyes while examining the reading materials on the floor.

"Hmmm. Essays on Mayan numerology, journals of Mayan astronomy, monographs on Mayan architecture. And you say you're not the one to do this project. You're made for this trip. As long as you keep out of your own way, you'll save the day."

Blossom emerged from the bathroom wearing baggy shorts and an oversized t-shirt made even sloppier by her slumping shoulders.

"I would tell you that the outfit is all wrong, among other things, but you never listen to me. Come on, let's go. You have a meeting with destiny. Or, more likely, a dubious group of archaeologists and academic hangers-on in the rainforests of Guatemala. Lost cities, temples of doom and all that."

"I cannot go, Cassandra. I had a nightmare last night. A woman's face, bleeding from the mouth, told me I was the chosen one. It is a bad tiding."

"That's an easily analyzed dream, my darling. You are afraid of leaving your comfort zone. A nightmare isn't getting you out of this. Now, out the door!"

The two women left the apartment and proceeded to an airport one of them had never seen. Cassandra tuned into her favorite dance remix. Blossom winced and wriggled in her seat, blinking feverishly as the song hit its high notes.

"Noise, light, color. They unnerve you, don't they?" said Cassandra. "Some friendly advice, honey. Let a little life in. You're sensory deprived."

Blossom covered her ears. As the airport came into view, she trembled at the sight of such a large-scale building.

"No more of this," said Cassandra. "Time to face it. Do you know what airline you're flying?"

"I know the number."

"Of course you do, you numbers geek," said Cassandra as she shoved her reluctant passenger out of the car.

Speeding away, offering Blossom no chance for a retreat, Cassandra yelled, "follow the numbers and you'll make all of your connecting flights. And all will be well."

Resigned to her fate, Blossom trudged into the cavernous terminal. Confronted by the continually changing arrival and departure screens, she watched the letters and words shuffle and reshuffle. Transfixed by the system, assessing the size and frequent use of certain letters, she lost track of time until she heard her flight number announced. She bolted across the concourse, but only for a few yards until she smashed into a giant of a man.

"Woah!" yelled the man.

"I am so sorry. My flight is leaving. Forgive me. I do not know where the gate is."

"It's okay. Where are you going?"

"Guatemala."

"Gate twenty-three. Is this your first time?"

"Yes. I have never traveled before."

"Never?"

"Never. I do not go anywhere."

"We all go somewhere, even if it's a few feet."

"Well, um, I need to go. Excuse me."

Blossom ran off and boarded the plane. She had covered more miles on this morning than on any day in her life, thus far. The waiting plane would bring her further still.

TWENTY THREE HOURS LATER

"Good morning, Ladies and Gentlemen. We have reached our destination. Welcome to Guatemala City. The weather is a mix of clouds and sun. And the high temperature is expected to be ninety degrees with a dew point of eighty-seven."

Blossom waited in the last seat at the back of the plane while the motley crew of fellow passengers veered between the sacred and profane. Rosaries in hand, a tour group from a church in Bethlehem, Pennsylvania fumbled with their carry-on luggage, twittering over lost water bottles and misplaced devotional pamphlets. Plugged into their iPhones, a gang of college students en route to Belize flirted and fought with each other and forgot to thank the flight attendants as they poured out of the plane. Humidity came upon Blossom as a lead weight when it came her turn to step outside. The asphalt tarmac radiated heat like a blast furnace. Instantly perspiring with a force she had never before experienced, Blossom stumbled towards the main terminal. Once inside, the air conditioning steamed up her glasses. Unable to see, caught in the hell between hot and cold, she stood rigidly in the middle of the hall not knowing where to go or what to do.

"Hey! You must be Blossom," called a young lady with sparkling green eyes and a lush main of frizzy brown hair tied in a bun. "I'm Hannah, your workmate. That's the only luggage you have? Just as well. No place to store anything bigger."

She took Blossom's hand and charged forward.

"I assume you are Blossom? You haven't said anything yet."

Jostled and shoved by the crowd, Blossom struggled to keep her glasses on her face, her bag on her shoulder and her hat on her head.

"Yes. That is me."

"No, no, no," said Hannah. "Saying 'that is me' makes it seem like you are describing yourself from afar, like you are detached from your own body. You should declare, 'it's me' when you talk about yourself."

"I never thought of it that way. Although I often do feel like that."

Hannah tightened her grip on Blossom's hand.

"I've heard great things about you."

"Me?" said Blossom.

"Yup. Cassandra told us about you. Now that you're in front of me, I'm sure of it. On the surface, I see reserve. But I can tell that you are someone to be reckoned with."

Blossom shrugged her shoulders and stumbled in Hannah's wake as she plowed through people and packages to reach a jeep randomly parked on the sidewalk.

"Sorry you couldn't fly into Flores, but their runways are closed for repairs. It's a ten-hour drive to camp and I need to pick up supplies in the city so you're going to get quite the orientation tour. Here's the old junk. Hop in. We should be at Tikal by early evening, if everything goes well, which it rarely does."

Putting the jeep into high gear, Hannah drove them away from the expansive modernity of the airport and through streets alarming to Blossom in their disarray. Piles of garbage competed with stalls offering locally woven Mayan fabrics and imported accessories of the cheapest variety. No one in a car or on foot observed any of the traffic signs. Weaving through the confusion of the city, Hannah steered the vehicle into a narrow street and

stopped before a warehouse.

"You stay here while I pick up our month's supply of cornmeal and condoms."

As Blossom slightly blushed, Hannah bounded onto the pavement and gave the two waiting store clerks generous hugs. While they struggled with huge sacks and parcels, Blossom occupied herself with counting the number of fruit containers lining the sidewalk, deducing a way to organize these objects for optimum efficiency based on calculations of available space. Just as she arrived at a solution, she noticed a group of five men, all donning black caps, strutting defiantly towards a group of five muscle-bound hulks wearing red caps. In an instant, they began to brawl, beating each other with broken bottles and rocks, bashing with fists and elbows. One poor soul smashed against the jeep, blood gushing out of his mouth, his scraped arm brushing against Blossom's leg as he fell to the ground. Jumping into the driver's seat, Hannah hit reverse and backed swiftly and ably down the street. Crossing a main plaza, the vehicle kicked into high gear, zig-zagging through back alleys until the open countryside offered a straight and clear path of escape.

"You've been blessed in red," said Hannah. "Although it seems that the red capped dudes lost the fight."

"Oh my god," shrieked Blossom as she wiped the fallen man's blood from her leg.

"Brutal place," said Hannah. "Don't judge everything by what we've just seen. It's also beautiful and most people are really friendly when they aren't inflicting vendettas."

"The men in red caps should have won the fight," said Blossom.

"Oh, you don't say," retorted Hannah. "Is this based on your intimate knowledge of gang behavior?"

"It has to do with numbers. The five red-capped men were more

muscular, so they outnumbered the black-capped gang in weight. One could say, they had one extra man based on their additional body mass."

"Right, numbers girl," said Hannah. "But you left out a key factor. The black caps anger outweighed the red caps' body mass."

"I hadn't thought of it that way," said Blossom.

"Emotion, baby," said Hannah. "It's always part of an equation.'

Blossom looked ahead without blinking, not uttering a sound while Hannah rocked out and sang along with lyrics blasting forth from the radio.

Banging on the steering wheel, Hannah declared, "gotta love some Led Zeppelin. Stairway to Heaven. Best song, ever. Girl, this is our anthem."

With every word, the song beat into Blossom's head as the jeep left vast fields behind and entered lush forest.

"Rough ride ahead," said Hannah as she dabbed Blossom's forehead with a wet cloth. "A land of extremes. Nowhere else like it on earth. Life in the raw."

The rusty vehicle flew along the highway where stark contrasts composed every view. Shanty towns, with an air of the desperate, deprived and decaying, huddled in the midst of abundant nature. Blossom began to feel easier among the relative peace of this scenery. With no shocks to her system in this quiet countryside, her jet lag eventually overcame the day's traumatic incidents. She dozed off but, in due course, Hannah's renditions of classic rock jolted her awake. Any attempt at rest and relaxation ceased once they turned off paved road onto pebble and mud, driving into territory with no signs of human habitation.

"The Peten rainforest," proclaimed Hannah in a celebratory tone. "Paradise."

Thick foliage brushed against the jeep as rutted roads became

narrower in an all-enveloping jungle abuzz with noise and ablaze in color. Macaws, parrots and toucans squawked as they showed off feathers in hues of brilliant blue, green, red and orange. Monkeys chattered, asserting their presence from the tops of trees, while leafy branches and voluminous shrubs screened ocelots, deer and foxes silently in search of their dinner. Through this land of heat simmering with the smell of drenched earth, Blossom eyed stone towers soaring above green mist.

"Tikal?"

"Stairways to heaven, babe," said Hannah. "All of those pyramid temples reaching to the sky."

"Hidden here in the jungle," said Blossom.

"Yup," said Hannah. "The lost city of a lost people crying out to be found. I'll show you our tent and then we'll meet up with Miriam."

They entered a compound which the Tikal Project staff called home. Twenty-three tents arranged in a circle around a central wooden pavilion provided accommodation for an international team of archaeologists, linguists, historians and assorted technicians and supply officers. Professors and ponytailed graduate students sat under a grove of trees smoking, drinking beer and eating corn chips.

"Did this think tank make any mind-boggling discoveries today," quipped Hannah. "Or did you just go through all of my smokes and never make it to the temples?"

"Oh, Hannah, babe," said a young man with an unkempt beard, "it's been an awesome day. Found another stela. I mean, we were like, in awe. But now we are, like, oh no man, one more stela and we can't decode it."

Tugging the young man's whiskers, Hannah said, "slacker," as she placed the box of condoms on the communal drinks table.

"Take what you need, not what you can get."

The young bearded man patted her behind. Hannah did the

same to him, then grabbed his cigarette, took a generous puff, held for what seemed to Blossom an eternal inhale, and slowly exhaled. She offered the smoldering treat to Blossom, who cast her head down.

"Demure if you will," said Hannah. "But this makes the bad stuff tolerable and the good stuff even better."

Flicking the joint back at the young man, Hannah announced, "okay everyone, this is Blossom. She's a super smart girl. Doesn't talk too much but that'll be a nice break. And she's way, way smarter than any of you. Brought down here to solve all of your problems, so be nice to her."

The group gave her a collective wave and returned to their pleasures. Hannah led the way towards a tent fronted by stacks of broken boxes. Squeezing past the creaky containers, they stepped into a sparse arrangement of two cots, two lockers, a water cooler and a string of electric light bulbs hanging from the ceiling. A Led Zeppelin poster provided the only decorative accent.

"That's your bed. This is mine."

"Where is the bathroom?" asked Blossom, furtively seeking and nervously wondering what the answer would be.

"Unisex toilets and showers," said Hannah, pointing out the door to a rickety wooden building. "Flashlights next to the bed for nighttime trips. Shine it on the ground to scare away the critters. Smash it in anyone's face who doesn't mind their manners."

"Twenty-three feet and twenty-three steps," said Blossom as she eyed the outhouse.

"What are you talking about?"

"The width of the tent and the number of steps to the bathroom."

"Oh, babe, you are like a walking calculator. But your numbers are off. I can do the bathroom in ten leaps. You take too many prissy little steps. Can't do that here. Something will bite you."

Blossom drew several plastic bags out of her luggage and arranged them on the bed. She counted to herself as she lined them up in a single row.

"AHHHHHHHHHH! Help!"

"What's the matter," said Hannah. "You barely speak and now you shriek. My poor ears."

"A thing just ran across the bed," said Blossom, her face paler than pale.

"Oh, babe, that's a lizard. There are a million of them here. Harmless. Now, come on!"

Grabbing Blossom by the elbow, Hannah hauled her out the door and sprinted into the forest. Running amidst masses of greenery, the wet boggy soil beneath her feet squishing and wreaking of rotting vegetation, Blossom's pulse pounded so violently that she felt her heart might explode. Sweat dripped from every pore as she tried to avoid stepping on any living or dead thing mired in the mud or hanging from a branch.

A pang of relief finally welled up in Blossom's chest upon reaching a clearing where the sun shone brightly. Hannah ceased to run. Blossom ceased gasping for breath. Before the two girls lay all of the majesty of Tikal. Stepped pyramids with steep staircases dominated the skyline. Vast plazas, palaces and countless tombs and altars in white stone rested contentedly amidst emerald green turf and lofty trees.

"Precisely measured," said Blossom. "The Temple of the Jaguar. One hundred and forty-eight feet high. The Temple of the Masks. One hundred and thirty-eight feet high. Pyramid Six. Two hundred and thirteen feet high."

"That's right," said Hannah. "Tikal is the place to get high."

Blossom made a faint grin. All seemed so serene now that she stood in open terrain in the broad light of day. Such peace was short-

lived as Hannah marched onward. Blossom scampered to keep up, in fear of re-entering the forest. Such concerns were unnecessary, however, since in a few moments they arrived at a tent raised on a high metal platform. At the top of the ladder leading to a verandah stood a woman with a shapely figure and striking auburn hair.

"Welcome, Blossom. I'm Miriam. I see Hannah has delivered you in one piece."

Her immaculate maroon khaki shorts and deep red t-shirt, worn with grace and without a single bead of sweat, immediately struck Blossom, who had only met people, thus far, bedraggled in body and soul by the humidity. Miriam gave both girls an all-embracing hug and a kiss on the cheek, then directed them to a view over all of Tikal. A tray of drinks sat upon a small table laden with bean dip, corn chips and fried plantains.

"Liquor for the sinner. Lemonade for the saint," said Miriam as she handed Hannah the first and Blossom the second glass.

"Alright. Enough of the niceties. Now, for the interesting things," said Miriam as she invited everyone to be seated with her on the sofa.

"You come here unwillingly," Miriam said as she held both of Blossom's hands. "You will do your work hesitantly."

Blossom's downcast expression confirmed Miriam's words.

"But you will prevail."

"I am not sure how, Ma'am."

"Trust me. You will. But the present and future are not of concern. It is the past that calls out. We can take in the whole of Tikal from here. Before us is the sum total of the achievements of the Maya. This is where we start."

A gnashing sound stopped Miriam in her tracks.

"Sorry," said Hannah munching away on chips. "I didn't mean to

interfere with the sweep of history."

"On that note," said Miriam, "you've introduced a key point. Corn."

She offered the bowl of chips to Blossom, who sheepishly took one and bit down on it, looking up self-consciously to see if she made too much noise. Miriam smiled gently and presented her with a book emblazoned with the words *Popal Vuh*.

"The Maya were known as the Children of the Corn. Their creation origin in this, which translates to the *Book of the People*, ordains that the gods created heaven and earth."

She opened to a page of a drawing featuring figures set within a forest.

"The sky god, Huracan, planted a Cebia tree which connected the three realms. Its roots grew down into the nine levels of the underworld. The trunk created the space for animals and plants to flourish in the middle level known as 'earth' while the branches reached to the thirteen levels of heaven."

The constant movement of the trees below the terrace distracted Blossom, always watching for a panther or some other beast who might devour her. With a touch of her finger to Blossom's chin, Miriam turned her focus away from fear and back to the story.

"The gods were pleased but wanted to be worshiped so they made humans, first of mud, but they disintegrated. Then of wood, but they had no brains to comprehend and, thus, venerate the gods."

"Incomplete," said Blossom. "Thinking is what makes us human."

"Exactly," said Miriam. "But there is another vital element at work in the legend. The gods mixed corn with their own blood to create not only thinking beings, but feeling beings. Yet, these first humans were too perfect, rivaling the gods, so they were destroyed. Again, the gods mixed corn and their own blood. This time, they clouded the new human's eyes and minds with a fog so they could

pose no challenge to the heavenly powers. These people would make offerings of their own blood to the gods in thanks. Tikal is the manifestation of that mythology in stone. And the bloodline still courses in the veins of the local population. Know this and your work will be well done."

"I am not exactly sure what my work will be, Ma'am. I have not been given any instructions except to show up."

"All will be revealed," said Miriam.

"It's all about corn and fertility," said Hannah. "Tikal is a thank you to the gods for a good harvest, for survival. I should have been a Maya fertility goddess. I have all the skills for the job."

"Hmmmmm," said Miriam. "Fertility can be productive and destructive. Remember that, my girl."

"No use dwelling on what might be. Time to go," said Hannah, jumping up, dragging Blossom from her seat and racing down the stairs.

"One more thing," called Miriam from the top of the steps. "The Maya saw the sacred in everything from the smallest pebble to the grandest temple. Seek answers in all of those things."

Hannah made a peace sign while Blossom waved before they disappeared into the forest.

"Is she my boss?" asked Blossom as she glanced back at Miriam's tent.

"She has nothing to do with the project. And everything to do with it."

"What does that mean?"

"It means everything begins and ends with her," said Hannah. "Miriam is the head of the Maya Biosphere Reserve, about five million acres of national park and conservation land that surrounds Tikal. She's sort of the earth mother around here. Officially, she's

not involved with the project. That was Dr. Stultus's job, as you know, but he's been fired. And his replacement, Dr. Pettifer, is no better, which you also know. So, everyone comes to her for advice since she's an expert on the region. Her mom was an American archaeologist who fell for a Guatemalan ranger at Tikal."

Hannah led the way through the forest, hopping over twisted roots, some gigantic in scale, others thin like a multi-layered cobwebs permeating every inch of ground, choking out young saplings and tangling around broken stones. Rotting foliage decomposed in a muddy footpath littered with dead branches smothered in moss. Barely any light made its way through the blanket of green into this dim dank scene.

"Miriam spoke of nine levels of the underworld," said Blossom. "And one level of the earth and thirteen levels of heaven. That makes twenty-three in total. Our tent is twenty-three feet long. It takes twenty-three steps to cross the camp to the outhouse. I am twenty-three years old. That number seems to intersect everywhere."

"You make weird connections, girl genius," remarked Hannah. "Maybe it's all a coincidence."

As Blossom mumbled various calculations and counted repeatedly on her fingers, Hannah guided them in, around, up and over contorted trees as they navigated their way through the wet world of the jungle to the mildew-ridden beds waiting for them at camp.

THE NEXT DAY

Blossom froze in place, unable to speak or move, as she awakened to the sight of a furry creature on her sheet. Never had she seen anything so ugly with its deep-set black eyes, gray fur and scrawny body. The sad critter scampered away quickly the moment a tin box bounced off its head, the handywork of Hannah.

"I've perfect aim! Good morning, Blossom."

Hannah bustled about the tent filling boxes of supplies, mainly corn chips and beer.

"This is your very special day. Project team meeting in one hour with the entire full-of-themselves academic crew and their kiss-up graduate assistants. Everyone thinking they'll make the next big discovery. Guess what's been found so far? Nothing. Nada. Well, correction. They have produced total chaos. It takes effort to screw up this bad. The four countries funding the project have all pulled out and a United Nations representative has sent a nasty letter. That's something to be proud of. You'll be on the firing line now. They've been told a braniac has been shipped down to save the project."

Blossom rolled off of her cot and attempted to dress but the dampness of the t-shirt made her skin crawl. She found spiders in her shoes and a crushed brown bug floating in the soap dish. A shower in the communal bathroom offered minor relief until her plastic bag ripped and its toiletries scattered across the cracked tile floor. The return trip to the tent made her drip with sweat, negating any morning ablutions.

Wet and wrinkled, she went to the dining pavilion, fretting over what insects and animals had infected the food. Speaking to no one in the breakfast line, she selected a banana in the hope that nothing had penetrated the skin. The collective rabble of unkempt students huddling around communal tables made her shudder, so she returned to her tent.

Her mind began to spin as she retreated to her cot, holding her head and wondering what would be next. She felt filthier by the second as the humidity rose. Curled up in a fetal position, she stared at three plastic bags filled with her underwear, socks and t-shirts, the only things that gave her a sense of security until she observed that one of them had a tear.

"Yuck. Something has eaten my socks. Is nothing safe?"

Mold had formed on the inside of the plastic so she threw it away and fell back into bed.

"Um, what the hell is this!" exclaimed Hannah.

Blossom saw Hannah holding three plastic bags.

"I had extra so I packed a few of your things."

"So, you organized my condoms, lube and morning after pills into three neat little packets. Girl, you are beyond. That's all I can say."

"I just wanted to help. You have been so good to me."

"Well, that's very sweet. Now, get up," said Hannah. "The day of reckoning has come. The meeting begins in five minutes."

They crossed the compound to join the crew gathered around a table under the all-encompassing branches of a centuries-old Cebia tree. Not a smile or a nod greeted them. Blossom took their poor posture, dour expressions and pursed lips as resentment, by some, and resignation, by most, at her presence.

"A historical overview is in order, I believe, since you have no specific knowledge or understanding of this site," said a portly bespectacled man wearing a straw hat and seated at the head of the table.

"That's Dr. Pettifer," Hannah whispered in Blossom's ear. "A supposed authority on Mayan history. He never says hello, goodbye or excuse me. Starts talking about stuff but never engages in conversation."

Hannah placed a folding stool at the end of the table, opposite Dr. Pettifer. No accommodation had been made for Blossom to join them and not a single staff member offered any help. Giving Blossom the seat, Hannah remained standing behind her with arms folded, glaring at each and every archaeologist, scientist and

student. Dr. Pettifer, with head held high, made eye contact with no one, looking above everyone's head into the distance.

"The Maya dwelt here in the misty forests at the heart of Central America. When they first appeared, we cannot be sure, for they are so ancient that they might have been born at the very beginning of creation. Tikal was among the mightiest of their cities, reigning supreme for over a thousand years as the religious, political and cultural center of their world. Their astronomers searched the stars for messages offered by the universe. They created a calendar and form of hieroglyphic writing to mark the passage of time and the achievements of humankind. Their architecture and sculpture, of the finest quality in terms of both design and craftsmanship, rose from the damp soil to the silvery skies. The greatest of the pyramids were built during the phase known as the 'Classical Period' beginning in the year 600. Here, at these temples ascending to the heavens, they made their blood sacrifices to the gods."

The snoring of a graduate student put an end to the academic monologue. A fellow student gave his comrade a nudge. The awakened miscreant proclaimed, "whatever," and fell back to sleep. The wriggling of his moustache conveyed Dr. Pettifer's displeasure, which soon abated as he continued with his historical sermonizing.

"Tragedy struck. Of what form, we do not know. Around 900, the Maya abandoned Tikal. Some hold that an ecological disaster wrought havoc. Over-farming depleted the soil. Others say war and plague may have forced the population to flee. The rainforest reclaimed the city, which slept under its blanket of green for a thousand years until Ambrosio Tut, exploring for gum sap among the local trees, came across the ruins in 1848. Suddenly, Tikal became a world-wide sensation as archaeologists and treasure hunters sought out the lost city. Both saints and sinners have come here to do their part. Some tenderly uncovering the fragments of lost glory, others plundering. In 1853, the French artist Eusebio Lare produced a drawing of sublime beauty, capturing the magic

of the place. Alfred Maudslay mapped the site in the early 1880s, marking out the five major temples. Generations of scholars from across the globe continued to unearth this most splendid of all the pre-Columbian cities in the Americas. These brave souls began the resurrection of the Maya. We stand on the shoulders of these brilliant men and women. In 1979, UNESCO designated Tikal a World Heritage Site. Thus, our work here is of the highest order."

Dr. Pettifer stood up after his speech. Asking for no questions or commentary, he retreated into his tent.

"There goes the Almighty," said one of the students. "And here sit all of us, the blood sacrifices to his ego."

Some of the group burst into laughter then fell into gossip. Some bickered; others sat back with bitterness writ across their faces.

"You want to know the truth about this project?" said a young woman with thick glasses and humorless eyes who stood up and glared directly at Blossom. "Ten people have been fired already. Two archaeologists, five graduate students and three technicians. Each taking the blame for Pettifer's toxic cocktail of incompetence and corruption."

The bespectacled girl took out a journal, opened its pages and pounded them with her pen.

"The codes we've been working on are based on falsified information. Dr. Pettifer devised these. When he found out they were bogus, he never fessed up. The inconsistencies in his theories were discovered by an unwitting intern while logging information into the computer. The mistakes only appear when you start sequencing the data. We've wasted time and a fortune in donated funds we'll never see again. This is about to be exposed as the biggest fraud in the history of archaeology and linguistics. The good doctor has tenure so the university sent him here to be get him out of the way, but it's backfired. We're going be famous for all the wrong reasons."

She tossed the journal across the table to Blossom.

"Here you go. Take my notes and do what you want with them. This is your job now. I leave tomorrow. The UNESCO team is showing up in three days for a thorough inspection. There will be hell to pay."

Blossom leaned over to Hannah and said, "So, what happens next? I still do not have a specific assignment. Miriam talked about Mayan mythology and the professor just rattled off facts and dates, yet no one has told me what to study, what to look at, where to start or why I am really here."

Putting her arm around Blossom's shoulder, Hannah retorted, "what, where, why. Stop asking those questions of others and start asking them of yourself. Maybe that's where you'll find the answer. It's up to you now. It's your moment. In the meantime, I have to organize the graduate boys into a toilet cleaning squad. They hate it because it cuts into their hour for pot and porn, but I like hearing them moan and groan about it. And I love watching them bend over to do the job."

Left standing by herself in the middle of the camp as the staff dispersed to their duties and debaucheries, Blossom steeled herself for the task ahead. Taking the large brimmed hat out of her bag, she readied herself to leave the dense tree canopy of the camp and explore the temples of Tikal in the open sun.

Following a path for a short distance, she became disoriented when coming upon an intersection. Her heart pounded, her eyes ached and she began to quiver.

"You need help? You lost?"

"Whaaaaa!" Blossom shrieked, not knowing where the voice came from until she saw one of the camp workers.

"I sorry. I sorry. I help."

Holding her hand to her heart, Blossom said, "no, I am sorry. So,

so sorry. I am looking for the great plaza."

The man broke out in a generous smile, nodding excitedly.

"You follow me, please. We find the lost city."

He led her through the thick foliage towards a beam of light. Once out of the forest, they came upon five Guatemalans who instantly surrounded them. They all chattered at the same time, slapping the camp worker on the shoulder as he held forth with a story in rapid-fire Spanish. Then, they all raised their hands, laughed and embraced each other. One of the ladies in the group hugged Blossom tightly and pet her hair.

"It's okay. You safe now. You safe, little angel."

"Thank you, very much," said Blossom as she excused herself, the touching and laughter making her jittery, even though she appreciated their kindness.

Upon reaching the vast expanse of the great plaza, she thanked the camp worker, who sat on a nearby terrace watching over her as she assessed the myriad of temples aligned in every direction. Blossom paced about measuring, in her mind, the distances between monuments, the spatial relationship between each structure and the scale of the sculptures. While the soaring architecture attempted in its height to gently kiss the sky, the carved images at eye level struck her with their violent depictions of war and sacrifice.

Of all the great edifices, one called out to her in particular. Before the main acropolis, sited to the north, the Temple of the Jaguar lured her to the base of its staircase, which rose through nine stepped levels at a steep seventy-degree angle. Blossom's toe tapped the very first step.

"With this act, I begin the journey from the darkness of the world to the light of heaven at the summit where the tomb of the great king, Jasaw Chan K'awil, rests under the watch of the jaguar."

Passing to the second level of the pyramid, Bloom did not

observe in her usual empirical way. No numbers flashed before her. She did not memorize any data. Instead, she entered the realm of innermost thought, detached from the scene about her. A vision recalling the chaos of youth in the image of two fierce faces flashed before her mind's eye while her tongue recited words without prompting.

A house with two alcoholic parents. Always moving, never settling, forever fighting.

Her feet moved on as if she had no choice in the matter. Reaching the third level, she felt the fear of her father's rage after a few drinks.

Fire in the eyes, teeth clenched. Noise. Hell raising. I must hide.

Level four summoned up images of her mother admiring her own reflection in a dressing mirror.

What a shame. It's hard to believe you are my daughter. If you can't be beautiful like me, it's best to be invisible.

Her mind cleared suddenly at level five, where the physical world reentered Blossom's sight. Surveying the ruins below sparked recollections of the shambles of her bedroom after her mother took away her dresses, saying that she didn't deserve pretty things. The noises in Blossom's head increased with the chatter of the past, people talking around her but no one talking to her.

The silence of Tikal struck her on level six. Stone made no sound. She was too high up now to hear the birds and monkeys of the jungle. Memories of the stark silence of her own life came forth with a chill.

At level seven, she stood one hundred feet high from the ground, far from earth but not yet in heaven. She recognized this middle realm of nowhere, the prison of the lonely, reflecting on her own self-inflicted loneliness, her barricade against assault from fellow humans and her own fears.

"But isolation has its momentary joys," she murmured. "It is

familiar, the place where I can escape with the words, the numbers and symbols that are my only friends. They have never failed me."

Level eight presented her with the most dreaded curse.

"Despair. You have come to call. I almost made it to the top. Only one more level to go, but, as always, you insert yourself at the exact moment when I can see light and hope to reach it. You even push loneliness aside so even that uneasy friend cannot give me comfort."

A few more steps and she reached the summit of the pyramid at level nine.

"I give up. I surrender. There is nothing left to do."

Blossom perched at the edge of the stairs. Staring down at the one hundred and thirty-eight foot drop, the earth called to her.

"One step can bring release. For once, I can decide my own fate. Maybe this is the solution."

She imagined those who walked these same steps centuries ago as blood sacrifices to the gods.

"There is a dignity, of sorts, in that ultimate kind of offering. To own one's death can be a powerful act."

Then, the words, "you are the chosen," resonated through the air. It was the voice from Blossom's nightmare; the voice from the woman whose mouth gushed with blood.

"What do you want from me?" Blossom murmured. "I have nothing. I am nothing."

Moving her foot slightly, she slipped on the worn corner of the summit. Her head smashed down on the steps and she began to tumble down the stair, believing this to be the final fall to her death. This was not to be the end, however. Blossom grabbed hold of the nearest stone outcropping and saved herself. Crawling back up onto the summit, she laid down and felt a small gash on her forehead.

Taking a tissue out of her pocket, she cleaned the wound, pressed her hand against it and, in moments, the bleeding stopped, but not before a puddle of blood formed on the stone pavement.

"There is your sacrifice. Twenty-three drops of blood. I give it all up to you, whoever you are. I give you my fear and shame, my silence and loneliness."

Laying in the sun, having surrendered every emotion to the summit and the strange voice from nowhere, a sense of peace now came over her. She heard birds flying overhead and began counting them, listening to their cooing and singing as they landed on the tomb of the king.

Deducing the recurrent and rhythmic patterns in their tones, she took heart in how much she enjoyed deconstructing formulas, whether in sound, numbers or in words, for these saved her from the darkness of her early life. They had been her deliverance. In an instant, she realized that all was not lost in this lost city. Death and despair did not triumph on the pyramid. Quite the opposite. She lived and, at each level of the pyramid, purged the evils of the past. Her exact purpose in life was not clear, but she knew she had been chosen and did not question it.

Blossom surveyed Tikal from the summit of the pyramid and committed to memory the place of each building below. Hundreds of them spread out for acres, but counting posed no hardship since her mind processed each one in seconds. For this moment, she reigned as the master of Tikal, not a mighty warrior or a beautiful queen, but as a savior from far away whose gifts of the mind might set free the forgotten souls of this city. Above her loomed the image of a king sitting upon a jaguar throne. His bearing appeared royal and powerful, but Blossom also saw him as a prisoner of a lost age yearning to have his story told. Finally, a noise interrupted her silent observations as the roar of a jaguar drifted out of the jungle. She had no knowledge of the symbolism of the animal in Mayan culture, but she vowed to find out.

Unsure of what to do next, Blossom left the pyramid, descending from its nine levels and wandering aimlessly about the North Acropolis and back towards the plaza of the Seven Temples. Stopping for a moment to ponder, her eyes came upon a tomb. She had encountered many of these graves, but this one drew her to its ornamental carvings of men and women whose faces seemed so familiar.

"The bloodline really is intact; the Maya are still with us. As I run my fingers across these faces, I see the Guatemalans who helped me find my way through the forest."

Bewitched by the complexity of the sculpture, she attempted to follow the interwoven pattern of jewelry and mythological symbols worn by each figure. Sensing the coded messages that might lie within the composition, she scrutinized every detail, examining repetitions and sequences of form and ornament. Hours passed as Blossom perused the evidence. Twilight came unnoticed as she continued to compile data in her mind. Only when she felt a bite on her right arm did she realize dusk had descended with scores of mosquitos about to make an evening feast of her blood. She ran away from the swarm in vain since thousands of them emerged in the night air. The forest offered even less protection as insects of all varieties fed upon her and legions of bats flew in her face as she sped along.

At the intersection of many paths, Blossom turned left, unsure if it was the right way but being bitten by too many bugs to worry about her choice. Not a single light in the distance signaled the camp's location, so she ran faster. Her feet sunk into boggy soil while her head soon lost its hat to thorn-ridden shrubs. Darkness took over, robbing her of the ability to read, count or see anything that might be a guidepost. Only fear propelled her forward, tormenting her with the horror of what might lay behind and the terror of what might be ahead. These inner anxieties vanished when a vine lashed in a chokehold around her neck. Falling to the ground, she gasped

for breath. As she rolled to one side, the red veined pupils of the most grotesquely flaming eyes peered directly into hers. A hell-raising screech resounded in the dark. Then, all became black.

"She's coming to."

Blossom heard voices but she had not the strength to raise her head. Through her own clouded vision, she saw above her the roof of a tent and Hannah's face.

"You were eaten alive out there. Good thing the guard came across you on his rounds."

"I cannot," moaned Blossom. Trembling from head to toe, she burst into tears. "I hate it, I hate it. I do not want to be here. I do not want to be anywhere," she screamed as Hannah firmly held her arms.

"Baby, it's okay. You've just been in the darkest, wettest, nastiest, buggiest place on earth. You were found face down in the mud but you are okay."

"No, I am not. Nothing is okay," cried Blossom. "It is hell. I have always lived in hell and I always will. I am going home. I want to go home. At least it is a hell I know."

"If you go, your hell will only increase, my dear girl," said Miriam as she entered the tent. "There is no hell worse than the one you knew in Chicago because that was one of your own making."

Hannah helped Blossom sit up and offered her a glass of warm water with lemon. She gulped it ferociously. Tears subsided but a blank stare possessed her eyes.

"It came to me on the temple. I have had to live and walk through hell and I will probably never see home again. This is the final stop. This hot, hateful place."

Miriam and Hannah sat with Blossom, each holding one of her hands, until her eyes shut and sleep came. As evening progressed, fires were extinguished and lights went out in every tent. Night

reigned in the camp, the jungle canopy blotting out even the stars in the sky.

Amid the darkness, Blossom awakened to find herself alone. Only the muffled sounds of an animal broke through the silence. She got out of bed, wearing only a knee length t-shirt, and began to walk, shoeless, into the jungle. Guided by a groaning noise, she moved ahead at an even pace among jagged roots and decaying tree limbs. Hours passed. Worry did not enter her mind. No fear or despair blocked her way as she continued on until reaching the great plaza where a silken coated jaguar lay on a ramp.

The first faint light of dawn appeared on the horizon, illuminating a stone tablet, about six feet high, carved with the image of a woman adorned in an elaborate headdress of feathers, knots and bows. Kneeling before this figure, Blossom identified it as an ancient Mayan queen in full regalia. She deciphered the accompanying inscriptions as they extolled the greatness of this royal wife, her devotion to the all-powerful king, the number of princes and princesses born of her womb and her virtues of kindness, generosity and grace. Blossom then reeled back. This was the face from her nightmare, the face with blood gushing out of its mouth.

"You said I was the chosen," whispered Blossom as she ran her index finger along the hieroglyphs. In doing so, she viewed the standard forms of the Mayan language in a new way, one that seared through her like a thunderbolt. She realized that one symbol had been superimposed on another, concealing coded messages and letters repeating with a set mathematical formula. The first layer documenting the life of the queen offered no surprise for Blossom knew this as a typical feature of ceremonial stelae. The second layer revealed a prophecy.

"The Gods proclaim a girl will be sent to free me. She, the Chosen, will come in the fullness of Time and will be the savior of the lost city."

The sun now rising in the sky, the pyramids glistened white in the light of day. Blossom held her hands to her heart as she came to the truth of who she was and why she stood in the center of Tikal. She then returned to the inscriptions and deduced that further symbols and ciphers directed the reader to other stelae in the city predicting disaster and destruction, ruin and redemption. Blossom had discovered the key to an entire system of revelations. Reading further, she came upon an epigram at the base of the tablet.

"Temples rise and fall. Triumph and Tragedy pass without divine notice. Only the blood of the Maya prevailing on earth and under sky pleases the Gods."

The truth finally and wholly revealed itself. She knew for all of the grandeur of building, for all of the magnificence of kings and queens portrayed in stone, only life mattered. The gods had just told her so. This was their gift to her. All became clear. Everything and everyone she had encountered in what she thought was a god-forsaken jungle, made sense. The creation story of the Maya - the survival of their people, whether as ancient warriors or present-day workers - served as a testament to life itself. She fully understood it in terms of her own survival. Never had she been made to feel deserving of anything in the brutal world of her parents or the cold academic halls of her work. Others always seemed of greater value for the beauty, riches and accolades they so easily accepted as their right. Now, she embraced her own place in life as she pressed her hand against the image of the queen.

Blossom took in Tikal with new eyes, seeing the peacefulness of the scene with its orderly rows of altars, temples and terraces. As she scanned the sacred precinct, she no longer saw the jaguar. The Guatemalan camp worker who had guided her through the forest the day before now sat in the same spot in sunlight where the animal had stood guard under the moon. He gave a smile and a wave, both of which she returned in kind. She did not question where the jaguar might have gone or what the man was doing in its

place. She posed no theories or hypotheses.

With a parting nod to the stone image, Blossom made her way back to her tent. Barefoot, she felt the grass between her toes. Deep in the jungle, she welcomed the coolness of the shade, brushing a welcoming hand along the leaves of mango. Drifting along, she took a route she had not yet trod and came into a clearing with a grove of cacao trees playing host to hundreds of orchids. The flowers seemed to float among the greenery as sun, filtering through the foliage, dappled faint droplets of light on each petal. White, purple, blue and green, the blooms held court like blessed spirits in a forest that now presented itself to Blossom as gentle, generous, even gregarious.

"Where have you been!" bellowed Hannah as she poked her head through a mass of ferns.

"I found my way out of hell," said Blossom.

"Miriam and I left you alone for only a few minutes last night," said Hannah. "When I came back to check on you, I found an empty bed. I've been searching for you in the dark imagining how scared you must be!"

"I am fine," said Blossom. "I had protectors."

"What have you been doing?" said Hannah as she brushed Blossom's dirt-laden feet.

"I figured out what I came here for."

"And that is?"

"I discovered another layer of messages in Mayan inscriptions. The gods speak through them. Prophecies are concealed, one beneath the other. Follow the trail from one stelae to the next and a whole other history of the place emerges. There is an epic tale waiting in the stones. It will reveal why the Maya built Tikal and why they abandoned it."

"Girl, you just made history," exclaimed Hannah.

"Or history paid a call on the girl," came a voice from the greenery as Miriam emerged from behind a cacao tree. "Here's your trophy," she declared while placing an orchid in Blossom's hand and kissing her on the forehead.

"A breakthrough. A triumph. You were the one to do this. You were the chosen."

Miriam led Blossom through the forest with Hannah trailing closely behind. In moments, they were at Miriam's pavilion climbing up onto its terrace with Tikal presenting itself in the full wash of morning sun.

"The jaguar led me to it," said Blossom. "To a royal stelae near the Temple of the Jaguar. I had seen the face of that queen before."

"The jaguar is the Mayan's sacred symbol of night and darkness," said Miriam. "It is the ruler of the underworld and can endow one with the power to face one's fears." Placing her hand on Blossom's cheek, Miriam continued, "when sad and fearful, your quick, organized, constantly inquiring mind turned to obsession. You heard and saw nothing. You related to nothing for you were preoccupied with protecting yourself. Once you surrendered, you heard the jaguar and faced your fears. Then, you were free to do what you were chosen for."

"It happened all of a sudden," said Blossom. "The inscriptions on the queen's stelae revealed themselves in an instant. I saw the hieroglyphs, then I saw glyphs beneath glyphs shuffling back and forth in my mind."

Hannah set down cups of chocolate. She placed a pair of sandals at Blossom's feet and began to comb out her hair.

"Reckonings happen at dawn."

"Bless you, Hannah. You have taken care of me from the moment I arrived."

"You're good people, Blossom. I could tell. And I always had

faith in you."

"We both did," said Miriam. "I will report all of this to Cassandra. She will be so pleased. You have saved the day."

The three women finished their chocolate and watched the day flourish in full color with a clear azure blue sky. With the work of decoding secrets done, the ordinary things of life resumed. Visitors began arriving at the holy sites below. Tour leaders jostled for their places in line, elementary students jumped about the stone terraces and an archaeological society debated on the remnants of a royal frieze. A local man, the spitting image of the ancient crowned heads carved in stone on Tikal's stelae, swept paving stones as he had done for the past fifty years.

"Stairways to heaven," said Miriam as she surveyed the scene. "I think it's time for our Blossom to get some rest."

The women left the pavilion, retreating from the daytime bustle of Tikal to the seclusion of their tent. Sitting amongst her few possessions, Blossom threw out her remaining plastic bags. Packing was of no importance, however, as she replayed the night's happenings until fading into a deep sleep. No nightmares invaded her slumber. She dreamed instead of the colors of the rainforest and the white pyramids glowing in moonlight. Tikal rose as the mystical realm of kings and queens, of warriors and star gazing astronomers, of artisans and craftsmen creating one of the most beautiful sites on earth. All beamed with happiness until the earth shook.

"Get up, get up," said Hannah as she throttled Blossom's cot. "Cassandra is on the phone for you and says it's urgent."

Her head cloudy and her vision blurry, Blossom struggled to answer the phone.

"You are a heroine!" exclaimed Cassandra. "You did it. Girl, you did it. You've revealed the secrets of the Mayan gods. Get on the first plane back here. Big things are coming your way. I see an

official appointment, an office, a staff and all the money you need to fully report the research you've done in Tikal."

Sitting up straight, Blossom fully awakened and took full possession of herself.

"No, Cassandra. Thanks, but I am going to stay here awhile and then roam a bit."

"Um, is this the same girl who never left her house?"

"Yes, I was that girl, in the past."

"You'll be lost without your work."

"Oh, Cassandra, I was lost, but not anymore, thanks to this lost city."

"Now, Blossom, I'm sure we can arrange something. You are a star now. The institute will never let you go."

"Well, Cassandra, there are already enough stars in the heavens. And the institute has no choice but to let me go since nothing can stop me. Without you, I would not have gone anywhere and I thank you for that."

"But where will you go?"

"To get Benny, first. Then we will be off to Peru or Paris. Maybe Japan or Jerusalem. Maybe all of them. Heaven only knows."

Blossom hung up the phone, put her earphones on, laid on her bed and listened to Hannah's iPod, twiddling her toes to the beat of Led Zeppelin's *Stairway to Heaven*.

CONFUSION

"WHAT'S THAT MESS IN THE MIDDLE OF THE FLOOR?"

Janus sneered as he eyed a young lady with unkempt hair and thick glasses fumbling about with a large tote bag precariously perched on her left shoulder and a pint of ice cream melting in her right hand.

"She says she owns a painting by Jackson Pollock," said Sibyl.

"In her dreams," said Janus. "One more lost lamb. We've seen this before."

"She showed me documentation, Janus. So, who knows? It's a slow day and will only take a minute. If she's delusional, we can send her on her disheveled way."

With a measured shaking of his head, Janus witnessed the young lady drop her bag, its contents careening in every direction across the slickly polished floor of his Brooklyn gallery.

"There's no such thing as a slow day at Janus Rock Art Space. Remember that, Sibyl, if you want to keep working here. Go deal with that, whatever that is!"

With a roll of his eyes, Janus retreated to his office. With the shrug of a shoulder, Sibyl made her way across the gallery. Clad in a

fitted white cotton dress demanding an unrelenting poise from her lithe figure, she approached the young lady, a disorganized heap of wrinkled skirt and untucked blouse groping for her belongings. A pack of bubble gum, five bottle caps, three beaded belts and four ice cream receipts made for a trail of trash while an array of magic markers, pens, crayons, a half-eaten orange and a broken jar of raspberry jam produced a striking display of smears and streaks on the floor.

"Mr. Rock has agreed to see you. He can only spare a few minutes. Your name, if you please?"

Hands dripping with ink and other unidentified substances, the young lady wiped her fingers on her skirt. As she straightened her glasses, she blotted them with remnants of the jam stuck to her thumb. The attempt to clean the spectacles only caused further confusion as her blouse became the unwitting recipient of soil and stain. Finally, resolution of this disaster arrived when Sybil produced a moistened tissue.

"Oh, thank you. It seemed to be getting worse rather than better."

"Most definitely," said Sybil as she made a final swipe across the glasses. "Now, your name, please."

"My name? My name. My name," mumbled the young woman.

"That's right," said Sybil. "I'm asking your name."

"Yes. My name. I am Pansy. And, thank you so much for seeing me. I have a letter. Oh, well, I found it, then put it back in the bag and, now, well, oh, I am not sure. Maybe. Oh, yes. Here. No, that is not it. Um. It is here, somewhere."

Sybil took Pansy firmly by the arm.

"Mr. Rock is waiting."

"Oh, yes. Thank you so much. So kind of you. Thank you."

The two of them walked down a hallway hung with prints and

paintings bearing names Pansy did not know.

"These are the hopefuls," said Sybil. "But here is the one and only treasure."

They stopped in front of a black and white photograph at the end of the hall, separated from the other works, bathed in a silvery light from the ceiling.

"The pride of Mr. Rock's collection. The only work of art not for sale. This is the legend that lures people in, then they are tempted to buy the hopefuls."

The intense distinction between light and shadow in the photograph struck Pansy's eye, as did its image of a man naked except for leather straps wrapped around his waist. She peered closely at 'Mapplethorpe' scrolled boldly across a black edged label.

"I don't know this name. Funny things, names. We remember some and forget others. I wonder why?"

"Fame," said Sibyl. "Mr. Rock specializes in that rare commodity. Everyone starts out as an unknown, like Robert Mapplethorpe, but now he is a legend and his work is worth millions. When someone buys one of these pieces, they share in a hoped-for fame-making moment."

"Can anyone really buy fame?" said Pansy.

"A worthy subject to ponder," said Sibyl. "But, right now, Mr. Rock is waiting for you."

Entering through a tall mahogany door, Pansy beheld the man himself, a slim figure with steely green eyes and a mask-like face showcasing the smoothest skin, portraying not even a single unscrubbed pore. Dressed in a tightly fitted black suit and V-neck t-shirt, his black hair oiled and combed back in shining precision, Janus Rock sat assuredly in his well curated inner sanctum where a black leather chair sufficed for his seat of honor and a tubular steel desk his platform of authority.

"A Pollock. Can it be true?"

"I believe so, Mr. Rock. Well, I think so. I came to you for an expert opinion."

"How did you ever find me?"

Pushing the mass of curls away from her face, Pansy adjusted her chunky spectacles, in the process marring them with thumbprints. As she removed her glasses, her eyes, fully revealed, radiated a pale blue innocence and illuminated the whole room. Among the wreckage of her outfit and accessories, she glowed, unencumbered by awareness of her own clumsiness.

"My friend, Jerome, discovered you in the art directory. He can find anything. He just received his degree in astronomy because he likes to stargaze. And he also likes modern art. He likes so many things and is good at whatever he does, but he does not always think so. The library could not do without him."

"What does any of this have to do with Pollock?" asked Janus.

"Jerome found a postcard."

"A postcard of a Pollock?" quipped Janus as he reclined further into his seat and pivoted back and forth. "Maybe worth one dollar. If there is more to this, please enlighten me."

"Jerome remembers every postcard," said Pansy. "The library has a big collection. He assigns accession numbers to each and every one. But he doesn't even need the numbers. He has a photographic memory so he can find any one of them in an instant."

"So, you have a postcard of a Pollock. That's it?"

"Yes, Mr. Rock. It is in my purse, somewhere."

Janus thrust his arms forward, raising his hands in a halting motion.

"No, no purse. Please."

Pansy stood very still, scanning his face then moving on to the

carefully arranged Chinese immortals in jade on his desk. Her eyes bounced to and fro between the stone figures and Janus, who ceased the halting gesture and sat up ever so slightly and formally, his right eye twitching slightly as his left hand embraced one of the immortals.

"Pansy, let's get back on point. Pollock or no Pollock?"

Digging through her tattered bag, she pulled out a grocery list, a dry-cleaning receipt and, finally, a post card, which she placed on the desk.

"This does not make for solid evidence," said Janus.

Pansy reached back into her bag and produced a piece of discolored paper.

"This is a letter Mr. Pollock wrote to my great aunt in 1947."

Janus took the note and scrutinized it, eyeballing the erratic penmanship.

"This is your Pollock? Just a note?"

"No, Mr. Rock. I have a painting. I found it in the closet of the children's reading room at the library where I work."

He handed the crumpled document back to Pansy who proceeded to read it aloud.

"Dear Mrs. Poundacre, you are my angel. Last week, you saved me. Accept this painting as a token of my thanks. Jackson Pollock."

Seizing the piece of paper, Janus ran his index finger across the artist's signature.

"Where are you from?"

"Poughkeepsie."

"Pansy Poundacre from Poughkeepsie," he said with a grin from ear to ear. "Sounds like a porn star's name."

"I am not a porn star. I am a librarian."

"Believe me when I say I believe you," retorted Janus. "But the note isn't believable since Pollock never went near Poughkeepsie."

"My great aunt lived in East Hampton at the time she met Mr. Pollock. Later on, she moved to Poughkeepsie to be near her family."

"Where is the painting now?"

"It is in the cardboard box I brought into the gallery."

Janus sat up abruptly.

"Bring it in. One doesn't keep a Pollock waiting. Even a pretend Pollock."

"Yes, Mr. Rock. Right away. Thank you. Thank you so much. I will be right back."

Dropping her bag as she rose out of her chair, Pansy spilled its contents on the floor.

"Not to worry," said Janus. "Sybil will take care of it."

Sybil pursed her lips and glared at Janus while proceeding to sort the mess as Pansy stumbled out the door.

"Pansy Poundacre," said Janus as his jaw dropped. "She can't be for real. It has to be an act."

Picking up the remnants of a box of cinnamon donuts from Pansy's bag, Sybil said, "I doubt it. That girl is the genuine article. I sensed it the moment she came in."

"Well, you are all-knowing," said Janus. "Time will tell."

The door opened swiftly, banging Sybil in the backside and sending her crashing onto the pile she had just organized.

"Oh, jeepers! I am so sorry," yelped Pansy as she quickly closed the door and retreated into the hall.

"Heaven help us," said Sybil.

"Come back in here," barked Janus.

Nudging the door open only an inch, Pansy whispered, "I am not sure how I should come in."

"Oh for the love of God," exclaimed Janus, who flung the door open, pulled Pansy into the office, sat her firmly in a chair and went into the hall to retrieve the painting.

"May I help you up?" asked Pansy as she put her hand on Sibyl's shoulder.

"No! No! You just sit on the sofa and stay out of the way, please."

Carefully moving the painting into the office, Janus leaned the three-by-five foot canvas against the wall and beheld its splattered swirls and dots. The closer he looked, his eyes began to sparkle.

"Pansy, leave the room."

"Oh, okay, Mr. Rock."

"I mean, please wait in the gallery," said Janus with a nod. "Sibyl and I need to do a proper assessment."

Pansy closed the door then opened it again to release her skirt.

"Sorry about that," she murmured as she exited.

Yet again, the door came ajar as Pansy grappled with her charm bracelet which had wrapped around the handle.

"Excuse me. Oh, by the way, the painting is called *Reflections on the Big Dipper*."

"Yes, I know," said Janus as he waved his hand in dismissal.

He probed every detail, tracing the powerful curving streaks of black dominating the canvas, relieved only by the spattered dots of yellow and blue.

"Heaven help us! It might actually be the real deal. That mess from Poughkeepsie may have unearthed one of the greatest finds in modern art. But only we can know this. You got that, Sibyl?"

"As always, Janus. Shall I go get the poor little creature?"

"Yes. But don't act too excited. We don't want to encourage her in case the painting is genuine."

"You know me, Janus, acting excited is not my style."

Leaning back in his chair, Janus sized Sybil up and down.

"Mmmmmm. Detached is your mode. I never quite know what is going on behind the cool façade and the understated dress."

He rocked back and forth as he quipped, "and none of my concern, really. You are here to handle Pansy. And don't you make a pretty pair, the chic gallery manager and a shambles of a girl. I see a makeover story coming soon."

With a cold countenance, Sybil left the office. She returned in an instant with Pansy, the door being held wide open to prevent any more mishaps.

"Jam," said Janus with a sigh as he offered up a tissue. "On your cheek."

"Pardon me," said Pansy. "I found a raspberry cookie in my pocket."

She scrubbed her face with unnecessary ferocity then searched about for a place to discard the tissue.

"Give it to me," said Janus. Pansy put it in his hand, the sticky side of the tissue adhering to his palm. After several attempts, he finally peeled it off and threw it away.

"Tell me the whole story from beginning to end. Don't leave anything out. I want to know where and when you found this painting and how you came to think it might be a Pollock."

Sitting in a vintage Saarinen tulip chair, Pansy's rounded shoulders and knocked-knees were at odds with the effortlessly sinuous form of the museum quality piece of furniture. Both of her arms became tangled in the cords of her tote bag, which seemed to wage war on her as it became increasingly impossible to escape its web.

"Tragic," whispered Janus as he shook his head.

"Comic," Sibyl retorted as she pressed her cheeks with both hands.

Pansy finally surrendered to her bag and slumped into the seat.

"Talk, Miss Poundacre," said Janus, grinding his teeth. "Slowly and succinctly, if you can."

"Um, I work in the children's room at the Poughkeepsie Library. I have been there for three years. Hired right after graduation. Well, actually, I interned there during college on summer and winter breaks. I also helped out on weekends when I visited my parents. You know, I was not sure about library science. I started out as an English major but when I started working at the library, I realized how much I loved books on shelves, you know. And getting books off of shelves for people is very exciting. So, I am pursuing my master's degree in library science. Jerome feels the same way about postcards. He began as an accounting major but then volunteered at the library and fell in love with making lists of objects and letters and postcards and things like that. And now he charts the stars and planets, making lists of them too. It makes sense. He went from making lists of numbers to lists of things. He is part time as our special collections manager so he is still with the accounting firm because he needs to pay for his dog's obedience school. Jerome is not very assertive so his Labrador is out of control. The dog trainer is very nice."

Pansy stopped speaking and stared blankly at Janus, who sat rigidly, pulling at his jacket lapel and flaring his nostrils more widely with every passing second of silence.

"Pansy, the painting. Not libraries, not Jerome or his astronomy or his dog. Just the painting. That's all I care about. The painting. Got it?"

"The painting," mumbled Pansy ever so dreamily as her eyes wandered about the room, finally settling on a small sketch on

the wall. "I cannot draw or paint. I do not know anything about art. I found the Pollock in the closet of the children's room at the library. No one ever went into the closet but I needed extra space for supplies. The janitor said the painting used to be taken out to decorate the refreshment tent at the summer art festival, but that was a long time ago. It had been sitting there in storage for years. They thought of throwing it away, but the committee could never agree on anything so it just sat there."

"Throw it away?" asked Janus.

"Yes, the library doesn't have much space. You should see the old VHS videos. We do not know what to do about them either."

Janus's jacket became tighter as he tugged at the buttons.

"The Pollock. I only want to hear about the Pollock. Nothing but the Pollock."

Pansy reached into her bag, took out a cough drop and began to unwrap it, dropping the candy on the floor. She offered one to Janus, who waved it away. She offered one to Sybil, who buried her face in her hands. Unfazed, Pansy popped the lemony treat in her mouth and began to suck on it until she noticed Janus's eyes piercing hers.

"Oh, sorry. I should finish the story. It is very curious. The same day I found the painting, a college student came in and asked about books for her research paper on Jackson Pollock. As I helped her, I noticed the similarity between Pollock's works and our library painting. I called Jerome and he went on to all sorts of databases. That evening, my mother and I were at my great aunt's house to sort through her belongings. She passed away about a year ago and her place was crammed full of things. That is when I came across the note from Mr. Pollock. My mother also found a letter from the library thanking my great aunt for lending the painting. Then, Jerome called and said a museum in Holland had a painting identical to our Pollock. All of this just came together in one day. Life is funny that way."

Janus turned to Sybil and said, "around us are the works of all the mediocre artists who I hope to make famous through the relentless spin of publicity. Now, through the twisted hand of fate, sits a discombobulated girl who might make us rich and renowned beyond our dreams."

"A chaotic mess," said Pansy.

"Excuse me," said Janus. "To what do you refer?"

"That is how some critics described Mr. Pollock," said Pansy. "I feel sorry for him. Imagine, my aunt gave him a ride, not knowing she had the greatest living American painter in her car. Although, I am not sure why he was one of the greatest painters.

"Because he danced," said Janus, who rose from his chair and circled around the painting, his right hand floating in air as it followed the black lines, his left hand pointing to each colored dot. "Pollock moved around the canvas as if in a supercharged ballet. *Reflections on the Big Dipper* is done in his drip technique, throwing and spattering paint across the canvas in what looked like chaos but which, in fact, produced the most elegant compositions. Here we see the puddles of color and blotches of black which seem so ominous to me, like spirits from the past. Then, there is the silver, as if it is a call from heaven, lightening and uplifting the whole work. It truly evokes the abstracted essence of a cathedral. Genius. Divinely inspired."

Pansy listened intently as she watched Janus no longer sitting tightly wrapped in his fitted clothes. Instead, his tall frame moved easily before Pollock's creation.

"Seems like God used the tortured soul to be his messenger on earth," said Pansy. "If you travel with the lines, weaving in and out, all of it comes full circle. He is showing us the way, if we pay attention. I am usually confused by just about everything, but not when I look at *Reflections on the Big Dipper*. I see the order in the chaos. At the library, I like to make order out of mess. I love chipping away at heaps of paper nobody wants to touch."

"Out of the mouth of babes," said Sybil. "Where did this measured, articulate voice come from?"

Pansy shrugged. Sybil and Janus faced each other and shook their heads in unison.

"Pansy, leave the painting here, if you will," said Janus. "So I may muse on this a bit longer. Give me a week or so, then I will be in touch."

"Okay, Mr. Rock. Thank you. Thank you, so much. I better get going now since I have to make the four o'clock bus to Poughkeepsie. They do not run that often."

"I can't imagine why?"

"Really? You cannot?" said Pansy.

Putting his hand on her shoulder, Janus delivered her into Sybil's arms. Arching his eyebrows, he said, "Miss Poundacre is leaving us. Get her a taxi to the bus station."

As Pansy pulled away in the yellow cab, a piece of her skirt stuck in the door, Sibyl breathed a long sigh.

"That girl will make her mark someday. I don't know quite how, but I'm sure of it."

"She's already made her mark," said Janus as he pointed out the riot of stains on the floor. "Pansy Poundacre's version of Pollock. That's one art work we don't need. Clean it up."

Sybil drew the window blinds and locked the door. She cleared the debris, mopped the floor and turned off the lights, putting the gallery to bed for the night.

Only one light continued to burn that evening as Janus sat in his office pouring over data on the collective works of Jackson Pollock. On Janus's shimmering steel desk, a Bauhaus lamp shed a razor-sharp ray as he stared with unrelenting attention at a computer screen. Several miles away, Pansy blithely made her way back to

Poughkeepsie, enjoying a dinner of pretzels and orange soda on the bus.

When daylight appeared on schedule, Sibyl arrived to open the gallery for another hopeful day of sales. She found Janus asleep at his desk, the computer screen aglow with images of abstract expressionist paintings. Raising his head, the bloodshot eyes and unkempt hair revealed a man burned from the inside out.

"Any news?" she asked.

"None. I'm going on instinct here. It's possible that Pollock made another version of *Reflections on the Big Dipper*. But I can't connect the dots, yet."

He flopped on to the office sofa and held his hand up, the standard command for coffee. Sibyl dutifully went out for his latte as he faded off to sleep. The ringing of his cell phone, however, ruined any chance for rest.

"Hello, Mr. Rock. This is Pansy. I want to let you know about some research Jerome has done. He contacted the Stedeljik Museum in Amsterdam. Funny thing, his cousin works there. Jerome's aunt married a Dutch man and their son became a paper conservator. He also likes to bicycle and we went on the best rides along the Hudson when he visited last summer."

"Pansy, I know that the original *Reflections on the Big Dipper* is in Amsterdam. I already emailed them and came up with nothing."

"Well, Mr. Rock, Jerome's cousin made a discovery in the museum's archives. He found a letter to Jackson Pollock from a former director stating his admiration for the study of a painting he saw when visiting the artist in New York. So, we can assume that my painting is that initial study. The letter was misfiled and forgotten about, just like my painting. How about that?"

"Pansy, we need to meet. I'm coming up to Poughkeepsie tomorrow."

"Really? Okay, Mr. Rock. I think you will like the library. The building dates to 1876 and is a fine example of Victorian architecture."

Janus hung up without responding.

The Palisade Parkway freely offered up its autumn hues as Janus sped along in a 1965 Aston Martin. Orange, rust and yellow leaves yawned lazily against the blackened trunks and branches of trees giving up their summer coats. The faster he drove, the landscape about him became a blur of color. As he arrived in Poughkeepsie, he did not slow down, his car a streak of silver along the street. Pulling up to the public library at top speed, he parked in the space reserved for the director and marched into the small but venerable building of rough-hewn granite. Dashing in and out of offices without announcing himself, he waited for no questions or assistance. At the end of a long gallery, he noticed a mass of curly hair behind a pile of books.

"Pansy!"

Popping her head up from her dictionaries, monographs and journals, Pansy appeared more distracted than usual.

"Mr. Rock. We are all over the news. What's happened?"

"My girl, you are famous. Last night, I received confirmation from three experts that your painting is indeed a preliminary study by Pollock. The auction is set for November first."

Pansy hid her head behind the books.

"No you don't," said Janus. "No burying yourself here in this old tomb."

"Shush," said Pansy. She took him by the arm and led him to a marble vestibule dominated by a statue of Athena seated on a stone and holding a book, a scroll and a painter's palette.

"Mr. Rock, do you know I have received a phone call from

Converse to be their spokesperson? And Skidmore, Hampshire, Oberlin and Williams have all invited me to speak. I cannot lecture at colleges. And I cannot be a footwear spokesperson, either. I want to be quiet and alone. It is why I work in a library."

Resting his hand on Athena's knee, Janus glanced back and forth to see that no one could hear.

"This is a once in a lifetime moment. You have no choice. Fate has made you its messenger. There's no avoiding fame. In 1949, LIFE Magazine did an article on Pollock, aptly titled 'is this the greatest living artist?' He was the master of Abstract Expressionism, the hope of America at mid-century. But his life was cut short by a car accident in 1956. The anxiety ridden genius taken from us. Your discovery will resurrect him. You can't back away from all of this."

"The painting is famous, not me."

"No, Pansy. It doesn't work that way. The press wants the innocent girl, the shy librarian who discovered another gift from the god of modern art."

Janus glanced upward at the statue, his right eyebrow gesturing for Pansy to follow his line of sight.

"The goddess of wisdom and war agrees with me. The universe commands it."

Pansy furrowed her brow as she polished the sculpture's brass plate with the cuff of her shirtsleeve. She tapped her fingers on the marble several times, appealing to Athena for an answer. When a shadow cast itself upon the statue, Pansy reeled backwards in a panic. In fact, it was Jerome, carrying a stack of books.

"Pansy, are you okay?"

"Oh! I saw the shadow as a bad omen, but it is you!"

"Well, maybe she is trying to warn you," whispered Jerome. "Deities work in mysterious ways."

Pansy smiled and made a deep sigh, reassured by his very presence in the cold vestibule.

"This is Mr. Rock. He says the universe demands that I sell the Pollock."

"The universe?" said Jerome. "It's your decision alone, Pansy."

Pansy looked up at Athena again. Jerome placed his hand on hers.

"Just a few minutes ago, the reference librarian took calls from Covergirl and Keds. Both are offering you contracts. And the calls keep flooding in."

"That's right," said Janus. "Pansy is big time now. Total hipster superstar. No time for your postcards and lists and whatever else you do in Poughkeepsie. Real life is calling."

Jerome dropped the top two books in his pile. As he bent over, his shirt came untucked and his glasses fell off. Pulling himself together, he fixed his spectacles, gave a sad glance to Pansy, a cold stare to Janus and moved on. Leaning in over Athena's knee, Janus broke out in a deep dark grin.

"Trust me. This is all as it's meant to be. You sought me out, remember? Why did you do that? There is a reason and it's bigger than both of us."

"Well, if you say so, Mr. Rock. I suppose you know best."

"You're an angel, Pansy. Do those lectures and product endorsements. And come to New York for the auction. It's only one month away. November first. On that day, we'll see what the future holds."

Janus left Athena's vestibule, his lean figure in a black suit snaking through the quiet of the reading room where Pansy caught the library ladies peering with interest and a touch of desire. Jerome, standing behind a bust of Plato, his arms still filled with books, clinically observed the man who appeared to have possessed his

workmate. Once he knew Janus had cleared the building and Pansy was safely at her desk, he returned with his rare volumes to the special collections vault.

The library resumed its quiet, contemplative tempo while Pansy fretted at her computer. She returned emails, surrendered to every request and readied for what might come. Jerome occasionally passed by, hoping to connect, to talk, but she never engaged and he would not intrude. As minutes turned to hours, she lost herself in library minutiae. When the closing hour arrived, she turned off her desk lamp and left her beloved books in the darkness, only Athena remaining illuminated by a spot light.

ONE MONTH LATER

"Pansy is a sensation. Who knew our shy girl would become a star?"

The library director sat in her leather armchair as if she were the queen of heaven, lording it over her domain. She never had time for the meek little girl who cared for the children's room and barely made a peep in the workplace. Now that Pansy had achieved fame, she became a favored daughter. The staff gathered around like a chorus, all chirping in admiration for their homegrown celebrity.

In the past four weeks, Pansy has been all over the press," said the director. "And our library always gets an honorable mention. We have been the protector of the Pollock for decades. I've never been so proud.

Jerome sat among this gaggle of bookish busybodies.

"Can we truly say that the library protected the Pollock when it had forgotten about the painting and let it wile away the years in a closet, in danger of being disposed of by any one of us?"

Ignoring Jerome's words and very presence, the director and her coven continued to banter, gossip and scheme about how the library could benefit from Pansy's notoriety. Since none of it made any

sense, Jerome excused himself. As he made his way to the special collections vault, he was startled by a figure entering the building.

"Pansy. You are back."

"Hi Jerome. I hope you have been well."

She stood, shoulders back, her hair soft and silky, pulled back into a ponytail. Fitted jeans, a t-shirt screened with a Pollock print and a tailored suede jacket made her an idealized figure of hipster chic. Heavy spectacles no longer concealed the pale blue eyes, which now drew the attention of the entire room. Everyone gawked in amazement at a girl transformed. Clucking and cooing, the library ladies cornered Pansy and pushed Jerome out of the way. Pansy mouthed to him, "ice cream parlor, later." He nodded and pointed to his watch, "in half an hour." Pansy smiled in affirmation.

As the clock ticked, Jerome sat in front of his hot fudge sundae, watching the butter pecan ice cream and chocolate sauce melt into a medley of swirls. He knew it would be at just the right point for eating once Pansy walked through the door. And that she did, just in time to order her a strawberry parfait with a dollop of green tea ice cream and honey coated almonds. He grinned at her. She returned the gesture.

"So, you are back."

"Yes, Jerome. Thankfully. And I wish I could turn the clock back."

"You seemed to enjoy it according to all the media buzz. But, I know appearances can be deceiving. How is Rufus?"

As she raised her spoon for a first taste, Pansy knocked over her parfait, a reddish-green stream spattering everywhere. In his attempt to help, Jerome dipped his shirt cuff in his dish, adding chocolate sauce to the smears on the table.

"Rufus is fine. He is with the band in L.A. Well, I am not sure how fine he is. It is complicated. I realize now that we dated only because he wanted to use the Pollock for his album cover. I like him,

I think. Well, I don't know. You know."

"Actually, I don't know," said Jerome who diverted his attention to his pocket, pulling out a small notebook.

"I've been doing some research, making a list of all of Pollock's known works. The experts have missed many things."

"Oh, really? Well, you are so good at lists. Do tell."

Jerome's lips pursed into a grin.

"While you were away, I went out to East Hampton and sought out some of the local folks. One day, while I was having ice cream, I met a one hundred-year-old-lady who told me she delivered eggs to Pollock and his wife, Lee Krasner, before he hit the big time. I asked her if she recalled seeing any small paintings by Pollock. She said the artist showed her a study he gave to a lady who acted as his Good Samaritan."

Pansy slammed her spoon down and took both of Jerome's hands firmly in hers.

"Jerome, you are a genius. You have discovered more about the painting than any of the art dealers and experts I've met this past month."

"Thank you, Pansy. That means a great deal coming from you. After traveling so much and meeting so many people, what will you do now? Will you stay in the city after the auction? It's like a whole new life has started for you."

"Who knows," said Pansy as she rifled through her handbag and pulled out a magazine article.

"This is something I found. It's a story about Lee Krasner. After Pollock died, she wanted to take care of his legacy and honor his true talent rather than his celebrity. She knew fame was his enemy. But she made sure he would be remembered in the right way. Instead of making millions selling his work, she started a foundation and ensured that his art was seen far and wide, not just

at big museums, but at small galleries and schools. It makes me think about *Reflections on the Big Dipper* and its future. Who am I to decide its fate? I'm just its accidental keeper. It doesn't feel like mine."

Jerome read the article, making lists of key words in his notebook.

"Pansy, may I go down to New York with you tomorrow for the auction?"

"Please do, Jerome. We will have to leave at dawn."

"The dawn of a new day, Pansy."

They both returned to their ice cream, finishing it in silence, the occasional almond topping or droplet of caramel sauce spilling onto the table.

9AM THE NEXT DAY

New York City greeted Pansy and Jerome with cold hard pavement and far too much noise for their tastes. Pushed and shoved by the masses on the sidewalks, they struggled along Fifth Avenue to the auction house, where Janus Rock waited at the front door. As they entered the building, cameras flashed at Pansy, the new star of the art scene. Reporters hailed her as the "Angel of Modern Art" and solicited her opinions on everything from painting to the perfume to be named in her honor. All the world appeared to hang on any word she might utter. Janus Rock held onto her arm as if she was his personal property. Two meticulously suited executives paid homage to her as they ushered in their newly minted star to the front of the auction hall while Jerome faded into the background.

"Ladies and gentlemen. Welcome to a moment that is history in the making. A rare Pollock has caused a sensation and so has the young lady who brings it to us."

The auctioneer gestured for the curtain to be pulled back and rapturous applause ensued as *Reflections on the Big Dipper* showed

itself to the assembled worshippers. Wall Street tycoons, technology titans and a sundry collection of the internationally rich each made their offers as the price rose and kept reaching to the stars.

"Eighty million. I see eighty-five. Ninety. Ninety-five. One hundred million. Ladies and gentlemen, do I hear one hundred and ten million? One hundred and twenty million? On offer now, one hundred and twenty-five million. Now, one hundred and fifty million."

In the midst of the hyper-bidding, an assistant presented the auctioneer with an envelope.

"Ladies and Gentleman, I have news. The painting has been sold."

The gavel slammed down, ending the auction.

"For what amount?" asked Janus, springing from his seat and running up to the podium.

"How much? You didn't state the final offer?"

"I can only say, Mr. Rock, that the painting has been sold."

Janus searched for Pansy, who stood at the back of the room with Jerome. Confusion reigned. The crowd milled about hoping for news while reporters lobbied anyone for information. No one had an answer. Speculation and rumor ran rampant as Janus made his way to Pansy.

"I don't know what's going on, but not to worry. I'll get to the bottom of this. At least we know that the Pollock is worth one hundred and fifty million. And an online bidder may have sealed the deal with even more. This is an epic day."

"Yes it is, Janus," remarked Pansy. "It is All Saints' Day."

"What the hell does that have to do with anything?" snapped Janus.

"Jerome told me that November first is All Saints' Day, the day when the Christian church honors the lives of all saints and their sacrifices for humanity. It made me think of Pollock. How, through his own pain, he created something heavenly."

Janus looked up at the ceiling as if beseeching someone or something to deliver him from another of Pansy's ramblings.

"Um, okay, we know he was a tortured artist and all that. I just want to know how much his painting sold for."

Pansy jerked her chin in defiance. Her soft blue eyes radiated a laser-like intensity aimed at Janus.

"Fame made Pollock suffer. It exposed him when he needed to be protected. So we decided to expose him no longer. Jerome bought the painting for one dollar and he is giving it to the library."

Fire filled Janus's eyes.

"What!"

"Stop there, Janus. Speak no more," said Pansy as she held her hand up in a halting gesture. "The painting will reside in the Poughkeepsie Library closet until it is taken out once a year on All Saints' Day to be shared with sixth graders on organized field trips. Jerome will be its guardian as special collections manager. He's good at that. Do you know that St. Jerome was the patron saint of libraries? Quite appropriate."

Shaking and quaking in his streamlined suit, Janus appeared thinner than ever. His face grew as white as a raw canvas, untouched by the joy of color.

"You can't do this!"

"We did."

"Indeed they did," remarked Sibyl, who emerged from the crowded showroom. "I always knew you would make your mark, Pansy. You're standing tall now and everything has fallen into place

rather than on the floor."

"I have you to thank you for that, Sybil. You did not turn me away that day I stepped into the gallery."

"I would never turn away a good soul," said Sybil.

"What is going on here?" barked Janus. "You two-faced liar, Sybil. You've betrayed me."

Resting her hand on his arm, Sybil retorted, "as you may know, Janus was the two-faced god of ancient Rome. He presided over beginnings and endings. This is your role, Janus. No one has betrayed you. Simply put, you were the vehicle used by Fate to bring this girl to meet her future."

Pansy and Jerome joined hands.

"We are going for ice cream sodas. Then, it's back to Poughkeepsie to stargaze. Jerome is going to show me the Big Dipper. The one in the sky. We will see how it compares to the painting."

"Back to Poughkeepsie with that lumpy bookworm?" screamed Janus. "Leaving money and fame and cool clothes and hot guys behind? You had the world in the palm of your hand. I put it there for you. And now you are going to nowhere with a nobody."

"I know where I am going, but do you? I think you are confused. But maybe you can find your way."

Pansy undid her ponytail, letting her hair fall in her face. She put her spectacles on and leaned against Jerome's shoulder.

"Janus, I saw true love in your eyes when you first explained the Pollock to me. Find that emotion again. It might be your salvation."

The Journal of San Carlo

Prologue

Herein is the account of a journey from hell to heaven in seven days, or, more precisely, notes on the restoration of a remarkable pile of stones in the eternal city. Let this, my journal, serve as a moral lesson and spirit guide to anyone who attempts to confront and control the intersection of the earthly and divine in built form. Beware of men who are boys. Be assured that bricks will break. Believe that brains triumph over bravado. We can be certain of what makes a building stand or fall for these are measurable things. We can never be sure of what causes the human spirit to sink or soar for a soul is as complex, infinite and unknown as the universe itself.

Signed on November 4th, the feast day of St. Charles Borromeo. Laurel Eve Vittore, Restoration Architect for San Carlo alle Quattro Fontana, Rome

Day I: Chaos

Morning:

Darkness, dirt, disarray. I wonder how Italians ever created beauty in the midst of such chaos. I might regret accepting this position. Upon entering the church, I find workmen hanging from rickety scaffolding

with buckets flying through the air on ill-attached winches. Wood planks cover the windows, making the interior drab and details impossible to see. Dust blankets every blessed surface. I console myself with the hope that this unsafe and unsightly scene might keep my mind off of him, her, them and that whole other disaster. That's in the past. Only the present matters now.

On appointing me to this lofty role, Father Belloguardo said only I could do the job. I told him I had no faith in myself. The task at hand is impossible. He responded with priestly authority. "God created the world in six days and rested on the seventh. You, the brightest fellow at the American Academy, winner of no less than the Rome Prize, can repair God's house in the same time." He then handed me my orders. Oversee a current slipshod window installation and develop a summary for a long-term restoration plan in a week, in time for the visit of some cardinal on the feast day of St. Charles Borromeo, for whom the church is named. Declaring only a miracle would achieve this end, I immediately regretted my words. I'm sure he'd heard it before. Thankfully, he showed mercy and didn't respond. This project could be my damnation, but it's good for the resume if I can pull it off. So, onwards and, maybe, upwards, if the Italians cooperate. What am I saying? I've lived here for a year and know better.

I begin by measuring the circumference of the building. About sixty-six feet long and thirty-nine feet wide. The heart of the plan is a simple oval, the stage upon which an architectural rhythm rises with the pairing of columns and moldings that curve and bend in a Baroque flourish without equal. It's truly masterful. This is not monumental but rather small by Roman standards. Big and bold is easy. Concise and complex are hard, but they are oh so compelling. The walls project and recess in a fluid sort of elegance made even lighter by a uniform surface of white paint with faint touches of gilding. The dynamic and restrained joined in harmony. I'm in love. Even in its woeful condition, the power of the structure is fully evident.

I do NOT assemble the workmen as a group. Being marshalled in an obvious way might not be to their liking, especially by someone young and female. It's inappropriate to apply stereotypes and assign prejudices, but from their attitude and posture, the opinions of these gents is apparent. So, it's up on the scaffolding to join them at the window on the east side of the dome. As I ascend, their expressions range from flirtatious and flippant to defiant and disinterested.

Upon examination, it's clear that the new window frame won't fit. Picking up a level, I test out the evenness of the stone sill. It's about one-eighth of an inch off. I take a chisel and shave off the exact amount. The frame sits in its new home with unfailing precision. Most of the gentlemen nod their heads in approval. Every look conveys acceptance of some sort. The flirtatious ones become more so, the flippant ones hold their tongues, the defiant ones soften, the disinterested attempt to remain neutral, but are betrayed by their knowing looks. Now, we can get to the task at hand. With the two senior craftsmen, I inspect the remaining windows, citing good work accomplished and new projects to be done. With each point made, I improve my worth. I order the dust cleaned up and the scaffolds stabilized. They think I am overdoing it, but they respect the wishes of the "Signorina who knows the craft."

Afternoon:

Signor Rossi arrives an hour late. He is all fine leather shoes, bespoke jacket and silk scarf tied with arrogance and worn with condescension. In an instant, he takes stock of my "bella figura." My credentials don't seem of any import. I think "whatever" to myself, ignore him as best I can and carry on. Story of my life. This is the supervising architect who took six months to make this mess and I get seven days to clean it up. But I still have to collaborate with him because I have no license to practice in Italy. What form of hell is this? I do all the work. He prances and gets paid. Incompetence seems the order of the day in Rome. At least most of the crew

appear to be on my side.

We walk about the interior. I take notes because I record everything, even what many deem insignificant. Nothing and no one escapes my attention, not a word, an image, a gesture or an expression. The only way to succeed here is with hard facts, which have been utterly disregarded. Incomplete drawings, insufficient spreadsheets and outdated survey forms litter the place. This is the chaos of Signore Rossi, who ignores me and speaks of the sensuality of the space and points out nuanced light cascading over what he calls "fluid forms." He's full of it. A form is a form, not a fluid. They are polar opposites.

Signor Rossi says, "pay special attention to the light. The brickwork is sound. No problems there. Don't worry about the structure. It's lasted for over three centuries. And don't fuss about the details. They'll take care of themselves." His parting shot is, "it's all about atmosphere, you know. The marriage of stone and light. The building shifts its shape, and, thus, so does the soul. Then, one is transfigured. It's a beautiful ensemble that seduces the senses and steals the heart." He then offends, whether intentionally or not is of no concern, as he tells me what I am like and what I should do. "The secrets here cannot be unlocked by an intellectual like you from the American Academy. You are too earnest, my dear Signorina. A touch of decadence is essential to fully grasp this place. Alas, I am no longer needed. The good Fathers of the Church once viewed me as their saving grace. No more. Their hopes for salvation have now fallen on you."

He makes a grand exit, appropriate to the theatricality of the space, by proclaiming, "Rome, where every hill is a chore and every monument a bore." I do note some dust clinging to the cuff of his pants, a reminder that, for a few moments, he has walked on earth with mere mortals. He leaves behind a pile of erratic sketches and nonsensical notes. I will put all of this in order, starting with the floor and working my way up those curvaceous walls toward the dome.

The day's triumph comes with the unveiling of the windows. The supervisor warns against it. "No, Signorina. We don't take the planks off until all the windows are finished." I say, "Signor, let there be light." He begrudgingly acquiesces. The shaking of his head clearly indicates that I am wasting time with my lofty ideas about restoration. As the workmen remove the wooden planks, light pours forth along the ceiling, down columns and across ornament. It dances on the newly restored window frame and lintel, highlighting superb craftsmanship. I clap my hands. The workmen do the same. Score one for me. The supervisor willingly raises his hands in defeat.

I recall Father Belloguardo's words to me. "Saint Charles Borromeo worked in chaos, creating light where there was darkness." Dare I say, I have done the same? I won't clasp my hands in prayer as I'm not a believer. But I'll just cross my fingers for good luck. Faith has its place but facts will be the salvation of this church. And I must begin at the beginning with research on the origins of this enigma. Architecture and history will occupy tonight. What tomorrow reveals is anyone's guess.

Day II: Borromini's Sky

Morning:

The day's objective is to understand the whole, to start on a methodical plan for restoration so the majesty of the building shines with its original luster. History has the honored position here. In the darkness of last night, I studied the past in the hope that it will inform me about big ideas and small details. It has introduced me to an angel. Here enters the genius.

The creation of San Carlo alle Quattro Fontane was an act of brilliance, both aesthetically and structurally. Francesco Borromini produced a masterpiece of Baroque architecture, a church transcending mere magnificence. It is a structure made by human

hands that appears to defy the fundamentals of construction and space in its praise of the divine. How does a dome appear to float? How do columns soar? How does light emanate from unknown sources? Simple. It's a marvel of design, engineering and craftsmanship done with brio. The Romans do everything with swagger, whether it be buildings or music or food or dressing or walking. But, behind that bravura is remarkable thought, inspired talent and exacting discipline. If these traits were not in play, none of the bricks would stand or, more importantly, sing.

Borromini hailed from the Ticino near Switzerland. This boy from the countryside had to navigate the realms of competition and corruption in the heart of the Papacy. Succeed he did for the brilliant young man conquered Rome, the center of the Christian universe, where he turned the earth upside down. Melancholic and idiosyncratic, his intensity and mood swings may have been his personal torment, the curses he had to bear in a life of instability and depression, but in his architecture he had complete control. He was the unrivalled creator. This church is a flight of fantasy grounded in solid structure. Borromini knew how to build. From the very first brick, his designs are a case study in geometric precision and meticulous construction. There are problems with the windows and a few lintels, but the body of this place is sound.

Afternoon:

Gianlorenzo Bernini claimed the title of golden boy of Baroque Rome, the charming courtier always winning the choice commissions, ever the favorite of the Pope. A talent? To be sure. Yet, no one built like Borromini. San Carlo is the triumphant proclamation of his genius. Little did anyone know what was about to happen when the Spanish Trinitarians, an order dedicated to the freeing of Christian slaves, asked the architect to design a house of worship and a monastic complex on the Quirinal Hill. Cardinal Francesco Barberini paid for it all and, thus, required that it stand opposite his palace at the intersection of four streets, each corner

marked by a lavishly sculpted water font, thus bestowing the name of the Church of San Carlo "alle Quattro Fontane," or at the four fountains. Built between 1638 and 1641 and dedicated in 1646 to Saint Charles Borromeo, this work of architecture is a portrait of Borromini, a man whose extraordinary ability came from the heavens but whose life on earth spoke of suffering. Withdrawn, nervous, quick tempered, the lone artist felt more at ease with his drawings and mathematical calculations than with people. Bernini captivated everyone; Borromini hid from them. His greatness and sadness are both here. I will seek him out and beseech him to guide me as I attempt to do justice in restoring his masterpiece.

Day III: Creating Form

Morning:

Borromini drew an oval plan, overlaying circles and triangles upon it. He made this play on geometry the source of all, the guiding framework for the humble building materials of brick, stucco and glass. This sublimely beautiful oval is formed like pizza dough, pushed and pulled this way and that into soft curves. The walls break forward and recess backward, making me believe Borromini hovers in the dark watching the faithful worshiper encounter his work. We are enveloped by these undulating walls yet, for all of the movement, there is a strict axis bringing one from the entrance directly to the altar. Columns lining the walls rise to the oval dome illuminated as if by a mystical force, but in fact by windows concealed behind high moldings. Coffers in the shape of crosses and hexagons make the ceiling a play of patterns with no historical precedent. Here is Borromini taking time honored traditions and making them new again. Complexity, geometry, ingenuity. I take note. Of course, you, master architect, manipulate Greek and Roman forms to suit your fancy. You summon up the classical models Michelangelo exaggerated with vigor, a broken cornice here, an oversized baluster there. Through these shape-

shifting architectural feats, I have come to know you. Of course, it's more than knowing you. I must confess. I'm being seduced by this place, ever so subtly drawn in. I'm obsessed with figuring it out. This building is so illuminating but illusive, like the man. What have you done to me? Maybe, arrogance aside, Signor Rossi has a point. Sensuality does rule here. But who are you? There is so much more hidden in the building. I'll find it, though. I am thorough. This has only just begun.

Afternoon:

The façade plays the same tune as the plan. A line of engaged columns divides the walls with discipline yet they curve and bend, the sides of the church sweeping inwards, the central entrance bursting forth. The concave and convex surfaces undulate in a very non-classical way. Sculpted saints reign in their niches while stone angels trumpet from a window. Small in scale, finely proportioned, San Carlo stands on its cramped and difficult site in an effortless way. The eye is led along in a never-ending feast of architectural puzzles, from the cornices of the roofline to the wizardry of the multi-storied steeple, a concoction of pillars, arches and upswept spires.

How could such a creative force be destroyed by its own hand? To take your life after bestowing all of your talents on the world. How did such a tragedy occur? I suppose in the great arc that is infinity, you do still live on in your brick and stone creation but you are still partially hiding from me.

As I sit outside on the small square, musing on the façade, finishing my detailed analysis, regretting Borromini's fate, I hear an earth-shattering crash inside the church. Debris covers the vestibule; a broken scaffold lies on the floor and a cloud of dust floats in the air. Broken bricks are scattered everywhere. An entire window frame is gone, collapsed in a heap of rubble. "The wooden planks were the only things holding the lintel up," says the supervisor. I behold the disaster in horror. I am utterly shamed.

My reputation with the workmen is as shattered as the bricks. My obsession with Borromini's spatial harmonies and interlocking shapes led me astray. I've spent too much time flirting with a long lost architect instead of inspecting the structure. This is my fatal error. Forgive me. Tomorrow, it's back to basics. Hopefully, that will be my redemption.

DAY IV: SUN, MOON AND STARS

Morning:

Bricks are being stacked, one by one. New supports for each lintel appear. The supervisor informs me that Adamo, the finest bricklayer in Rome, is joining the team to rebuild the ruined window. I climb up the scaffolding to meet him. To my relief, he is warm and welcoming. No sense of blame is cast upon me in any of his words or actions. I confess my sin and he tells me life happens, that none of us is perfect. His rugged hands, bearing the marks of working with hard materials, touch each brick with remarkable lightness and place them with quick and graceful movement. I remark that he works like a true artisan. He thanks me but insists that he's simply tending to the small things, setting one brick at a time in its proper home, and nothing else. I make one more confession, to myself only. He is the epitome of manliness and exudes a modesty and sincerity that is the final devastating touch. I remind myself that I'm not here for romance, only restoration. Besides, I won't be the source of gossip in the workplace, so I leave the bricklaying Adonis to his art.

Afternoon:

Temptation visits me. I'm helpless before Adamo. He stands there in all of his muscularity rebuilding the window frame I allowed to crumble. I am the project director so it is my prerogative to have him inspect other areas of the building. He informs me that if he stops his work, we might get behind schedule. "Not to worry,"

I say. "Your expertise is essential to the success of this venture." We walk along the scaffolding, high above the church, inspecting the heads of winged cherubim that smile between the round plaques of saints and the foliage border of the dome.

"This cornice is decorated in carved laurel," says Adamo. "And that is your name, Signorina. It stands for victory and fame. A small feature, but it ties the design of the whole church together."

I tell him he is observant. He glances at me almost sheepishly, the brown of his eyes turning richer in hue. The solid Adamo becomes softer in his stance as he leads me around the dome, pointing out his favorite motifs. He singles out the intricate series of coffers in the shapes of octagons, hexagons and four-sided crosses, telling me how they are based on the ceiling of the fifth century Santa Costanza, the Roman church where he was baptized. We then climb up to the lantern. "This is where the sun, moon and stars can shine upon on all who enter the church," says Adamo. "It's the source of the light cascading down every wall. The windows I am restoring are the supporting cast. This lantern is the centerpiece."

I realize I had been missing the point. Borromini used ovals, triangles, squares and every other geometric shape on the ground to express the human realm of form, but the lantern is the portal to the spirit. I only considered it as another special effect. Form is so easy to see, so dependable. Light is so vague, formless in fact, hard to grasp yet it infuses all it touches with soul. One can't exist without the other. Light falls on form; form is a foil for light. And light certainly falls perfectly on Adamo. As we proceed along a narrow part of the scaffolding, my hand rests upon his forearm to support myself. I then run my fingers down over his shoulder blade, an unnecessary gesture but one not to be resisted. The act communicates everything. He doesn't flinch or move away. *Summon a priest*, I think to myself. *I could marry him on this very spot high above the altar. Hell, who needs a priest. I'm ready for some profane in the midst of all this sacred.*

A crackle fills the space between us. He doesn't say or do anything in particular, but I know he wants me. Just the way he lowers his head and glances at me says it all until the supervisor bellows from the floor below. "Adamo, your son is here. He said your wife wants you to pick up more vino after work." My insides collapse. In a moment, hopes shatter. We finish our inspection, of sorts, and come back down to earth. I return to my notes, Adamo to his masonry.

DAY V: ALL CREATURES TO THE FORE

Morning:

The dutiful man tends to his labors while the worst of men returns. Birds wreak havoc on the ceiling. Excrement drips from Corinthian capitals and a cherub's cheek. Rains made for equal havoc last night, pouring in through the unfinished windows and lantern, streaking down the walls. Nothing feels right today. I fear the presence of a curse.

My instincts serve me well. The curse appears as a darkened silhouette in the entrance to San Carlo. Of all beings, him. The master of evil. How dare he step into this sacred space. Of course, sanctity has no meaning for him. Arrogant, selfish, self-serving. Destruction in human form. I won't reveal his name here for he is nameless, shapeless. He doesn't deserve to be recorded for posterity. But I will document his actions for these will condemn him.

"Soooooo, this is the new job," he says with a sneer. "Think this will redeem you from plagiarism?" I inform him that my dissertation committee found my thesis free from any misconduct, even though his accusations delayed my graduation and cast a dark cloud about me. And his vile assistant, a true she-devil who did his bidding, poured acid in my wounds, bearing false witness to corroborate his claims against me.

He relishes intrigue and smiles so gleefully as he delivers his news. "I've been appointed to this project's advisory committee. Me,

the expert on Roman Baroque." I feel paradise has just been sullied. This vile body in Borromini's church. This warped being presuming to dictate the future of a masterpiece. "I will make your life hell. You know how natural that is for me," he proclaims with fire in his eyes. "Accept it, Laurel. I'm your past, present and future. Your name and fame rests with me." I recall how Adamo had applied the world 'fame' to me in such a different way. Not as a threat, but as encouragement. And as the unnamed evil one pours forth his hate, Adamo works directly above, tending to his window frame. I want to call out to my honest mason for help but there is no cause to draw him into my own special curse.

"Your shame lies with me too," says the despicable one as his hand makes its way up my arm until I shake it off. He likes my use of force and enjoys trying to conquer it even more. "Unless we cut a deal," he says in his oily voice. "Hand over all your research notes and I will go away."

As Adamo tends to his bricks and the other craftsmen clean up bird droppings, my thoughts waver from defiance to surrender. Who am I to worry about the evil one stealing my work and using it to produce an award-winning book? It's how he operates. And his assistant gleans a few crumbs of glory by catering to him in her own shameless way. Let them have it all. They had engulfed me in chaos at the university and I finally escaped it by coming to Rome. Resist them and they will harm Borromini's creation. Unseemly a scenario it may be, but it's worth the sacrifice. "You'll have your answer tomorrow," I said. He moves uncomfortably close. "No, by tonight," he retorts. Leering at me, he made his final demand. "When nightfall comes, I do my best work. Those notes are to be on my desk before the moon is full."

Afternoon:

While pondering the end of my career as the price for the preservation of Borromini's dream, I see the window frames coming to life. Bricks broke because of my own arrogance but the

boys persevered. Adamo led them. His arrival spurred them on. By some miracle, the deadline will be met in spite of me. It took the fall of bricks to bring me to my senses. Now, I will fall again. The vileness of him and her will prevail. They will triumph, yet again, at my expense.

Inspection of the window frames, done with due humility, is scheduled for three o'clock. My heart isn't in it but I cannot appear disinterested. I know the craftsmen are doing a stellar job. Duty calls. Ascending the scaffolding once more, I progress around the dome. Adamo fills me in on every detail, then stops and puts his hand on my shoulder.

"Signorina, something is wrong?" The question jolts me. "What? Everything is fine. You've all done superb work." Adamo says, "I am not asking about the building. It's your spirit. I see you struggling today."

His words break my heart. Nothing can be kept from a good man. I confess my troubles to him, wondering how an Italian bricklayer could understand the predicament of an American restoration architect and her heinous academic adversaries. Even more, I know he won't be able to help. As I finish my woeful tale, he simply responds, "tomorrow brings hope." I don't believe him but I bow my head in thanks and let him return to his bricks. I spend the rest of the afternoon reviewing final restoration plans, appearing busy while accomplishing nothing. The remains of the day are spent contemplating my deal with the devil.

As the boys announce quitting time, I sit at my work table overlooking Borromini's altar, watching the birds rest on the holy water basin. Adamo stops to say goodnight. He dips his fingers in the water and makes the sign of the Cross on his forehead. "The rains filled the basin. A priest has not blessed it but the birds have." I made a half-hearted grin. Adamo set his heavy workbox aside and sat on chair next to me. "The rain and the birds made things well again." I told him that was an odd thing to say considering

the damage they did. "You are like the rain and the birds," he says, as I shudder at the comparison. "A little trouble at first. A few bricks broken. Then, the light comes in and everything is good, as it should be. You are a blessing, just like them." Not waiting for a response, he gathered his tools and left. I stayed, expecting the unholy one to arrive at any moment. For hours, I wait but no one appears. Night falls. I remain in Borromini's church, readying myself for an appointment with Fate, yet it does not come to call.

DAY VI: RESTORATION

Morning:

"He's back!" exclaims one of the workmen. My head shoots up with dread realizing I have fallen asleep underneath Borromini's altar. "Who has returned?" I ask, dreading the answer that it might be him finally coming to exact his revenge. "Pietro!" boomed the workman. "Pietro ran away six days ago, which was a very bad omen. Things will be okay now that he's back." Pietro made his new home on my drawings, disregarding my need to read them, in order that he could purr and preen as only a masterly cat can do. Visitors also begin to poke their heads into the church. I instruct the workmen to put a no admittance sign with "restoration under way" in Italian. Adamo tells me they are the neighborhood ladies and gentlemen who usually come to pray but they have been denied for some time. We decide they can be safely let into the church now that the windows are nearly done. "Birds, cats and now people have all come back," says Adamo, "all God's creatures. Now, San Carlo comes to life."

Afternoon:

Fate still has not paid a call. Pensive and agitated, I wait and wonder about the future while, in the present, the crew are putting the finishing touches to the building. All bricklaying complete, smooth coats of stucco and white paint cover every surface. The

church becomes increasingly lighter and brighter as each window happily displays itself in now pristine condition. The windows are only phase one of the restoration. Criticism might come from him, cursing the quality of mortar or finishes, casting doubt on Adamo's work. All of this to make me look bad. Waiting is a torment, one purposely planned by him. I am sure he left me waiting all night so I would be exhausted. Watching the workmen take down the scaffolding, I recall the chaos of only a few days ago and sit in fear that chaos is about to return in the guise of the evil one.

"Here is your reward," said Adamo as he places a brick on my table. "One of Borromini's originals as a remembrance." Pietro the cat rubs his chin along the brick's rough edge while I become downcast. Adamo informs me that his sister works in the architecture department of the university. I don't know what this has to do with me nor do I care at this moment. He says, "she tells me that the department dismissed the professor last night and cancelled his committee appointments." Snapping my head to attention, I said, "what professor?" Adamo replies, "that man you told me about yesterday." With an all-knowing look, he takes two more bricks out of his toolbox. "The professor's sins caught up with him. Bribery, sexual misconduct, plagiarism. He and his assistant have been cast out." Adamo slams the two bricks together and lets the crumbled bits fall to the floor.

DAY VII: REFLECTION

I stand before San Carlo and watch priests, the faithful and the curious gather. Flowers, candles and cut velvet altar cloths all pass by. Cats and birds flutter about, unwilling to give up their home to humans. My work is done. I rest. Borromini's creation is fully realized. Chaos has been exiled. The bricks are back in their place. Both the sparkle of the day and the stars of night are now able to illuminate the church through the restored windows and lantern. The celebratory mass will be said in an hour. I will not attend.

Religious ritual means nothing to me. Father Belloguardo praises the restoration, proclaiming, "you've done the Lord's work." I tell him it has been a trial of both the sacred and the profane. His eyes twinkle. As music resounds from the church, the kind priest invites me inside. I decline. "My work is done. The Lord takes it from here." Father Belloguardo raises his hand. "Bless you, Laurel."

I find a perch at one of the four fountains on the street and watch the crew of workmen stand in ceremonial formation in front of the church to bow before the Cardinal, arriving in a flourish of red hat and cape and commending them for the project. After the obligatory formalities are over and the Prince of the Church enters San Carlo, the supervisor of the crew seeks me out and presents me a with a white rose. "Signorina, you invented the supports for the window frames. We used to toil in the dark with shutters closed. You brought the Lord's light in and we saw everything differently. You breathed spirit into the place." Nodding in thanks, I fully accept such a heartfelt compliment even if I firmly believe I am not the heroine of this story. I confess, however, to a revelation. I now see that I did not fail entirely. When I fell, I rose up again and learned my lessons, good and bad, from every force and being who entered the church.

"A day to rest," said Adamo, who arrives with a wreath of laurel. "And to celebrate. I bring this for the altar." I behold the finest of men. God's best work, so to speak. Adamo, the first among men, the hero, the repository of all manly virtues, the ones that made me want to taste some vices as well. Always blameless, he floated above the church on his scaffold like a guardian angel. I, on the other hand, proved to be all too human, but what's a girl to do when confronted with a man who combines the beauty of a god, the bravery of a warrior and the smoldering earthiness of Rome in flesh and blood. Adamo was my momentary diversion but Borromini has become my abiding passion. He is the man of my dreams who leaves me easily bewitched and eternally bemused. I've beheld his

space, his forms, his light. There may have been pain in Borromini's mind and body, but the church he left behind is hope edified. He instructed no plaque or epitaph should crown his tomb in a city full of monuments to personal glory. San Carlo alle Quattre Fontana speaks for him.

EPILOGUE

This is a tale of my own seduction and obsession and I am the better for it. My journal is closed, the metal clasp tightly affixed, a knotted red ribbon the final accent. This is never to be touched. No one needs to read it. This small volume is the confessional. With pen in hand, one pours out all the deadly sins, or at least one's thought of sins, and one's hope of committing certain sins. My revelations are on paper, wrapped in canvas, sealed and tied with silk. I no longer need the book. It has done the Spirit's bidding. My soul is now one more brick in that divine building. Borromini's church is restored. I am redeemed.

Whisper of a God

"Where are we going?"

"All will be revealed, Aidan. Keep moving."

"You always say that, Delphi. There are no other runners around. You've led us onto the wrong path and now have no clue where we are."

"Pace yourselves, you two," said Zed, focused on every pebble and blade of grass as his feet landed on the ground with unerring precision. "We've got to make it to the top."

In single file, the three athletes ran along a stony precipice. One wrong step might lead to a fall into the deep ravine below. Before them loomed a landscape so vast its scale seemed more suited to titans than ordinary mortals. Forming an impenetrable wall to anyone who dared to cross, layer upon layer of hills stretched to an endless horizon offering no sight of village or tilled field. No evidence of the hand of humankind marked this wilderness. Rocky terrain played host only to pine trees, their twisted torsos adapting to high winds and parched soil, their branches saluting the sun, their needles lending an evergreen coat to a topography beautiful in its brutality.

The magnificent view and the heady scent of trees might have given passing pleasures to the runners, but they spurned these offerings and

devoted their energies wholly to mastering the few inches of uneven and unforgiving earth at their feet. Evenly paced, moving in unison, they formed an unstoppable force. Muscle spent itself and sweat poured forth as a sacrifice to the challenge, to make it over the mountains and reach the valley where they could claim their prize. Delphi's thoughts, however, did not dwell on trophies. She kept face forward with a single-minded determination, following the path higher and higher, hoping to find what had eluded her, knowing that challenges lay ahead, for she had been warned. The determined youths traveled in the wake of ancient gods and heroes as a lone, unobserved figure sat silently watching them.

"My god!" exclaimed Zed. "I know where we are. This is the slope of Mount Parnassus."

Stopping dead in his tracks, he fell to his knees.

"And this is the sanctuary of Athena Pronaia. We are at the entrance to Delphi."

His comrades, given no time to react, crashed into him, over him and onto the rock-strewn path.

"Now you tell us," shouted Aidan, brushing dust from his face and wiping blood from a scraped elbow. "We are so off course. All this time wasted."

Delphi, fallen but somehow free of dirt or bruises, quickly raised herself up and checked on Aidan's injury. While examining his wound, she noted the smile on his face and how he firmly rested his hand on her shoulder. She did not encourage him with a smile in return, but she did not dissuade him by pulling away from his touch.

"There is the tholos," declared Zed as he pointed to the foundations of a temple. "Three Doric columns still standing."

"Three," murmured Delphi, her eyes aglow as she beheld the marble remnants. "Three there shall be. Three mortals, three challenges, three chants to thee. One sees, one decrees, one pleas."

"So, now we have rhymes, when we should be running," grumbled Aidan as he left Delphi's healing hand and rose to his feet. "Who cares about a ruin when we have a race to win."

Delphi stood icily still, mesmerized by the three slender columns marked by thinly carved flutes drawing the eye ever upwards. The white marble of these faded beauties still glistened in sunlight. Time had only increased the nobility of their stance as they watched over the sacred precinct, dutifully at attention to the heavens above. Delphi assumed the same devotional demeanor, her torso straight, firm, patiently waiting.

"What is the meaning of three?" asked Zed.

"Deeds, words, thoughts. Three will be. Three make one. Three are thee."

Neither blinking nor moving, Delphi faintly mouthed the words again and again as she paid homage to the silent stones. Zed took hold of her arm. At the moment of his touch, her eyes fluttered and her trance-like state fell away just as quickly as it had come upon her.

"Delphi, what's going on?"

"What do you mean?"

"You recited a rhyme about the number three."

"What? I didn't say anything. The sun must be getting to you."

Zed shrugged his shoulders and followed Delphi as she tiptoed along the circular base of the tholos.

"One, two, three. One, two, three."

"What are you counting?" asked Zed.

"The measurements of the temple."

"You seem to be obsessed by the number three."

"Nonsense," she retorted. "It's just common sense. The foundation blocks are three feet in length and height."

"Three is a sacred number in many cultures and religions," said Aidan. "Since we are at a holy site, three as a measurement does make sense, to use your very own word. And there are three of us who had better start running or there will be three losers at the end of the race."

"Let's rest here for a bit," said Delphi as she completed her navigation of the tholos. "We need to pace ourselves."

"The ancients always stopped in this tholos," said Zed. "So, we are following in their footsteps. Here they made sacrifices to the goddess Athena before moving higher up the hill to the temple of Apollo, where the oracle told of fortunes good and bad."

"It's no time for the classics major to show off," said Aidan. "It's time to run."

"The finance major might like to slow down and learn something," said Zed with a pinched nose, as if he'd come upon a foul odor.

"Wait, please," said Delphi, taking a seat on the steps. "I'd like to know more."

Zed knelt before Delphi while Aidan kept to himself some feet away, choosing to sit high upon the remnants of a cornice that had once proudly occupied its place atop a shrine.

"Secrets are held in this sacred spot," said Zed. "Any man who found his way to the oracle might see his future."

"Only men?" asked Delphi in a sardonic tone.

"Oh, no. I'm sorry," he said in a hesitant voice. "I meant to say that all humans came here in hopes of discovering their fates."

"Well put," said Delphi. "But I sense your first statement is the one you truly mean. Truth is revealed more fully in quick words rather than measured monologues."

"She's got you there," yelled Aidan. "Talk all you want, but Delphi isn't fooled. She's all-seeing, all-knowing."

"If only you were," retorted Zed.

Aidan threw a rock, missing Zed's head by only a few inches.

"My aim is perfect so I did you a favor. Next time, I won't be so kind."

"Now, boys," said Delphi. "Enough of that. This sanctuary is far more interesting than your endless competition. Please, Zed, go on."

Zed puffed his chest slightly as if winning a round.

"Legend holds that Zeus sent two eagles flying to the east and west. Their paths crossed at Delphi over the stone called the "omphalos" marking the navel of Gaia, the Mother Earth goddess. My friends, we have stumbled upon the center of the world."

"Have you been here before?" asked Delphi.

"No," said Zed. "I did an analysis of the site for my seminar on Greek culture."

"Boring!" exclaimed Aidan. "Dead poets, forgotten gods. Nobody cares."

"You might benefit by looking and listening," said Zed. "We are running in the Pythian Challenge, named for the oracle who dwelled in Delphi. In her honor, the ancients held games here every four years. But you would have been at a disadvantage in those days. One had to compete in poetry and music as well as sport. The Greeks demanded sound minds along with sound bodies. Needless to say, no victory laurels would have crowned your head."

"I would beat anyone in any age," pronounced Aidan. "With the Egyptians, the Aztecs, you name it. I was born to win."

"Aidan, the name of the Celtic sun god, fiery and uncontrollable," said Zed. "It suits you."

Flying off of his perch, Aidan came to the steps of the tholos and stood face to face with Zed.

"Z is the last letter in the alphabet. Last place is where you will always be. And my name begins with the letter A. My point is made."

Neither of the young men would give an inch in retreat. Both firmly stood their ground until Aidan raised three fingers.

"Delphi said there are three challenges. Okay, let's start now. First one to the top of the hill wins."

Crouching down, both hands on the ground, one leg extended forward, the other backward, Aidan tightened every inch of his core as he assumed the position to run. Zed did the same. The tautness of the two bodies waiting to spring into action made time heat up like a spark seeking its combustible pyre. At the count of three, Aidan launched ahead with all his might, kicking up a storm cloud of dirt into his opponent's face. While Aidan soared ahead, Zed collapsed onto the ground coughing and gasping for air, his eyes burning from the dust while his competitor's laughter resonated over hill and valley.

"Good god, I'm blind!"

A hand rested upon his forehead and wiped his eyes.

"You'll be fine."

"The touch of an angel," said Zed.

"No. It's me. Delphi," she said a soft voice, pressing her hand on Zed's cheek.

Opening his eyes, he sat up and shook the earth from his shorts.

"You shine like a goddess in this light. In any light, in fact."

"Greek role playing at your little liberal arts college in the Berkshires has gone too far," said Delphi. "You've let your imagination run amok."

"Maybe mine has," said Zed. "But you seem to have lost yours, robbed by that science program at Columbia. All work and no

play at your big city school. You've certainly trained the brain but possibly neglected the spirit."

"All make believe," said Delphi, tugging at his wavy locks before running off. "You're prone to flights of fantasy."

Springing into action to catch up with her, Zed called out, "at least I know where we are."

"But I arrived where we are before you did," said Delphi as she hurdled effortlessly onto a pedestal that once supported the statue of a goddess.

"Truce," said Zed. "The Greeks always declared a truce before the Olympic Games."

"But we are on the site of the Pythian Games," said Delphi.

"I see you easily recall historical details to counter my argument."

Alighting from her pedestal, Delphi put her hand on Zed's shoulder to steady herself.

"I've read my classics."

"Well read indeed, but you are a very hard one to read, Delphi."

"I'm not a book, Zed."

"No, you are a riddle."

"Aren't we all?"

"You say few words, Delphi, and, I, the wordsmith, can't make sense of them."

"Words mean many things to many people," she said with a tilt of her head. "They are subjective creatures."

"Take your name, for instance," said Zed as he tilted his head towards hers. "Delphi is short for Delphinium, the flower that symbolizes an open heart. If only it would open for me. What words can I say to make that happen?"

"No more words," said Delphi. "It's time for action. We run now or else Aidan wins. He waits for no one."

"That's because he is no gentleman. What can one expect of a philistine from a state university?"

"Now, now," said Delphi. "You know the price paid by that kind of arrogance. Haven't you learned the lessons from all of those Greek myths you spout. Flying too high. Challenging the gods. I believe they call it 'hubris,' or being too big for your britches."

"The Greeks didn't wear britches," said Zed.

"I'm not going to play semantics with you," countered Delphi. "Onwards, now!"

They ran at a quickened pace, Delphi gliding with apparent ease and Zed becoming lighter in step. His long lean frame put up little resistance, naturally adapting to an even speed behind the girl whose diminutive feet barely seemed to touch the ground. As they ran faster, Delphi felt the presence of a stranger. She saw the movement of shadows behind the ruins about her but could not make out if it was a person, an animal or the branch of a tree.

"Mere mortals. How are things down there on earth."

Delphi and Zed saw Aidan high on a rocky outcropping at a sharp curve in the road. He stood with legs apart as if he were a warrior of Greek legend, flexing his quads, his right arm stretched out before him in a salute.

"Oh, Aidan. It's you! I had the weirdest feeling of being watched and now I know why!"

"Ha! I'm everywhere Delphi."

"If you knew about Greek culture," said Zed, "you would be taking a classical contrapposto pose, one leg bent, the other strong, waiting calmly for victory. Instead, you weigh heavy on the ground like a brute, the earthly opposite of the god you hope to be."

"All words, no action. Where does it get you?" said Aidan. "Down there in the dust."

"It can't be denied," said Delphi. "Aidan's the victor. He reached the top first."

"He's won a battle, not the war," retorted Zed. "History tells us so. The Persians were at the gates of Athens in the year 480 BCE. The Athenians sought out the oracle of Delphi, who told them to hide behind their wooden walls. They interpreted the prophecy to mean their navy would save them. So, they took to their ships while the enemy burned the city and desecrated their shrines. It looked and smelled like defeat but the Athenians trapped the Persian fleet in the bay of Salamis and vanquished them. In the end, final victory belonged to the Greeks."

Quibbling came to an abrupt halt when Delphi ran into the nearby shrubbery.

"What is she doing?" asked Zed.

"I don't know but she can't be left alone," said Aidan, coming down from his mount. As both young men pushed through the scrubby greenery, they saw Delphi kneeling before a spring, cupping water in her hand and splashing it on her face, allowing it to run down her neck and over her breasts.

"Do you boys need to cool down?"

The two young men, still partly hidden in foliage, fumbled their way into the clearing.

"You've taken the waters of the Castalian Spring," said Zed. "It's where women purified themselves before moving on to the sanctuary of Apollo. History repeats itself with every droplet on your skin."

"You mean men don't need to purify themselves?"

Delphi received no answer since Aidan and Zeb appeared to lose the gift of speech as they stood over the spring. Once she finished with her ritual bath, the young men suddenly took off at high speed up the hill.

"Boys. What fools these mortals be," said Delphi. As she sat by the spring, running her fingers in the water, she heard a rustling sound as a goat stuck its head through the leaves. It made its way around the spring, munching on any blade of grass in its path, and stood next to Delphi.

"Aren't you a cutie. And possibly lost. Shouldn't you be with a herd somewhere?"

All became clear as more goats roamed into the spring enclosure. Through a small break in the trees, Delphi saw a goatherd standing at a distance in the meadow. He raised his staff then turned about and walked away. Delphi waved back, pet the goats and then, fully refreshed, retied her shoes and left the sacred waters in search of her comrades. She found them a short distance up the road, Zed waiting for her while seated on the remnants of an Ionic capital, his hands caressing its delicate scrollwork.

"Behold this two-thousand-year-old beauty made by an artisan as a manifestation of divine order. Here is honeysuckle. There is acanthus vine. Delicate carvings, poetry in stone."

"While he moons over little flowers, I'm on top of what's left of a monument to soldiers," proclaimed Aidan from above. "That's me, a modern-day Spartan. I never give up or give in."

Aidan beamed, Zed moaned. Delphi ignored both of them and took a stance to begin running again, which made both boys hurry into place. With Aidan taking the lead, they ran along the Sacred Way with its treasuries built by Athenians, Siphnians, Corinthians and countless Greek city states all vying for glory and a glimpse of the future from the oracle on high. The sculptural remains about them bespoke of heroes and legends, of omens and tidings both glad and sad. The young runners, however, did not appear to notice the shadows cast among crumbling columns and shattered ornament, nor did they see the figure watching them from afar. They sought only the summit of the hill rising above.

"I'll get there first," declared Aidan as he swept up a staircase and sat smugly on the top step. "Victorious, yet again, while you both trail behind. This is all too easy."

Aidan threw little chips of marble at his running mates as they came closer.

"Since you, Zed, are a man of words rather than of action, tell us about the stones I use as my throne. Upon what sacred pile does my butt make its home?"

"The place of death," said Zed. "A memorial. The site where Apollo slayed the serpent Python."

Aidan waited no longer and ran up to the ruins of a temple set on a terrace, where he raised his arms in triumph before its monumental colonnade. When Delphi joined him, she stood unnaturally still as if frozen in time.

"Know thyself," she remarked. "The stones speak."

When a few tendrils of golden hair escaping from her ponytail caressed her cheeks and fell across her face, she did not move a finger to brush them aside. Only when Zed caught up with her and placed his hand on her arm did her eyes blink and her pose relax.

"Delphi, are you okay? You've been saying strange things since we arrived here."

"I'm fine," she snapped. "I haven't said anything. Maybe you are dehydrated so your mind is playing tricks on you."

"Of course, the Delphic maxims," said Zed as he hit himself in the head. "They are over the entrance. Know thyself, carved right above us. The essence of Greek thought and the fountainhead of all of western culture. You pointed out the obvious, Delphi, but I wasn't paying attention."

"And nothing in excess," she said. "That's the other one which you've missed."

Placing his hand over his heart and making a slight bow, Zed said, "too true. One must remember that the first maxim is a statement, the second a warning. There are many more, but these are the most critical."

"Blah, blah, blah," quipped Aidan. "Delphi, stop going into a daze every time you see an old stone. And, Zed, stop boring us with the know-it-all stuff. We've got to run!"

Disregarding the command, Delphi entered the temple. At the far end of the building, she sat down to inspect an opening in the floor, giving the two young men no choice but to stay with her since the marathon rules required that they all work, and win, as a team. The veins in Aidan's neck bulged with impatience while Zed's eyes never left Delphi.

"This is the place where the oracle pronounced her prophecies," said Zed. "She sat here above the crack in the ground, the very navel of the world. The whole of Delphi is built around this small spot. Some say gases from the earth made the oracle go into a hallucinogenic trance. She sputtered words that seemed to make no sense. Then, the priests of Apollo deciphered her utterings and returned with a prediction."

"The girl had the knowledge but the men were her voice," pronounced Delphi. "Beware those who speak for us."

"I hear some women's studies and feminist attitude coming our way," quipped Aidan.

"I'm simply following the maxims," said Delphi with a twinkle in her eye. "Making a statement and offering a warning."

"That's it!" exclaimed Zed. "It's finally dawned on me. Delphi, you are the oracle. The heiress to all those women who foretold the future."

"You really have gotten too much sun today, Zed," said Delphi as she gave him a shove.

Aidan burst forward, grabbing Delphi by the waist.

"I hate to admit it, but he's right. You've been going into this trance-like thing since we got here. Do you know what this means? If you can tell the future, the world is yours." Gliding his hand down over her back, he declared, "and I'll bet you see me in your future."

Delphi pulled away from him, indignantly straightening the strap of her tank top. She sat back down near the crack in the floor, running her hands over the broken marble paving stones as her eyes glazed over.

"First challenge. Tell me the true nature of knowledge."

Aidan's face and shoulders tensed up. Zed's gaze became deeper and wider.

"Knowledge is power," said Aidan

"Knowledge is virtue," said Zed

"Knowledge is a double-edged sword," replied Delphi.

"What do you mean?" said Zed as he clasped her hands in his. "Are good and evil the two sides of the double-edged sword? Do they balance one another, or does one prevail?"

"I don't know," she said, "but I'm sure it will be revealed in the challenges."

"What are they?" demanded Aidan.

"The first already done. The second a run, the third the spoken word," said Delphi. "The triumph rests in the end, a mystery, a riddle, so simple, so fine."

"A run!" exclaimed Aidan. "I've been saying it all along. I've been right but Zed wouldn't shut up long enough to listen."

"He who finds the rock of the Sybil will be a victor," mumbled Delphi.

Aidan shot like a rocket in the sky, catapulting off the terrace.

"You'll never find it," yelled Zed following at breakneck speed. "Since you know nothing about this site and I've memorized every inch of it."

"Intuition, buddy," shouted Aidan as he wound in and around the detritus of centuries. "You're too stuck in your head. I go on instinct."

Within an instant, Aidan climbed on a mound and proclaimed, "the rock of the Sibyl."

Zed's eyes popped and his jaw dropped.

"You won this battle, not the war."

"Boohoo," cried Aidan. "There's no stopping me. I'm the victor. You are the vanquished."

"The gods decree recitations in threes," said Delphi just as she disappeared behind the temple colonnade. The two boys pursued her but she could not be found.

"Did she go down into the navel of the world?" asked Aidan.

"Don't be an idiot," said Zed. "It's too narrow, like your world view."

Hearing the crunch of pebbles emanating from the distance, the young men caught sight of Delphi moving towards an open-air theater set into the side of the mountain. Following in her tracks, they found her standing at the center of the stage, the hills and valleys beyond serving as the backdrop, the heavens above the only ceiling.

Stretching out her arms towards the two competitors, Delphi proclaimed, "Recitation in three phrases, gentlemen, if you please, on love and desire."

Aidan stepped forward first and held his hand high in a fist.

"Desire is a Force. It drives the universe. Love stripped naked."

When Zed took center stage, he knelt down and raised his right hand open to the sky.

"Desire is a Spirit. It floats through time. Love the only anchor."

Delphi nodded her acknowledgment of the chants by tapping her index finger on her forehead, her mouth and her heart.

"Three phrases more, if you please."

"Desire conquers love. We surrender in the face of the animal. Lust knows no cage," said Aidan as he stared into Delphi's eyes.

"Desire burns. Love sooths. One is passing, the other everlasting," Zed recited as he bowed to Delphi.

Nodding again, Delphi raised her three fingers for the last chant.

"One line, three words. Any words. Choose them with care. Three words will be sung by the victor or be swallowed by the vanquished."

"Desire is life," pronounced Aidan.

"Love is eternal," proclaimed Zed.

Delphi closed her eyes and raised her arms to heaven.

"The two shall never be as one. For they cannot make three. The truth makes its home in the number three. These mortals offer squares when the universe calls for a circle. No victors or vanquished yet appear. Desire and love in thrall. Happy union if united at all. But, alas, those who seek will fall."

Stomping off the stage, Aidan shouted, "this game playing is over!"

Seizing Delphi, he kissed her.

"You are a piece of work," said Delphi as she pushed his face away. "What cave did you crawl out of?"

"I'm everyman, Delphi, and you know it. The way you look at me, the way your eyes widen when you watch me run. I see it. Every

time I flex a bicep, you heat up. Every time I wipe sweat from my forehead, you want me even more. Admit it."

Delphi watched the fullness of his lips as he spoke. She was appalled but drawn to the form. His skin glowed in the sun as she followed the outline of his cheekbone, an ideal line on a brutally handsome face. She saw the perfection of flesh but the absence of soul.

"She doesn't need a bully," said Zed. "She needs a real man, in mind and body."

"You think your little poses and poems will win her? Might impress her for a half-minute, but they won't keep her. Girls swoon over smooth words but, when it gets real, they want the beast."

"Your recitations were better than I expected," said Zed. "But these latest words betray you for the savage that you are. Love is not always a fight."

"It isn't a poetry slam either," said Aidan. "Why do you think Delphi brought us here. It's no accident. We're here for the contest. To win her."

Delphi said, "the master of words has a point."

"I win," said Zed as he glared at Aidan.

"Except for one thing," she said. "You have never once asked me what I think, Zed. You just impose your vision of the ideal woman onto me."

"Ha!" shouted Aidan. "I win. I knew it! You go off about all things Greek, but why haven't you sung about the warriors who killed for love? Paris seized Helen and brought her off to Troy, starting the deadliest of wars. No greater compliment to a woman. You didn't mention it because you are no Paris. How's that for a bit of ancient history? See, not as dumb as you think."

"You may come across as a brute, but you tell the truth," said Delphi as she lay her hand on his chest. "An honest man is hard to find."

With a wry look at Zed, she said, "words can deceive, but actions are true."

Delphi took both of Aidan's hands in hers and kissed them.

"You have the physique of a warrior, but you have no heart."

"Ha!" yelled Zed. "Checkmate."

Aidan lunged at him, both men falling to the ground in a cloud of dirt, grunts and groans.

"You will never spout a word again," said Aidan as a crushing blow sent three of Zed's teeth scattering on the ground.

Grabbing a nearby rock, Zed belted Aidan in the right ear and smashed his face, marring its beauty beyond recognition. The two bloodied men beat and bashed one another, standing up only to bring each other down again with fists to the head, elbows to the chin and knees to the stomach. With every punch, push and pull, they came closer to the edge of a high retaining wall. With one final assault, they both flew into the air and landed on jagged rocks, which did not deter their rage. They continued the pitched battle as they tumbled further and further down cracked staircases and broken pillars towards the edge of a mighty precipice. The furor only ended when Aidan and Zed gave each other their fiercest swipes, so forceful that they both disappeared over the slope of Mount Parnassus. Convinced that they must have dealt each other death blows, Delphi ran down to the edge of the hill. She found not two dead warriors but two living fools at the bottom of the ravine. Both men lay next to one another, bruised but breathing.

"Boys," she sighed. "To fall that far and not meet your deaths is a miracle. The gods are looking out for you."

"Have you found what you were looking for?" came a voice from behind.

Delphi turned and saw the goatherd.

"Finally," she said.

"And what might that be?" he asked.

"Myself."

"Know thyself," said the goatherd.

"And know the boys," she responded. "Aidan is honest, I'll give him that. But he's a brute."

"You found the truth in that," said the goatherd.

"Zed is brilliant. He plays at being virtuous, but it's a veneer. He's all ambition."

"Again, true indeed."

"Those boys never listened to me even though they named me the new oracle. They wanted to know the secrets I might reveal, but only to serve themselves."

"Their eyes did not see," said the goatherd. "Their ears did not hear and their hearts did not truly feel. They read the maxims on the temple but they did not embrace them."

"They can't help it," said Delphi as a pert smile flashed across her face. "The curse of being mere mortals. They both treated me like something to be won or conquered. Aidan acted like a god. Zed made me a goddess. Neither of those roles appealed to me."

"Girls don't need gods," said the goatherd. "They are already within you. They are you. You are them. All are one."

The goatherd picked a few blades of grass and shook them in his hand, which lured his little pack of goats into a circle.

"Know thyself and you will know the three sacred states: heaven, earth and, in the end, yourself. Isn't that right, my little flock?"

While the goats chewed contentedly, he plucked a sprig of laurel from a nearby tree and offered it to Delphi.

"You did warn me," she said. "I didn't hear it at first. I felt it at the spring, I read it in the maxims, but it finally dawned on me at the seat of the oracle."

Resting the laurel behind one ear, Delphi bid the goatherd farewell and ran on by herself, moving as if on air between the earth below and the heavens above. Before disappearing over the summit, she called down to the two young men still prostrate in the dust.

"A final message from the gods. Know thyself."

CPSIA information can be obtained
at www.ICGtesting.com
Printed in the USA
FSHW011831170619
59152FS

9 780368 478345